Mapping Memory

Mapping Memory

VISUALITY, AFFECT, AND EMBODIED POLITICS IN THE AMERICAS

KAITLIN M. MURPHY

FORDHAM UNIVERSITY PRESS

New York 2019

Fordham University Press has no responsibility for the persistence or accuracy of URLs for external or third-party Internet websites referred to in this publication and does not guarantee that any content on such websites is, or will remain, accurate or appropriate.

Fordham University Press also publishes its books in a variety of electronic formats. Some content that appears in print may not be available in electronic books.

Visit us online at www.fordhampress.com.

Library of Congress Cataloging-in-Publication Data available online at https://catalog.loc.gov.

Printed in the United States of America

21 20 19 5 4 3 2 1

First edition

CONTENTS

Introduction

April 24, 1998. Following nearly four decades of genocidal civil war, Guatemalan Roman Catholic Bishop and leading human rights defender José Gerardi stood in front of the Metropolitan Cathedral on the edge of Guatemala City's central square and publicly presented the four-volume final report of the Recuperación de la Memoria Histórica (Recovery of Historical Memory, REMHI) project. The report, entitled *Guatemala: Nunca Más* (*Guatemala: Never Again*), included statements from thousands of witnesses and survivors, and paved the way for the successive work of the UN-sponsored Comisión para el Esclarecimiento Histórico (Historical Clarification Commission, CEH). The report predominantly blamed government forces for the brutally violent, racially infused war waged largely against the rural indigenous communities that live in Guatemala's highlands, a war that resulted in 150,000 deaths, 50,000 disappearances, and more than one million refugees (Beristain 1998, 24). In his presentation, Bishop Gerardi explained to his audience: "We are gathering the memories of the people because we want to contribute to the construction of a different country" (Gerardi 1999, xxiii). Two days later, in the garage of his parish house, three military officers bludgeoned Bishop Gerardi to

death with a concrete slab. He was identified by his episcopal ring; his face was smashed beyond recognition and his body disfigured by dog bites.

Less than a year earlier, in July of 1997, Guatemalan photographer Daniel Hernández-Salazar, who documented the exhumations of mass graves for the Fundación de Antropología Forense (Guatemalan Foundation of Forensic Anthropology, FAF), was at a gravesite where the remains of nine peasants were being painstakingly disinterred. A forensic anthropologist showed Hernández-Salazar a bullet-pierced shoulder blade resembling a butterfly wing. Another set of unearthed scapulae brought to mind the wings of an angel, an image that would continue to haunt Hernández-Salazar in the following months (Hoelscher 2008, 207). Covering the impact of the civil war in Guatemala had left Hernández-Salazar increasingly dissatisfied with what he felt was photojournalism's inability to adequately portray the atrocity's magnitude. He reflected, "Years pass by. They pile up like pages in a book. Everything goes unpunished. I have to scream" (quoted in Hoelscher 2008, 207).

Searching for new ways to convey both the visual and affective impact of war, Hernández-Salazar drew from his work with FAF to create a photographic series entitled *Eros + Thanatos* (1998). A varied reflection on life and death, the series juxtaposes skeletal remains from digs with a nude male figure staged in positions that evoke both violence and eroticism. Many of the images are collages of multiple photographs, the sutured edges evoking the fractures, seams, and scars that mar Guatemala's relationship to its past. In what has now become Hernández-Salazar's most famous work—a triptych of three images, entitled, respectively, *No Veo, No Oigo, Me Callo* (*I Don't See, I Don't Hear, I Remain Silent*)—a young Mayan man faces the camera. Naked from the waist up and black hair loosely swept away from his face, he alternatingly covers his eyes, ears, and mouth. The scapulae (real bones from a dig), enlarged and superimposed into the image, expand in angel-like wings behind him. Embodying the familiar proverb "see no evil, hear no evil, speak no evil," these angels are a powerful condemnation of Guatemalan society's quiescence in the aftermath of barbarity.

The Archdiocese of Guatemala's Human Rights Office requested to put this triptych on the cover of the final REMHI report. Hernández-Salazar agreed, and added a fourth image: an angel staring into the camera with his mouth wide open in a silent scream. This fourth angel adds new, defiant meaning to the previous three angels, who refuse to see, hear, or speak about the past. This angel channels the screams of the dead, demanding

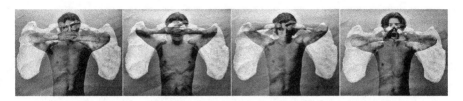

Figure 1. Daniel Hernández-Salazar, *Esclarecimiento* ©1998.

to be heard, demanding justice. This new polyptych was entitled *Esclarecimiento (Clarification)*.[1]

After Bishop Gerardi's murder, thousands of people took to the streets in protest. Marching in silence and dressed in black, many of the marchers carried posters of *Esclarecimiento*. The procession began at the Metropolitan Cathedral, where Bishop Gerardi's body lay in state, and ended at the Church of San Sebastian, where he was murdered. Those who walked did so in complete silence—their rage, grief, and clamor for justice embodied and amplified by the silent, visual scream of the angel they carried in their arms. Hernández-Salazar later reflected, "It was one of the most impressive moments in my life because everyone in the march was silent. I could hear only the noise of the steps and the clothes of all the people marching. In the background [tolled] the slow and somber sound of the bell from the Cathedral. It was difficult to focus the images in the camera viewfinder because my eyes were full of tears I could not stop" (quoted in Hoelscher 2008, 205).

In the wake of centuries of violence, racism, and oppression, and in a country where the dominant political culture has long been characterized by indifference, complicity, and rampant human rights abuses, Hernández-Salazar's work is a multifaceted visual intervention. The brutality and social apathy that his images condemn emerge from the deeply unequal and racist social structures that were set in place by Spanish colonialism in the 1500s and led to constant conflict and even war almost four centuries later.[2] From 1960 to 1996, Guatemala was immersed in a horrifically violent US-supported civil war marked by death squads, forced displacements, and the genocidal massacre of indigenous communities.[3] U.N.-brokered peace accords were signed on December 29, 1994, and REMHI began its work soon thereafter. However, as Bishop Gerardi's death demonstrates, the historical legacies of impunity and gross violence continued to impact Guatemalan society even after the war officially ended.[4]

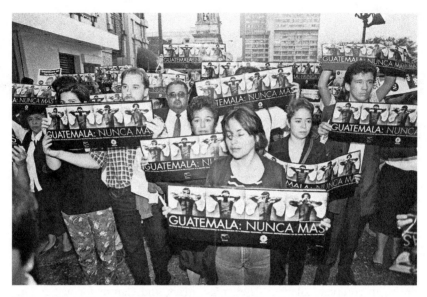

Figure 2. Daniel Hernández-Salazar, *Marcha de Silencio* ©1998.

Hernández-Salazar's images map a direct connection between these his-
torical legacies: bones dug up from the graves; the insouciant who refuse
to hear, speak, or see these atrocities; and the screams of frustration and
demand for address in a society where the vast majority of deaths and abuses
have long gone unacknowledged. They also demonstrate how images travel
both spatially and metaphorically, taking on additional meaning, haunted
by the events of the past and the dead, and imbued with the desires of those
who march in the present. Like a palimpsest, the images are embedded
with the artist's own thoughts and desires, the meaning they accumulate
as the cover of the REMHI report, and then, in the aftermath of the bish-
op's death, what they come to symbolize—what affects they are called
upon to anchor and embody—when they circulate with the marchers.
Expanding outward on either side of Hernández-Salazar's angel, the shoul-
der bone wings—which are clearly bones, and yet also unmistakably
wings—connect close to his face, drawing the viewer's attention to the in-
tensity of the angel's gaze. The plain gray backdrop leaves no room for
distraction: there is nowhere for the spectator's eye to look but at the angels.
Much like Walter Benjamin's angel of history, these angels want to fix the
wreckage of the past.[5] Yet, Hernández-Salazar's angels face forward,
toward the present and future, maintaining eye contact with the viewer.
Benjamin's angel of history is a figure for understanding the perversity of

the Enlightenment ideal of "progress" (the angel of history embodies the desire to redeem the past, even as the detritus of the present interposes itself, pushing him into the future). By contrast, Hernández-Salazar's Mayan angel's demanding gaze represents both an imperative to see, hear, and speak in the present as well as to be seen and heard in the ongoing aftermath of a violent, deeply racialized history. While the call for justice is universal, and the figure of the angel an immediately recognizable motif in Western art, the indigenous features and scapular wings of the figure anchor him in the particular Guatemalan context. He is a Mayan angel risen from the grave, intent on speaking for the dead who cannot speak for themselves and working within the politics of memory and human rights to demand sociopolitical change in the present day. Benjamin cautioned, "Every image of the past that is not recognized by the present as one of its own concerns threatens to disappear irretrievably" (1968, 255). *Esclarecimiento* demands recognition. It is object, act, and metaphor: as an object, it is embedded with memory, grief, and rage; when carried in the arms of those who marched, it is called upon to affectively and visually transmit this meaning, its potency magnified by the converging masses of images and bodies. It is both an act of memory—of remembering and of demanding the right to remember—and an act of protest, wherein its very name is a call for transparency and clarification of what really happened in the country. In its explicit refusal of silence and invisibility, *Esclarecimiento* metaphorically performs an enacted mode of visual labor that is at the core of many visual, embodied acts of dissent in the Americas.

Multifaceted and strongly anchored in the specificities of place, *Esclarecimiento* demonstrates the powerful role of visual culture to perform as an embodied agent of memory and witnessing, one that is intrinsically tied to human rights, both by rendering *visible* their absence and making demands for them. The paucity of justice, compromised democracy, and insufficient address of individual and collective experience and memory are unfortunately common issues that have manifested in different countries across the Americas in the wake of Cold War violence, US imperialism, and internal conflict. I open this book with *Esclarecimiento* because it is exemplary of the ways in which visual works have the potential to speak outside of and in a different register than government narratives—and to render visible the ongoing impact of past violence and unreconciled injustices by working at the intersections of visuality, memory, human rights, and place. The call for transparency, accountability, and justice that *Esclarecimiento* makes is specific to the Guatemalan context but not unique to it. As I argue throughout, certain visual works, such as *Esclarecimiento*, employ

the politics of visuality as a tactic for undermining and subverting discourses and visual regimes that suppress certain subjects and occlude the truth of historical events and human rights abuses. By affectively and performatively engaging with the politics of memory, these visual works seem to work off of an equation wherein *seeing* leads not only to knowledge but also, importantly, to *feeling*—and that this, in some direct or indirect capacity, will then result in sociopolitical impact.

Even though on some level this equation rings true, there is no direct line between visuality and human rights, and reality remains much more complicated. Nonetheless, much documentary and human rights–oriented media hinges on the premise that *seeing* atrocity and gross human rights violations will influence public opinion, prompting increased pressure on decision-makers and demands for cessation or intervention. History has demonstrated that this belief in the power of the image is both partially warranted and overly optimistic; nonetheless, this desire for a direct correlation between visual texts (primarily photography and documentary film), the acquisition of knowledge, and social and political change persists unabated. Scholars have studied aspects of this visual economy at length, ranging from the study of what pictures "want" and can do (Mitchell 2005), to the politics of spectatorship in relation to images of pain and suffering (Sontag 2003), and the visual vernacular of human rights principles and the discourses that articulate them (Hesford 2011). Other scholars have argued that images can challenge notions of citizenship, change how viewers understand and relate to violence and conflict, and shape intimate relationships and community. For example, in her expansive exploration of the relationship between photography and citizenship, Ariella Azoulay (2015) contends that photographs are political spaces and tools through which to realize change. Similarly, Susie Linfield (2010) argues that learning to truly *see* the subjects depicted in images of political violence is an ethically and politically necessary act, and Sharon Sliwinski (2011) asserts that photographs of distant human rights struggles function to form a virtual community of spectators.

It is likely that this investment in the correlation between images and social change is linked to the long-held belief in the relationship between photography and feeling. In *Camera Lucida*, Roland Barthes wrote of the photograph's ability to emotionally "touch" the viewer. In contrast to the cultural knowledge that shapes the viewer's interpretation of an image (what Barthes calls the *studium*), the power of the image lies in the unexpected "wound" of the image that emotionally "pricks," "pierces," and "bruises" the viewer (the *punctum*) (1980, 25–27). The image's ability to af-

fectively "touch" the viewer frames the act of viewing as both strikingly tactile and essentially linked to feeling. This line of inquiry continues in contemporary scholarship, such as in Margaret Olin's *Touching Photographs* (2012), which explores how images "touch" us, and in *Feeling Photography* (2014), a collection of diverse essays edited by Elspeth H. Brown and Thy Phu and organized around how feelings affect viewers' experiences and understanding of photography.

Such beliefs are surely not without merit. The photograph's capacity to "touch" viewers, shape public opinion, and influence political change has been demonstrated in tangible ways across the globe. Several iconic examples include Nick Ut's Pulitzer Prize–winning 1972 image of a nine-year-old Vietnamese girl running naked down a road after being severely burned by a napalm attack and Kevin Carter's Pulitzer Prize–winning 1993 image of a starving Sudanese child collapsed on the ground while a vulture lurks nearby. More recent examples such as the collective archive of professional and amateur images of the 9/11 attacks on the World Trade Center in New York and the infamous 2003 Abu Ghraib photographs taken by US military personnel demonstrate the profound influence images can have on the shaping of public opinion.

Scholars have coined a range of similar terms for the kinds of affective seeing visual works may induce, including "seeing for" (Bal 2007), "empathic vision" (Bennett 2005), "ethical imagination" (Goldberg 2005), "ethical spectatorship" (Kozol 2014), and "ethical vision" (Maclear 2003). All of these terms attempt to grapple with seeing as a form of knowing that is also embedded with some sort of ethical imperative, although the extent to which this seeing and knowing translates to any sort of tangible impact remains less clear and highly subjective. Accordingly, I am less interested in attempting to definitively determine if there is a correlation between visuality and human rights impact, because the answer is inevitably both yes *and* no, or sometimes. Instead, my interest is in *how* visual works operate within this equation. In other words, are there specific, identifiable strategies or characteristics in visual texts that work to induce what we might consider a form of affective seeing and knowing? As I studied a range of visual interventions, I realized that the key could perhaps be found in performance. Each visual work, in different ways, demonstrated a productive dialectic between visuality and performance that was playing out in specific and strategic ways with regard to memory.

Mapping Memory is thus framed around two overarching theoretical questions: First, what is the relationship between memory, visuality, affect, and human rights? Second, how does analysis of the intersections between

performance and visuality deepen our understanding both of this relation-
ship and the interventions these visual texts make? Across a range of case
studies, this book investigates how visual works engage and render visible
specific memory narratives in order to create a context for publics to *see*
and *feel* past and present injustices. As I progressively argue, the perfor-
mative elements, or strategies, of visual texts—such as embodiment,
reperformance, reenactment, haunting, and the performance of material
objects and places—facilitate the anchoring of memory into specific bod-
ies, objects, and places. Consequently, studying the intersections of per-
formance and visuality enables us to better understand how these works
act to expand viewer's perceptions of specific bodies, places, and tempo-
ralities, articulating both "where memory dwells," to use Macarena Gómez-
Barris's phrase, coined in 2008, in the aftermath of mass conflict, and also
how these texts work to produce a form of affective seeing intended to cre-
ate change in the contemporary public sphere.

 Mapping Memory focuses on a diverse range of visual works created at
the end of the twentieth century and the beginning of the twenty-first.
The twentieth century in Latin America was a distinct and tumultuous
revolutionary period (from the Mexican Revolution, ca. 1910–1920, through
to the Central American conflicts of the 1980s) marked by consecutive at-
tempts to escape from unsustainable state forms that were based on "ex-
clusionary nationalism, restricted political institutions, persisting rural
clientelism, and dependent, export-based development," and consequently
resulted in widespread displacement and poverty (Grandin and Joseph
2010, 28). One after the next, countries across the region experienced a
wave of successive crises that originated in national contexts but nonethe-
less produced ripple effects of radicalization that "extended spatially, that
is, across the region, and temporally, from the first cycle of post–Second
World War coups, through the rise of the New Left and the New Right of
the 1960s and 1970s, through to the Central American civil wars of the
1980s" (29). And though each conflict was unique to the specific country
context, the patterns they followed were often quite similar: they originated
in oppressive circumstances that galvanized the masses, only to be followed
by counterinsurgency, civil war, and dictatorship. Moreover, "what most
joined Latin America's insurgencies, revolutions, and counterrevolutions
into an amalgamated and definable historical event," according to Greg
Grandin and Gilbert Joseph, "was the shared structural position of subor-
dination each nation in the region had to the US" (29).

 As exemplified by the Guatemalan case study that anchors this chapter,
many of the periods of conflict and processes of political transition in this

study were heavily impacted by Cold War politics, US imperialism, and the rapid proliferation of neoliberal policies. During and after the Cold War, the United States supported (and encouraged) anti-communist dictatorships in Latin America over any democratic governance that might open the door to Soviet Communism.[6] Interwoven with this fear and mistrust of Communism was the desire to extend US imperialism by increasing control and protecting US business investments in the region, which yielded higher profits while exploited, nonunionized workers earned lower wages. Guatemala was the first country in Latin America to experience a covert, full-scale CIA presidential overthrow, but by the time President Kennedy took office in 1961, the hand of the United States was seen in countries across the continent, working to turn Latin America into an imperialist counterinsurgency laboratory by reinforcing local intelligence operations, training military forces, providing technology and equipment, and, in some cases, facilitating coup d'états.[7] During this period, national intelligence agencies that had been fortified by the United States began to transform into what was to become the region's brutal death squad system, a system that was ultimately responsible for the torture and death of hundreds of thousands of Latin Americans throughout the 1970s and 1980s. Influenced by the United States' interventionist policies and caught up in their respective internal struggles for power and domination through land ownership and control of industry, in the latter half of the 1900s, Latin American countries, one after another, suffered brutal military coups (Brazil, 1964; Panama, 1968; Chile, 1973; Uruguay, 1973; Argentina, 1976), while others lived under perpetual oppressive dictatorships (El Salvador, Guatemala, Haiti, Honduras, Paraguay) and decades of violent, internal conflict (Peru, Colombia).

Artistic Interventions

As countries across the Americas underwent the monumental political and social changes of the past fifty years, both the violent periods of conflict and precarious periods of transition that followed were met by vibrant, political, artistic production.[8] This book expands this archive of interventionist-oriented, politically engaged art of the Americas by analyzing a diverse range of understudied but critical visual works from the contemporary era that work with memory as a primary form of sociopolitical intervention. While my archive draws from different country contexts across North, Central, and South America, each case study emerges from the Cold War politics and counterinsurgency violence of the latter

half of the twentieth century and seeks to address the ongoing aftermath of these violent periods of restructuring. My aim in looking at these visual works is to explore how different strategies for embodying and producing knowledge and affect in relation to memory are negotiated through a variety of practices that all place the question of visuality as central to their intervention. These visual texts signal a shift away from the first-person testimonios and survivor narratives that were the dominant form of memory-based humans rights text of the 1980s in Latin America and toward new tactics and deployments of memory in relation to present-day politics. As such, this archive provides a lens for examining both a new era of Latin American memory politics and the affective and performative power of visuality in relation to memory and human rights. The case studies in this book include diverse photography projects, documentary film, new media, and a range of physical memory sites. I varyingly refer to them as visual works, texts, case studies, and, at times, under the more general rubrics of visuality or visual culture. While there is debate as to whether the word "text" should be used in the context of the visual, I use it in the cultural studies sense, meaning the range of objects, actions, and behaviors that can be analyzed and decoded within the context of both form and the cultural systems of knowledge that give it meaning. As I emphasize throughout this book, these visual texts function as spaces where audiences visually and affectively come into contact with memory.

I argue that the diverse visual works I examine in this book are principally united by a visual strategy, or mode, that I call "memory mapping." Memory mapping is the aesthetic process of representing the affective, sensorial, polyvocal, and temporally layered relationship between past and present, anchored within the specificities of place. Memory mapping works to develop affective, visual maps of the relations between bodies, memories, lived experience, and the mnemonic potency of physical objects and spaces. In so doing, memory mapping projects produce new temporal and spatial arrangements of knowledge and memory in the present that function as a counterpractice to the official narratives that often neglect or designate as transgressive certain memories or experiences. While memory mapping is not cartography in the literal, geospatial sense of the term, the concept of mapping is useful, because cartography is the attempt to define, mediate, and understand the historical and contemporary world by exploring how the spaces that constitute it are mapped—work, I contend, these visual texts *also* perform, albeit in a very different manner.

Maps are strikingly complex texts. Since the word "map" entered the English language in the sixteenth century, more than three hundred com-

peting definitions have been proposed (Brotton 2013, 5).[9] The generally accepted definition comes from J. B. Harley and David Woodward's *History of Cartography*, which defines maps as "graphic representations that facilitate a spatial understanding of things, concepts, conditions, processes, or events in the human world" (quoted in Brotton, 5). Maps are composite documents that simultaneously rely on multiple meaning-making mechanisms. As Jerry Brotton notes, maps are multifaceted, hybrid documents; they cannot be understood without writing, but a map without the visual is nothing more than a list of names. Maps offer a spatial understanding of the world's events, but they are also defined by time, because they enable viewers to perceive how events happen in succession. Brotton concludes, "We of course look at maps visually, but we can also read them as a series of different stories" (5).

Maps simultaneously record and produce relations of power. Mapmakers are always called upon to make choices about what to include and exclude; as a result, "mapmakers do not just reproduce the world, they construct it" (Brotton 2013, 7), and a map, "whatever its medium or its message, is always a creative interpretation of the space it claims to represent" (14). Mapmaking projects, especially those that are independent or artistic in nature (as in the case of the examples in this book), thus have the potential to function as a practice of claiming, or reclaiming, agency and autonomy. As Presner, Shepard, and Kawano assert, "maps are not stable objects that reference, reflect, or correspond to an external reality. Mapping is a verb and bespeaks an on-going process of picturing, narrating, re-symbolizing, contesting, re-picturing, re-narrating, re-symbolizing, erasing, and re-inscribing a set of relations" (2014, 15).

As a theoretical concept and metaphor, mapping has also been particularly useful in ways that exceed literal cartography. The most well-known example of this is Fredric Jameson's concept of "cognitive mapping," which tends to how we, as individuals, make our own worlds intelligible to ourselves through an understanding of our own relative positioning (Jameson 1991). Jameson's concept of cognitive mapping is grounded in the study of postmodernism and late capitalism, and focuses not on the individual's relation to a city but rather to the entire social system, yet he overtly draws from urban theorist Kevin Lynch's seminal text, *The Image of the City*, in which Lynch argues that people orient themselves in urban spaces through mental maps composed of bodily traced paths of both immediate experiences and memories of past experiences (Lynch 1960). While not explicitly articulated as mapping, Walter Benjamin's *One-Way Street* (2016) and *The Arcades Project* (2002) also demonstrate a certain (if distinct) affinity

with Lynch's claim in that they both function as a literary form of mapping place through the observations, memories, and commentary that result from meandering through urban spaces. Giuliana Bruno's sprawling and exploratory *Atlas of Emotion* is also ostensibly grounded in movement and place, and focuses on the potential for films to map emotions in such a manner that "moves" audiences and enables them, through a sort of haptic wandering, to then imagine themselves in those other spaces (2002, 36). Bruno writes that films can be understood as "emotional maps" that also become "a geographic vessel, a receptacle of imaging that moves, a vehicle of emotions" (207). Lastly, Jonathan Flatley's (2008) study of melancholia and affective mapping (with which I engage more fully later in this book) addresses how aesthetic practices of affective mapping can have transformative effects on melancholia, in part because they reframe the individual situation as being part of a collective experience. Ultimately, while these studies are diverse in subject matter and approach, they cohere around the concept of mapping as a metaphor and analytic frame that works to chart physical interactions and relations between individual and collective bodies, landscapes, experiences, and affects.

While my study is in conversation with these texts to varying degrees, I am specifically interested in how memory is housed and anchored in the visual through memory mapping strategies. I conceive of memory mapping as both a method for *analyzing* and the visual mode of *representing* the richly layered, affective webs that link bodies, objects, ghosts, events, and memory narratives to place and to each other. My study thus has a more direct connection to Presner, Shepard, and Kawano's concept of "thick" mapping in the digital humanities. They explain that thickness

> means extensibility and polyvocality: diachronic and synchronic, temporally layered, and polyvalent ways of authoring, knowing, and making meaning . . . Thick maps are conjoined with stories, and stories are conjoined with maps, such that ever more complex contexts for meaning are created. As such, thick maps are never finished and meanings are never definitive . . . thick maps give rise to forms of counter-mapping, alternative maps, multiple voices, and on-going contestations. (2014, 18–19)

While of a different register, the mapping I write of here performs in a similar manner. Memory mapping takes a thick, reconstructive, inquiring, and acquiring approach to memory, locating it in, and extracting it from, landscapes, stories, images, ghosts, and everyday practices, ultimately weaving together a memory map that affectively and visually represents the

aftermath of violence and makes human rights claims in the present. These visual memory maps thus function as places where memory is both anchored and housed and rendered visually and affectively accessible to viewers.

As will become clear throughout the chapters, memory mapping projects can take many different forms, but they all engage in an array of performative visual strategies, including embodiment, reperformance, reenactment, haunting, and the performance of material objects and places in order to redefine and make connections between specific places and memories, bodies, and objects. By anchoring memory to place and the present-day context, this performative visuality works to create affective and empathetic viewing experiences while shedding light on contemporary injustices. In so doing, memory mapping provides a counternarrative or new perspective to dominant or official stories about past or present violence[10] and cultivates what Macarena Gómez-Barris has called "witness citizenship"—when memory narratives are used to promote human rights awareness and political engagement, often in those places in which certain experiences and narratives have been elided by the official political processes (2010b, 27–29). Finally, while the theoretical points of contact between performance and visuality are largely unstudied in both fields, memory mapping demonstrates that analysis of the visual through a performance lens adds new depth to our understanding of both the relationship between visuality and performance, and also between memory, visuality, affect, and human rights.

Theorizing the Visual through Performance

The field of visual culture, or visual studies, finds its early theoretical roots in the works of some of the prominent European intellectuals of the late nineteenth and twentieth centuries, including German philosopher Karl Marx (1818–1883), Austrian neurologist and founder of psychoanalysis Sigmund Freud (1856–1939), and French philosophers Jacques Lacan (1901–1981) and Michel Foucault (1926–1984).[11] Theories on the development of the human subject—how human subjects are produced within and by systems of labor and capital (Marx); the relationship between subjectivity and the subconscious (Freud); the developmental phases of subjectivity, including the mirror phase (Lacan); and the production of the subject through discourse and relationships of power (Foucault)—laid the foundation for ongoing study of the production of the subject in relation to visuality.[12]

Investigating how and why people see what they see is at the heart of visual culture. While "vision" denotes the basic physical operation of sight, or what the eye can theoretically see, the term "visuality" refers to vision's "discursive determinations . . . how we see, how we are able, allowed, or made to see, and how we see this seeing or unseeing therein" (Foster 1988, ix). Visuality has similar connotations to the term "scopic regime," in that both refer to how sight is socially and culturally constructed. Yet, whereas visuality refers more broadly to the ways in which *how* and *what* we see is socially and culturally constructed and regulated by relationships of power, scopic regimes have to do with *technologies* that produce "particular forms of representation" that are "intimately bound into social power relations" (Rose 2001, 9). Initially introduced by film theorist Christian Metz to differentiate cinema from theater based on what he called "the absence of the object seen" (1982, 61), "scopic regime" is now used more broadly to analyze how structures of power are mediated and maintained through the visual realm.[13] This includes visual technologies such as photography, computers, and other visual surveillance mechanisms, and the politics of the gaze (whereas in common nomenclature, "to gaze" is simply the act of looking, in visual theory, "the gaze" refers to a relational, or reciprocal, act of seeing and being seen). Scopic regimes are *Matrix*-like, omnipresent and intangible, shaping and affirming structures of power and how people operate within them (how people look and are looked at) via the visual realm. Both terms are relevant here, since this book continually returns to questions of how people (including audiences, spectators, and witnesses) respond to visuality; how images circulate through the media and other visual technologies, their meanings subject to change in different contexts and with different audiences; surveillance and the regulation of visibility; and the politics of invisibility and hypervisibility. Nevertheless, because my study is not psychoanalytically derived, in this book I have tended to lean more toward terms that are grounded in materiality, such as "structures of visibility" and "economies of visuality."

Grounded in the analysis of a range of case studies, *Mapping Memory* suggests that visual texts are static only in the most literal sense. Their power comes from their performative characteristics, their ability to be in repertoire, and their capacity to create real effects *through* circulation, whether it be through engagement with audiences, embodied ritual (e.g., in the case of those who marched with Hernández-Salazar's images), or as proxy for the missing and the dead, both embodying the spirits of the dead and the cries of the living. Each of the book's chapters investigates performative visuality from a different angle, progressively analyzing how visual

works such as *Esclarecimiento* invoke and deploy memory narratives to deliberately push against scopic regimes and power structures that render visible certain things—people, abuses, memory, and human rights narratives—and others invisible.

For example, both the performative qualities within *Esclarecimiento* itself and the broader contextual framework—how the piece has been called upon to perform—give the piece much of its meaning. Hernández-Salazar's images embody painful historical legacies, with the body of the Mayan man representing those victims who are unable to speak for themselves. The winglike bones, dug up from the ground and haunted by the violence endured by the bodies from whence they emerged, are no longer just an item to be bagged and archived but are called upon to perform, transmit, and connect the past with the present, the dead to the living. The overt symbolism of the human with wings invokes the angel's ability to cross from world to world, bridging the realms of the living and the dead. Empowered by these wings, the Mayan body—the directness of his gaze, his bare chest squared off to the camera—is not an anonymous victim but rather embodies and transmits a collective demand for address. His scream struggles against the silencing and the ongoing insouciance toward indigenous people's suffering that contributed to the conflict in the first place. The April 1998 protestors who marched through the main plazas and city streets carrying these images were clearly denunciating Bishop Gerardi's murder, yet they were also transmitting memory of past wrongdoings and unatoned-for deaths, sharing those memories and extending their reach. There is an uncanny corporeal synchronicity between the silent, but living, protestors and the angels, as proxy for the dead, who open their mouths wide in a scream for justice—a scream rendered audible through the visual. Performing in this manner, the visual gathers audiences and witnesses.

Also a relatively young field, performance studies was formally established in the late 1970s, just a decade before the advent of visual studies, and draws primarily from two major lineages: linguistics and the intersection of theater and anthropology.[14] The influential "linguistic" stream of performance studies grew from J. L. Austin's scholarship on the power of the *speech act* and the notion of "performativity" and the "performative," an utterance in which the act of *saying* is also the act of *doing* (e.g., the saying of "I do" in a marriage ceremony) (Austin 1975). The other foundational branch of performance studies emphasized the importance of studying ritual and repetition, or what Richard Schechner calls "twice-behaved behavior" (1985, 36) and Diana Taylor later described as "reiterated corporeal behaviors" that function "within a system of codes and conventions

in which behaviors are reiterated, re-acted, reinvented, or relived" (2016, 26).[15] Identifying performance as "an episteme, a way of knowing, not simply an object of analysis" (2003, xvi), Taylor defines performance as a means of transmitting embodied knowledge, memory, and/or identity through acts of transfer (2). In her seminal analysis of the relationship between the archive and the repertoire, Taylor argues that the archive is thought of as recordable, enduring, and authentic because it is full of "documents, maps, literary texts, letters, archaeological remains, bones, videos, films, CDs, all those items supposedly resistant to change" (19). Conversely, the repertoire "enacts embodied memory: performances, gestures, orality, movement, dance, singing . . . As opposed to the supposedly stable objects in the archive, the actions that are the repertoire do not remain the same" (20). The embodied acts of the repertoire require liveness and presence to be transferred. Taylor therefore argues that "[e]mbodied memory, because it is live, exceeds the archive's ability to capture it. But that does not mean that performance—as ritualized, formalized, or reiterative behavior— disappears" (20). In other words, even if performance inevitably changes slightly with each iteration, it still serves as a means through which to transfer embodied knowledge, memory, and identity. These ideas are immediately relevant for memory mapping, because memory mapping is a means through which to analyze how visual works concentrate and transmit embodied knowledge and memory. Thus, to analyze the performance of the visual is in many ways to work at the overlap of the archive and the repertoire to understand how the two feed and constitute each other.

Films and photographs are fixed objects—they belong to the archive. And, as objects, they stay largely static (excepting for deterioration and destruction), even though how they are perceived has the potential to change. And yet, these objects achieve their meaning from how they circulate—they need to be seen to matter. In and of themselves, they are not performances in the literal sense, but there is a certain liveness to how, when, and why they matter. It is clear that they participate in vital acts of transfer of memory, knowledge, and affective awareness. While Taylor primarily focuses on live and embodied representational practices in *The Archive and the Repertoire*, and thus her discussion is of a different register than my own, it is also clear that it is possible for an object to perform, to be both "of" and excessive to the archive, to be both fixed and live.[16] Visual texts may be of the archive, but their performative effects occur not in the archive but beyond it, through their circulation and dialectical engagement with the world. Visual texts such as film and photography participate in a network of body-to-body affective transfer, wherein the visual text is both

medium and method of transfer. Ultimately, if the meaning of images comes from how they are mobilized, how and under what conditions they are seen, and how they are perceived, then images complete themselves *through* performance.

Investigating the theoretical intersections between visuality and performance in relation to memory and human rights enables a deeper inquiry into the interventions that visual texts make in service of questioning, and shifting, narratives of memory and human rights in the public sphere. The critical question then becomes *how* do visual texts work to affectively impact audiences and spectators and connect them with memory and human rights narratives, especially when those audiences are temporally and/or spatially distant? As David Gray and Jade Petermon ask, "What is the relationship between 'traveling' to a place in a film and standing on the ground? How do we stand then, together and apart from the bodies onscreen? When places fail to convey their memories . . . can media restore this texture" (2012, 2)? This book argues yes. By strategically mapping memory into and through images, bodies, and place, diverse visual works can contravene the apathy and indifference that render certain memory and human rights narratives inconsequential and largely invisible. Visuality functions as an essential form of translation and transmission of memory narratives—one that is crucial specifically *because* of its ability to connect to audiences both spatially and temporally at a distance.

Mapping Memory through Visuality

What, how, and why people remember has been the subject of substantial study in recent years, yet with little consensus as to the precise relationship between visuality and memory (individual and cultural) or analysis of the intersections between visuality, memory, affect, and human rights.[17] And yet, these exist in a dialogical relationship that both develops through and reinforces individual and cultural practices of remembering. My goal here is not to draw false battle lines between individual and contemporary memory; indeed, much contemporary memory scholarship emerges out of French sociologist Maurice Halbwachs's (1992) theory that it was impossible for individuals to remember in any coherent and persistent fashion outside of their group contexts. He argued that memories were a social phenomenon—in other words, that memories are inherently social, and that even memories that feel private, or individual, are collective and culturally specific, because practices of remembering are developed socially through various frameworks, such as family, religion, and social class. Contemporary

study of memory tends to extend this line of thought to frame memory as a dialectical relationship between experience and narrative, and between the narrating and narrated self. In other words, because "people emerge from and as the products of their stories about themselves as much as their stories emerge from their lives" (Antze and Lambek 1996, xviii), memories should be understood as "interpretive reconstructions that bear the imprint of local narrative conventions, cultural assumptions, discursive formations and practices, and social contexts of recall and commemoration" (vii). While efforts have been made to distinguish between diverse forms of memory (alternatingly called individual, collective, cultural, social, and public memory),[18] it nonetheless seems evident that individual memories both exist *and* are always connected to and impacted by social narratives that shape individual subjectivity. Along these lines, Marita Sturken asserts that defining a memory as cultural is "to enter into a debate about what that memory means. This process does not efface the individual but rather involves the interaction of individuals in the creation of cultural meaning. Cultural memory is a field of cultural negotiation through which different stories vie for a place in history" (1997, 1). Cultural memory manifests in and is produced through diverse forms of representations, visual texts, and objects that function, according to Sturken, as "technologies of memory, not vessels of memory in which memory passively resides so much as objects through which memories are shared, produced, and given meaning" (5). As a theoretical concept, memory mapping is specifically intended to analyze *how* this process of simultaneously embedding and extracting memory in bodies, objects, and places occurs, and what this process is intended to *do*. In other words, why engage memory as a form of visual, political intervention?

Alison Landsberg argues that mass culture technologies such as film have "the capacity to create shared social frameworks for people who inhabit, literally and figuratively, different social spaces, practices, and beliefs," and proposes that modern culture and technology make both possible and necessary a new form of memory, one she has termed "prosthetic memory" (2004, 8). Prosthetic memory emerges "at an experiential site such as a movie theater or museum. In this moment of contact, an experience occurs through which the person sutures himself or herself into a larger history . . . [T]he person does not simply apprehend a historical narrative but takes on a more personal, deeply felt memory of a past event through which he or she did not live" (2). While the notion that mass technology can enable people to take on memories originating outside of their own experience—which in turn means that memory is not only the result of

living within specific social frameworks but can also be taken on and worn like an "artificial limb" (20)—is provocative, Landsberg does not seem to be writing about *memory* so much as a form of affective witnessing. Certainly, the memory of a mediated *viewing* experience (which is a memory in its own right) has the potential to result in increased awareness or knowledge, but it is not a sutured-in memory of the actual event itself. This distinction is important, for it is impossible to prosthetically insert memories as though the viewer had been present for the original event. Conversely, it is certainly true that technologies of memory have the potential to represent another's memory and experience, and in turn to produce in the viewer an increased awareness and affective response. Indeed, art is capable of inspiring both critical and affective inquiry. And yet, as Jill Bennett reminds us, while art "often touches us . . . it does not necessarily communicate the 'secret' of personal experience" (2005, 7) but rather produces "a form of empathy that is more complex and considered than a purely emotional or sentimental reaction" (24). In other words, cultural texts may be "about" memory, but they do not "give" the viewer that memory so much as they transmit awareness of the subject matter in the form of an affective, visual experience. Visual memory technologies can map memories in specific ways to affectively contribute to a broader cultural memory and collective consciousness, but they stop short of becoming the viewers' personal memories.

The relationship between memory and visuality, then, is key, just not precisely in the way Landsberg argues. Images shape and inform memory, just as memory shapes and informs how we see images. Images can thus trouble, shape, reinforce, and challenge individual and cultural memory because they both give material form to personal and shared narratives and function as truth claims about the past. Photographs, films, objects, and specific sites are all mechanisms through which the past is embedded, reconstructed, and transported into the present. While visual technologies may capture a specific, temporally finite moment, how we interpret visual images changes as time passes and as the images travel. The images may remain static, but as our memories shift and are reconfigured with the passing of time, the meaning we attach to them will also naturally change. In other words, images, objects, and spaces may be embedded with memory even as the practices of memory, and the memories themselves, change over time. As Eduardo Cadava and Gabriela Nouzeilles assert, "Whatever transparency or 'fidelity to things themselves' photographs may suggest, they must be understood as surfaces that bear the traces of an entire network of historical relations, of a complex history of production and reproduction,

that gives them a depth that always takes them elsewhere, always links them to other times and places" (2014, 26). It is more apt, then, to think of visual memory technologies such as films and photographs not as prosthetic memory but as mechanisms for enabling spectators to both visually and affectively "travel" to other places and times. Similarly, as Giuliana Bruno contends, film spectatorship is "the very synthesis of seeing and going—a place where seeing *is* going" and the viewer is mobilized for "site- seeing" across a "geopsychic landscape" (quoted in Walker 2011, 116).

In the context of memory mapping, the visual engages a range of performative strategies to simultaneously document and map memory in and onto place, and thus to enable a "traveling through and to" time and place to where memory "dwells." As a result of memory mapping, memories and experiences that may have been otherwise hidden or largely unknown are made visually and affectively accessible to audiences. These processes are never objective or apolitical; they are always the result of decisions of inclusion and omission, framing, and narrative. Consequently, memory mapping is also an act of producing specific narratives about the relationship between individuals, collectives, memory, and place. This is true of both visual texts, such as film and photography, which I have argued have the potential to function as memory sites, and literal, physical memory sites.

Much scholarship on the relationship between place and memory has focused on official memory sites, such as the memorials, monuments, and other sites dedicated to victims of mass conflict and genocide. In his seminal essay, Pierre Nora (1989) asserted that memory was attached to physical sites, including burial places and battlefields, and that these *lieux de mémoire*, or places of memory, were intended to function as designated spaces within which the past would be remembered without infiltrating other aspects of daily life. James Edward Young has argued that the most basic function of memorials is to "create shared spaces that lend a common spatial frame to otherwise disparate experiences and understanding . . . [M]onuments propagate the illusion of common memory"—a function of monuments that, he notes, "is clear most of all to the governments themselves" (1993, 6). And yet, while official memory sites may seem stable on the surface, memory is never fixed—it is fluid, relational, and enduring, and the identity of specific places and their relationship with and to memory is wholly mediated by human engagement with those places. Memory is thus always, in a sense, under construction and subject to competing narratives. People create deep and meaningful attachments to the places in which they live, frequent, and experience impactful events, and these attachments are affirmed and reinforced through the patterns people

follow in those places. Even in seemingly static memory sites, the relationship between memory and place is thus largely a performative one. Steven Hoelscher and Derek H. Alderman reiterate this, noting that "bodily repetition and the intensification of everyday acts . . . like rituals, festivals, pageants, public dramas and civic ceremonies serve as a chief way in which societies remember . . . [These practices are] always embedded in place and inevitably raise important questions about the struggle of various groups to define the centre of urban politics and public life" (2004, 350). Although the authors do not discuss it, the visual also plays a key role in this process. This is exemplified in the silent marches in Guatemala City following Bishop Gerardi's death; in the Mothers of the Plaza de Mayo in Buenos Aires, who have for years collectively protested by slowly walking in repetitive, visible circles; and in the performative street protests known as *escraches*, in which large groups gather to performatively condemn dictatorship-era perpetrators who have gone unpunished for their crimes. As Jens Andermann reflects, embodied memory practices such as these "inscrib[e] in the cityscape both the ongoing impact of dictatorial terror as well as the unbroken resistance against it" (2015, 5). The visual is an essential part of these place-making practices—the mothers of the Plaza de Mayo carried photographs of their missing children, and *escraches* include images, text, and performance—but, more than that, it is the very visibility of their kinesthetically protesting bodies, a performative visibility that functions as a demand for recognition and a refusal to be silenced, that makes their protests so potent.

As Karen Till reminds us, "places are never merely backdrops for action or containers for the past. They are fluid mosaics and moments of memory, matter, metaphor, scene, and experience that create and mediate social spaces and temporalities. Through place making, people mark social spaces as haunted sites where they can return, make contact with their loss, contain unwanted presences, or confront past injustices" (2005, 8). This means that spaces are constituted by humans, and, as Doreen Massey argues, are "always in the process of being made . . . never finished; never closed. Perhaps we could imagine space as a simultaneity of stories-so-far" (2005, 9). The visual thus functions as an important space of critical, imaginative, and counterhegemonic place making. It has the potential, as Janet Walker asserts in her study of documentaries, to "reshape" and "refigure" individual claims to land (2011, 115), through a sort of "critical ventriloquism" that enables places and objects to "speak" and be heard (2010, 86). I extend this line of inquiry to argue that it is the mapping—the excavating, producing, and highlighting—of the affective connections between bodies,

memory narratives, lived experience, and the mnemonic potency of phys-
ical objects and spaces that makes it possible for the visual mode to locate
and restore memory when and where it has disappeared or been sidelined.
The visual does not just document but in effect also constitutes and re-
configures those bodies, objects, and places. In so doing, these performa-
tive visual texts use memory mapping to call attention to, and create a
context for, publics to visually and affectively engage with past injustices
and their ongoing impact in the present.

In April of 1999, on the one-year anniversary of Bishop Gerardi's assas-
sination, Hernández-Salazar gathered thirty-five friends to work through
the night in five teams of seven, secretly posting enlarged posters of angels
all around the city. Three dozen four-by-eight-foot angels appeared in
Guatemala City overnight. The street angels, as they were called, were
composed of sixty photocopied 8×10 sheets of paper and attached to public
surfaces with homemade glue. Each angel took less than ten minutes to
mount. Many of them appeared at sites with ties to mass violence: a former
military school, the army headquarters, army barracks, and military
intelligence facilities; others materialized at highly symbolic sites, including
the Metropolitan Cathedral, the San Sebastián Church (Bishop Gerardi's
parish), and the Office of the United Nations Verification Mission (Hoelscher
2008, 210). Those who marched to commemorate the anniversary of
Gerardi's death marched with these angels as a backdrop: the collective,
embodied performance of remembering past violence interwoven with
place, ghosts, and the passing of time. Some of the angels were immediately
removed, while others were left to slowly disintegrate over time. Hoelscher
reflects,

> Like memory itself, the angels became fragmented and woven with
> time, blending into the familiar landscapes of everyday life. Also, like
> memory, they would suddenly reappear and once again claim atten-
> tion, as one angel did atop the old post office building in April 2003 to
> commemorate the fifth anniversary of Gerardi's murder . . . *Street
> Angel* never ossified but changed with the weather and with varying
> levels of care and neglect, opposition and support. This was interactive
> art in the most dialectical sense: the very attempt to erase it only
> added to its evocative power. (2007, 60)

The various iterations and performances of the angels (in the initial ex-
hibit, on the cover of the report, in marches, and as place-based interven-
tions on walls) strikingly demonstrate how visuality, memory, human

rights, and place intersect, and how historical and shared memory is mapped onto and through bodies, movement, images, and physical spaces to function as interventions in the public sphere. Whereas Walter Benjamin's angel of history was faced with a continually mounting pile of debris, incapable of doing anything but desiring and falling short, Hernández-Salazar's angels represent all the possibilities of human response. Bones from mass graves protruding from his body, the fourth angel's active, affective, wordless plea for justice focuses not on the past but on the present and future. Taken as a whole, *Esclarecimiento* exemplifies how visual texts, and cultural memory objects more broadly, accumulate additional meaning in new historical and cultural contexts. It also demonstrates how memory persists in the present through ghosts, live bodies, and the performative, mnemonic potency of images, objects, and spaces. Lastly, it illustrates how visual memory mapping projects serve as witness to the ongoing effects of violence and conflict and make targeted interventions in the public sphere.

The Book's Chapters

Each chapter in this book is designed to explore memory mapping from a different angle. In Chapter 1, "Affect, Haunting, and Memory Mapping," I more fully develop the theoretical contours of memory mapping. Grounded in study of the Salvadoran documentary *El Lugar Más Pequeño* (*The Tiniest Place*, 2011), I investigate connections between haunting, memory, testimony, and affect in order to ask: How do we render visually and affectively knowable the ongoing negotiations of living among the ruins of history? What is the relationship between memory and affect? How might the lens of memory mapping offer new perceptions and understandings of the postconflict period? I argue that by visually, spatially, aurally, and affectively mapping the relationships between the dead and the living, and the past and the present, *The Tiniest Place* effectively portrays the lived, everyday relationship between memory and affect as one that is essentially dialectical in nature. Ultimately, by combining testimonial narratives, the ghostly presence of the dead, and the embodied, everyday practices of the living, the film sheds new light on the affective complexities of rebuilding in the aftermath of trauma, the performative possibilities of the visual to serve as witness, and the theoretical intersections between affect, memory, visuality, and place.

In Chapter 2, "The Materiality of Memory: Touching, Seeing, and Feeling the Past," I theorize memory mapping within the context of

temporality, materiality, and performative reenactment. Close analysis of how memory is documented, preserved, produced, and transmitted through documentary film facilitates my investigation of the relationship between memory and materiality, and how bodies, by way of reenactment, can function as a strategic component of exhuming and mapping memory onto place. This chapter centers on the prolific documentary work of exiled Chilean filmmaker Patricio Guzmán and focuses on two documentaries, *Chile, la memoria obstinada* (*Chile, Obstinate Memory*, 1997) and *Nostalgia de la luz* (*Nostalgia for the Light*, 2010). If official histories, by definition, sublimate and attempt to make transgressive memories disappear, then it is essential to investigate the ways in which memory persists in bodies and lived experience, and in the mnemonic potency of physical objects and spaces. Through meticulous memory mapping, Guzmán's films illustrate the immense historiographical value in bringing bodies, materiality (including bones, objects, images, and physical sites), and official histories into contact and dialogue with one another.

In Chapter 3, "Performing Archives, Performing Ruins," I analyze performance and photography, juxtaposed with analysis of official memory sites. My primary case study is Argentine photographer Julio Pantoja's hybrid photography performance, *Tucumán Me Mata* (*Tucumán Kills Me*, 2014), which performatively situates visual documentation of the 2013 Tucumán trials (for crimes against humanity committed during the dictatorship) in their historical and spatial continuity. I foreground this visual performance against three other Argentine memory projects: ESMA (Escuela Superior de Mecánica de la Armada) and the Parque de la Memoria, both in Buenos Aires, and the Museo de la Memoria in Rosario, Argentina. With the explicit intention of intervening in memory politics, all of these case studies map memory in specific ways, and yet they employ strikingly diverse strategies in the process. Studied side by side, they provide a lens through which to investigate the affective, performative power of visuality in relation to place and human rights and memory in Argentina. In this chapter, I ask: How do photographs map memory in live performance contexts? What makes a memory site? In the context of both performance and place, what are the ways in which visuality works to affectively impact viewers and induce concern for justice?

Chapter 4, "The Politics of Seeing: Affect, Forensics, and Visuality in the US-Mexico Borderlands," is grounded in the idea that how one sees or is seen is the direct result of visual economies that create and maintain power relations around questions of nationality, ethnicity, race, and class. Because of this, visual memory projects that are political in nature and

intend to subvert those power relations—in other words, to make certain subjects *seeable* in new ways—have an imperative to redirect the gaze toward new ways of seeing and feeling. This chapter focuses on *Who Is Dayani Cristal* (2014, a hybrid documentary-fiction film that combines forensic attempts to identify a body found in the southern Arizona desert with the fictional retracing of his steps along the migrant trail, running through Central America up to the deadly stretch of desert known as the "corridor of death," where his body is ultimately found. I examine the film alongside a range of other contemporary visual and new media texts, including the Electronic Disturbance Theater 2.0/b.a.n.g. Lab's 2010 Transborder Immigrant Tool and John Craig Freeman's 2012 Border Memorial: Frontera de los Muertos, both of which use cell phones as a form of creative, geospatial intervention into migratory movement, life, and death. Within the context of visual economies that simultaneously promote both the radical invisibility and hypervisibility of undocumented border crossers (both alive and deceased), I investigate how visual memory mapping projects work to redirect the gaze toward new ways of seeing and feeling. In so doing, I argue, memory mapping functions as a visual strategy to ask, and to challenge, why certain lives are rendered visible and thus grievable and others not.

Mass political violence is inextricably tethered to the human body, and thus the work of responding to this violence in the aftermath therefore must necessarily attend to the ways memory is performed in visual and embodied ways. The questions I pose in this book about memory, performative visuality, and affect speak to ongoing concerns about representation and unatoned for and unaddressed human rights abuses, silences, and absences. Ultimately, by developing the concept of memory mapping across a range of countries, mediums, and cultural and sociopolitical contexts, this book explores how visual texts affectively and performatively engage with the politics of memory and visuality to make political interventions in the public sphere.

Affect, Haunting, and Memory Mapping

Baseball cap propped over thick black hair, thin button-down shirt opened to expose a worn black undershirt, coil of yellow rope encircling his left shoulder, the middle-aged man walks. The narrow dirt path he traverses cuts through thick, verdant grass, the sparkling sunlight marred only by intermittent shadows cast by the lush foliage that frames the small meadow. In a voice-over, we hear, *They say what I've got is insomnia.*[1] He continues forward, his gaze focused downward at where he places his feet along the path. His mouth does not move, nor does he look at the camera. *I sleep very little. I don't know if it's a habit left over from war. Maybe so.* The camera angle shifts to follow him from behind; he continues up the path through the meadow away from us. *I'm going to tell you about a time I went mad. About seven years ago, I went mad. I had hallucinations. I kept seeing the army. Ugly men with glasses and gold teeth. They're devils, they are, is what I would say. When I saw the troops, I ran away.* The man sits in the shade of a large tree in a lush, grassy field and watches over a small herd of grazing cows. The voice continues: *And in the nightmare, I see them set the dogs on me, and they follow me. I feel their teeth eating into me. 'We've come to kill you.' I was punching, kicking . . . fighting them. I grabbed the machete. I was convinced I was lopping*

their heads off. My kids said, 'Dad, let us sleep!' And there I was, brandishing the machete in the middle of the room! He finishes with a small, flat chuckle. The man continues to sit calmly, unmoving, staring off into the horizon. Finally, *I still have nightmares. Because even though the war is over, the gunfire—I still hear it all the time.* (Pause) *There's no fixing me. There's just no fixing me.*

This scene appears early on in the documentary *El Lugar Más Pequeño* (*The Tiniest Place*, 2011), which takes place in Cinquera, a small village deep in the jungle-covered mountains of El Salvador. After unabated assault, brutal occupation, and slaughter by the Salvadoran military during the violent twelve-year civil war (1980–1992), the small village of Cinquera had ceased to exist, literally erased from official maps and swallowed by the jungle. The majority of Cinquera's residents were killed or disappeared; those who remained fled, often into the jungle, where they hid for extended periods of time, concealed in caves and among the trees. After the war ended, five families returned on foot through the jungle to rebuild Cinquera and live among their dead. *The Tiniest Place*, made by Tatiana Huezo Sánchez, whose grandmother was from Cinquera, explores this story of return.

Through the lens of these villagers' lives, *The Tiniest Place* examines the ongoing impact of recent historical violence, the challenges of rebuilding postconflict, and the relationship between memory, place, and people (both living and dead). Visually and affectively breathtaking, testimonial memory narratives provide the backbone of the film. These narratives are presented in an unusual manner: with almost no exception, each person, not looking at or acknowledging the camera in any way, is filmed going about their quotidian lives as their testimony is shared in voice-over.[2] The jarring contrast between the vibrant, visible present and traumatic aural memories of the past renders the testimonies both ambient and haunting. Blurring the lines between what *was* and what *is*, it is as though we observe the villagers from the perspective of the ghosts themselves, hearing stories that could just as easily come from the mouths of the dead.

The Tiniest Place presents a largely unseen perspective on the aftermath of the civil war and the everyday work of survival for villagers who live far from the capital and the reaches of official transition processes (which, in any event, were lacking: El Salvador's truth commission worked for just eight months under a mandate to investigate only "serious acts of violence" whose "impact on society urgently demands that the public should know the truth." Five days after the publication of the final report, which found government forces responsible for 95 percent of the abuses, a sweeping amnesty law was passed, resulting in minimal consequences for the vast ma-

jority of perpetrators. Four months after the report, a number of officials known to have been directly involved in major atrocities retired with full military honors, with then-president Cristiani praising them for having performed with "merit, efficiency, and loyalty to the highest duties that the nation can demand" [Hayner 2011, 50–51]). In places and times where political processes neglect justice and comprehensive reconciliatory efforts, art can shed light on the complexity of survival, providing insight into the individual and collective experience of trauma and survival that official narratives so often elide.

In this chapter, I investigate how *The Tiniest Place* depicts the ongoing negotiation of living in the aftermath of conflict. Through analysis of the film's depiction of those living in the material, spatial, and affective residues of mass atrocity, I argue that *The Tiniest Place* strategically *maps* memory onto and through bodies, objects, and places. I also investigate how the film portrays the lived experience of memory and affect in order to think more broadly about the relationship between the two. Ultimately, I contend that the combination of testimonial narratives, the ghostly presence of the dead, and the embodied, everyday practices of the living shed new light on the affective complexities of rebuilding in the aftermath of trauma, on the performative possibilities of the visual to serve as witness, and on the theoretical intersections between affect, memory, visuality, and place.

Legacies of Violence

Similar to neighboring Guatemala, the conflict in El Salvador originated in struggles over land and power. Starting with the Spanish conquest in the 1600s, land was seen as the most important resource in El Salvador. When El Salvador gained independence from Spain in 1821, power shifted from the Spanish to those of mixed European blood. Ninety-five percent of El Salvador's population was forced into serfdom, and a small group of wealthy landowners, known as the Fourteen Families, ruled through a long series of military dictatorships. The cycles of violence caused by this system of repression eventually erupted in January 1932 with a farmworker revolt led by labor leader Agustín Farabundo Martí. Two weeks after it began, the revolt was crushed in a massive military reprisal known as La Matanza. An estimated thirty thousand indigenous citizens were massacred during La Matanza, and the Salvadoran military ruled the country from that point onward. The political instability of the 1970s eroded any hope of democratic reform, and those on the Left became convinced that the only way to create change would be through armed insurrection.

During El Salvador's civil war, fought between the right-wing military government and the Farabundo Martí National Liberation Front (FMLN), a coalition of five leftist guerilla groups, more than 75,000 people were killed (equivalent to 1.4 percent of the population), more than half a million were displaced, nearly one million fled the country, and countless thousands more were tortured and/or disappeared (Hayner 2011, 49; Studemeister 2001, 7). In terms of population, the total number of confirmed deaths "would be proportionately equivalent to 3.2 million US citizens, or, seen another way, the total population of the second largest city in the US: the entire population of Los Angeles, California" (Katovich 2011, 13). As has been meticulously documented elsewhere, this war was heavily impacted by US intervention.[3] The combination of Cold War fears and interest in Latin America as a testing ground for US imperialism that played out across the region was magnified in El Salvador, resulting in the tiny country becoming the site of the United States' longest and most expensive military intervention during the period between the Vietnam War and the Persian Gulf conflict (LeoGrande 1998). Under the auspices of "nation-building," the United States sought to fundamentally repress any possibility of communist revolution; the result was not just the political backing of sadist military forces but sustained support of their campaign of violence in the form of $4.5 billion in military and other aid (Hayner 2011, 49). The military's terrorizing and forced disappearances of civilians by death squads, recruitment of child soldiers, and other gross human rights violations were not hidden. Indeed, one of the military's notorious killing strategies included using a meatpacking plant to dispose of human remains (Amnesty International 1982, 136). With the help of the United States, the Salvadoran armed forces adopted a "scorched earth" approach similar to the one employed in Guatemala (tactics that were primarily derived and adapted from US military strategy during the Vietnam War and subsequently taught to the Salvadoran military). This approach of "draining the sea to catch the fish" involved the massacring of whole villages, including Cinquera.[4]

Finally, after twenty months of UN-brokered negotiations between the government and the FMLN, peace accords were signed on January 16, 1992. These accords included an agreement to hold a Commission on the Truth for El Salvador.[5] The commission, which was given only six months to work, gathered testimony from more than two thousand survivors and collected extensive information from secondary sources, including national and international human rights groups, on more than twenty thousand additional cases. In addition, they met quietly with several senior members

of security forces who were willing to provide key information and brought in the Argentine Forensic Anthropology Team to exhume the remains of the notorious massacre of the town of El Mozote.[6] The commission ultimately concluded that the government forces had been responsible for 95 percent of the abuses committed during the twelve-year period of war (Hayner 2011, 51). Unfortunately, five days after the release of the commission's final report, El Salvador's parliament passed a sweeping amnesty law, and, aside from the removal of several high-level perpetrators from the armed forces, there were minimal consequences for the guilty, including those who had been explicitly identified in the report. Over the following years, little effort was made toward reparations or justice. As a result, in villages like Cinquera, once the violence ended, the few who had survived were left alone to pick up the broken shards of their former lives.

Many of those who went into exile in neighboring countries and further abroad never returned, permanently altering El Salvador's social fabric in unforeseen and ultimately catastrophic ways. As is well documented, many Salvadorans fled as refugees to the United States, and particularly to Los Angeles, where they were often victimized by Mexican gangs. Groups of Salvadorans organized into protective gangs in response, taking over a number of Mexican gangs and creating the Mara Salvatrucha gang, also known as MS-13. This gang is now widely considered one of the most notorious and violent gangs in the Western Hemisphere. After the civil war ended, many of these gang members were deported from the United States back to El Salvador, where they continued their gang warfare, only now linked to a transnational network of violence. This brought to El Salvador a level of violence the country had never seen, one that continues to far exceed both the homicide rates of the war and the country's capacity to control it in any meaningful way. While the contemporary gang violence and refugee crisis is not the focus of this chapter (I return to this issue in the final chapter), it serves as a devastatingly sharp reminder of the United States' influence on both the war and postwar period, and the enduring, fecund nature of violence.

The life of the film's director, Tatiana Huezo Sánchez, was shaped by the war. She was born in El Salvador but moved to Mexico with her mother when she was five to flee the violence. (Her father stayed in El Salvador and lived through years of the war.) Although physically at a distance, Huezo Sánchez was personally impacted by the war—an uncle was killed, other family members disappeared, and she had cousins who became orphans (Ponce 2011). Huezo Sánchez periodically returned to El Salvador;

on one visit, her grandmother, who had since moved to the capital city of San Salvador, asked Huezo Sánchez to accompany her to her hometown—the small, remote town of Cinquera. They traveled for three hours on increasingly smaller roads from the capital into the jungle before arriving in the quiet, nearly empty town. When Huezo Sánchez arrived, an elderly woman came up to hug her and said, "Rina! You came back! You look the same!" Huezo Sánchez told the woman she was mistaken, but the woman did not believe her—Huezo Sánchez shared an uncanny resemblance with someone who had been killed in the war (Ponce 2011). Following that encounter, she walked into a church, but instead of the religious symbols she had expected to see, the tail of a military helicopter hung on one of the walls, and the church was lined with rows and rows of portraits of young guerrilla children and teenagers, all killed in the war. The more Huezo Sánchez learned about Cinquera and became acquainted with her grandmother's friends, the more she wanted to make a film about Cinquera. Her dream became possible several years later when her project was selected in a contest for graduates of her film school, the prestigious Centro de Capacitación Cinematográfica (CCC) in Mexico City (Katovich 2011). Her resulting film, *The Tiniest Place*, joins a rich field of sociopolitical and human rights–oriented documentary filmmaking in Latin America.

Documentary in El Salvador

As has been explored at length within existing scholarship, documentary film has long played a critical role as chronicle of and sociopolitical commentary on the politics of the times. Since the mid-1950s, Latin American political documentary filmmaking has flourished, perhaps more so than in any other region.[7] New Latin American Cinema, a filmmaking movement shaped by postcolonial struggles for autonomy and empowerment in the face of underdevelopment and dependency, became known for exploring themes such as poverty and inequality, oppression, and life under dictatorship. As Julianne Burton argues, "nowhere have the manifestations of documentary been as multiple and their impact so decisive as in Latin America," and these films were "almost invariably circumscribed by inescapable social, economic, and political realities" (1990, 6, 18). Indeed, many documentary theorists claim that the goal and import of documentary film (in, but not limited to, Latin America) is "to describe and interpret the world of collective experience" (Nichols 1991, 10), and that it "can provide cultural spaces for audiences to contemplate the ethical and moral questions raised by the repetition of trauma and the violation of human rights"

(Hesford 2011, 91). Overall, the role of documentary film as testimonial evidence against human rights abuses and in advancing human rights agendas in Latin America has been profound.

And yet, with the exception of a small number of documentaries that focus on the violence, human rights abuses, and political maneuverings of the Salvadoran conflict, documentaries about El Salvador are few and far between. There were three largely anonymous Salvadoran political filmmaking groups—El Taller de los Vagos, Cero a la Izquierda, and Radio Venceremos. The most well-known of the three, Radio Venceremos began as the clandestine radio of the Popular Revolutionary Army, one of the five guerilla forces that united to form the FMLN coalition. In addition to radio broadcasts and print materials, Radio Venceremos produced films and videotapes made in 16 mm, Super-8, half-inch, and three-quarter-inch video (Hess 1990, 174). The footage came from a wide mixture of people, including combatants, journalists, tourists, and foreign supporters, and sound was recorded with cheap pocket recorders. All of this material was then taken out of the country to be edited and distributed (175). These films had an extremely rudimentary, journalistic style and targeted an "already committed community of political activists and socially concerned religious and community groups" (158). The challenges of filmmaking during the war were numerous. As Hess explains, artists

> had to develop, just as the guerrillas did, supply lines to get film, tape, cameras, and sound equipment in and the film footage out for processing, editing, and distribution. They had to rethink the purpose of their films. Without the large popular organizations as a logical distribution and exhibition structure, they had to address and figure out ways to show their work to mostly illiterate rural audiences, usually in areas without electricity, and also to get the work out to an international audience. These changes can be seen clearly in the films. (176–177)

Beyond these three guerrilla groups, whose films were not widely seen or known, the majority of documentaries on El Salvador from this time period were made in the United States (e.g., PBS's *Enemies of War* [2001], which is about the 1989 murder of six Jesuit priests and their housekeeper). These films were geared toward shaping US public opinion and, in turn, US involvement in the conflict.[8] Beyond these political pieces, however, documentaries about El Salvador are relatively rare.

It is surprising, then, to note the absence of academic scholarship on *The Tiniest Place.* No doubt this dearth is partially due to the relatively

recent release of the film and the fact that it has not been widely available beyond the film festival circuit and university libraries. Conversely, *The Tiniest Place* was nominated for more than thirty different film festival awards, including Best Direction, Best Cinematography, Best Documentary, Best Film, Best Feature, Best Sound, Best Editing, Audience Award, and Jury's Award.[9] The film was also exceptionally well reviewed in the mainstream press. It was called "world class" and "incandescent" by *Variety*, "beautifully rendered" by *The Hollywood Reporter*, and "brilliant" by *Indiewire* (which gave the film the grade of A).[10] And yet, I was unable to find a single academic monograph, book chapter, or article that even mentioned, much less focused on, this documentary.[11] Consequently, this highly lauded and extraordinary documentary remains all but absent from the scholarly discussion on El Salvador's posttransition period, which tends to focus on politics, violence, and the law (see, e.g., Collins 2010, Ladutke 2004, Lauria-Santiago and Binford 2004, Moodie 2010, and Popkin 2000), and the broader bodies of scholarship on hemispheric visual culture and the politics of memory in the aftermath of atrocities of the twentieth century. Both despite and because of these gaps, and due to the film's focus on mapping the spatial and temporal lived experience of memory and loss, *The Tiniest Place* provides a significant point of reflection on issues that have been critical in the fields of visual culture, memory studies, and hemispheric and Latin American cultural studies. Combining lush visuals with indirect testimonial memory narratives, the film highlights the dialectical relationships that exist between the landscape, the dead killed and buried in that landscape, and the living who choose to reside there among and alongside their dead. Mapping memory in this manner, the film produces for viewers an affective, visual rendering of the complexities of life in the aftermath of violence and the legacies of imperial histories. As a result, the film offers new ways of thinking about intersections between affect, memory, and place that have implications far beyond the film and the specific spatiotemporal context it depicts.

Memory, Affect, and Haunting

The Tiniest Place begins with an elderly woman recounting the night the five families walked through the jungle back to Cinquera, determined to rebuild their now-abandoned village from the ruins of destruction. A dark sky fills the screen, framed by the deep black shapes of trees and the intermittent chirps of nocturnal insects. The camera moves as though someone is walking while looking up, albeit slightly faster and with a softer tread than that of

the human body. A disembodied, raspy, elderly female voice says, *I felt happy.* She continues, *I felt joy . . . and sorrow. Sorrow and joy. Because we were going back to our village again. The road seemed to go on forever . . . We walked and walked. There were five of us, five families.* 'So where are we now,' I asked? 'We must be lost.' As the voice speaks, light begins to stream through the trees, and the disembodied cinematic gaze continues its swift walk through the jungle. *And when we arrived in Cinquera, my god, the whole place was wrecked.* The camera slows its advance and pans slowly around. The dense sounds of the jungle grow richer. She reflects, *Nothing there at all: no church, nothing. Nothing. Only the bell tower was standing. There were no houses, just fragments of walls. And big capulin trees on top of the fragments of walls. Snakes had curled up among the sticks and branches.* 'Oh my god,' we said. 'Is this where we're going to live?' 'Yes, this is where we're going to live.' *All that remained were masses of bones and bats all over the place . . . The bones of both the guerrillas and the military.* These early words articulate a direct link in the film between feeling ("I felt happy," "I felt joy and sorrow") and memory ("we walked and walked," "there were five of us"), and they are an early signpost for what is to follow: an exploration of the relationship between affect and memory, situated within a lush and haunted postwar landscape. The theoretical intersections between affect and memory are surprisingly underdeveloped in scholarship on both affect and memory; however, as I argue in this chapter, memory and affect often function in dialectical synchronicity.

As discussed in the Introduction, memory is a constitutive part of the fabric of human life—it "gives meaning to the present, as each moment is constituted by the past . . . memory provides the very core of identity" (Sturken 1997, 1). Conversely, affect, and the distinctions between affect, emotions, and feelings, is harder to pin down. I am not especially invested in working to carve out definitional borders between the three, as they clearly function in overlapping symbiosis and the terms are often used interchangeably in scholarship, rendering the exercise somewhat futile. However, generally speaking, emotions are physiological responses to one's environment, which may be conscious or unconscious, while feelings are culturally conditioned interpretations of those responses (i.e., feelings are the process and result of making meaning out of emotion). Feelings and emotions, then, are so closely related as to be almost interchangeable. Affect is both distinct from feelings and emotions in important ways and significantly more complicated, because of the slipperiness of the concept and because scholars engage the term in differing ways.

I define affect largely in line with Kathleen Stewart's theorization of "ordinary affects." Stewart writes, "Ordinary affects are public feelings that

begin and end in broad circulation, but they're also the stuff that seemingly intimate lives are made of. They give circuits and flows the forms of a life" (2007, 2). She continues,

> Ordinary affects, then, are an animate circuit that conducts force and maps connections, routes and disjunctures. They are a kind of contact zone where the overdeterminations of circulations, events, conditions, technologies, and flows of power literally take place. To attend to ordinary affects is to trace how the potency of forces lies in their immanence to things that are both flighty and hardwired, shifty and unsteady but palpable too. (3)

Stewart asks how we might attend to the stories, the memories, the ghosts— "the map of connections between a series of singularities" (47)—that so fully shape the human experience, noting that the goal is not to "finally 'know' [affects]—to collect them into a good enough story of what's going on—but to fashion some form of address that is adequate to their form . . . to create a contact zone for analysis" (4–5). These questions have immediate and direct relevancy, for, as *The Tiniest Place* demonstrates, trauma is neither isolated nor temporally bounded. Trauma travels with bodies through place and time, adapting and unfolding in the nooks and crannies of sidewalks and psyches. It shapes how people relate to each other and to themselves, and it shapes the stories they tell. In his study of affect and melancholia, Jonathan Flatley describes how certain objects or events will "generate a certain set of affects in certain contexts for certain groups of people," which leads to the creation of what he calls, following Raymond Williams, "structures of feeling" (2008, 26). Flatley continues, "If the function of an ideology is to narrate our relation to a social order so as to make our daily experience of that order meaningful and manageable, then *structure of feeling* would be the term to describe the mediating structure—one just as socially produced as ideology—that facilitates and shapes our affective attachment to different objects in the social order" (26). Although affects, and the structures of feeling that forge and feed them, are impalpable, operating "beneath" and "alongside" conscious knowing, they can nonetheless be impactful and enduring, shaping the way people experience and live their lives.

Affect, then, is about the spaces in between, the web of connective forces and immaterial circuits that connect bodies, movement, objects, and places. As Melissa Gregg and Gregory J. Seigworth write,

> Affect arises in the midst of *in-between-ness*: in the capacities to act and be acted upon . . . [A]ffect is found in those intensities that pass body

to body (human, nonhuman, part-body, and otherwise), in those
resonances that circulate about, between, and sometimes stick to
bodies and worlds. (2010, 1)

Affects can thus be understood as the resonances and connections between
body and place, object and body, object and place, haunting and being
haunted, the presence of absence of those lost, and the life constantly
being shaped around that loss. *The Tiniest Place* documents the web of affects
generated by the traumatic events of the war and its aftermath, and these
affects inform how the residents of Cinquera live, how they relate to Cin-
quera and the surrounding landscape, and how they negotiate their rela-
tionship with memory and the past. As the film articulates and transmits
these memories and lived experiences, viewers of the film are also drawn
affectively into relation with the film and the complex life stories it
transmits.

If memories are the stories of past events and experiences that shape who
we are, giving meaning to our identities, affect is what gives color and tex-
ture to memories, and what keeps memories alive, circulating in the pres-
ent. Affect is about unseen but felt—*sensed*—connections; it is the *feeling*
and *doing*, the acting and being acted upon, the way of being in one's life
that is brought on by the ongoing act of remembering and, in a sense, *living*
with memory. Memory, transmitted via aural testimonial narrative, pro-
vides the film's narrative anchor and temporal drive. It is the affective
experience of memory that communicates to the viewer that, for the resi-
dents of Cinquera, the past is not passed but rather the embrace that holds
together the fragility of their present. As one woman in the film describes:
Imagine the screen of memory; the same people constantly march past. All the
many people we lived with really closely—they never stop passing through the
mind . . . and the children. There are no words for it. I don't think it's suffering
but delirium . . . Affect is thus the temporally undifferentiated structure of
feeling, or sensation, that the film creates by interweaving aural narrative
with visual imagery. In this sense, the relationship between memory and
affect is articulated as one between narrative and the senses—both for
viewers and for those within the film.

In the film, the relationship between memory and affect is reinforced
by the ghostly presence of the dead, who manifest and articulate the struc-
tures of feeling that shape the villagers' lives. The woman continues, *No, it's*
not sorrow for me. Because I won't see them suffer anymore; it's just that they're
there. So it's as if I have a dual image. Here the present and the other, which ap-
pears and doesn't fade. Right now I'm sitting here eating and talking with you

and also with my comrades in Azacualpa who died. Right now I see you sitting there, and I'm seeing the time we buried a comrade. The two images are there simultaneously, and they don't torment me but are part of my life. The ghosts ("my comrades in Azacualpa") do not discomfit ("they don't torment me") but rather are a part of the everyday lives of those who live literally among the ruins of the past, working to rebuild lives that were so wholly shattered by the war. By presenting the testimony indirectly, the director deliberately invokes a sense of haunting, because many of the stories seem as though they could be coming from the ghosts themselves.

Invoking a sense of haunting is a powerful strategy. Ghosts serve as reminders of unreconciled histories, unfinished stories, and enduring loss, and they point to the urgent need for address, even as their very existence articulates its absence. Jeffrey Weinstock writes, "We value our ghosts, particularly during periods of cultural transition, because the alternative to their presence is even more frightening: If ghosts do not return to correct history, then privileged narratives of history are not open to contestation. If ghosts do not return to reveal crimes that have gone unpunished, then evil acts may in fact go unredressed . . . and without ghosts to point to things that have been lost and overlooked, things may disappear forever" (2004, 6). Ghosts, such as those in *The Tiniest Place*, are a means with which to signal a narrative lack of closure. They make known both the ongoing need to reconcile with the past and the ways in which that past continues to impact the lives of those still living. Jacques Derrida explains in *Specters of Marx* that ghosts represent justice:

> Of justice where it is not yet, not yet *there*, where it is no longer . . . where it is no longer *present*, and where it will never be, no more than law, reducible to laws or rights. It is necessary to speak *of the* ghost, indeed *to the* ghost, and *with it*, from the moment that no ethics, no politics, whether revolutionary or not, seems possible and thinkable and *just* that does not recognize in principle the respect for others who are no longer or for those who are not yet *there*, presently living, whether they are already dead or not yet born. (1994, xviii; emphasis original)

In countries such as El Salvador, where war crimes went largely unresolved and unaddressed, and perpetrators often walked free, there is an ongoing need to, as Avery Gordon has written so eloquently, reckon with what modern history has rendered ghostly (2008, 18). As a memory mapping project, *The Tiniest Place* functions as a necessary and targeted intervention in the face of visual economies in which whole communities (of dead and living) are all but invisible, their stories unheard, their memories

ignored. The film brings these stories to light, preserves, and transmits them. The film makes a very different intervention than *Esclarecimiento*, the Guatemalan photography intervention analyzed in the Introduction, yet both mapping projects demonstrate similar investments in the power of the visual in relation to the past: memory, visuality, and human rights are fundamentally intertwined, and the visual is a means through which the past may be visually, aurally, and affectively embodied by both the living *and* the dead. By working to affectively and visually document the aftermath of violence and point out continued injustices, memory mapping projects such as *The Tiniest Place* directly address the politics of visibility and witnessing postconflict. In so doing, the film creates a context for publics to see and feel the injustices that are the ongoing legacies of El Salvador's brutally violent civil war (1980–1992).

Testimony and Memory in The Tiniest Place

The Tiniest Place is a strikingly beautiful film, notable for how it interweaves visual and aural documentation of the seemingly mundane, bodily actions of the villagers in order to depict life in the aftermath of mass conflict. Following the opening scene in the night forest, the film portrays the village slowly rustling to life in the bright morning light. Against the vibrant aural backdrop of the jungle, the small shop is opened, porches are swept, children walk well-worn paths to school, women begin to make tortillas, and a man picks up his machete, slings his bag onto his back, and sets off into the jungle. As the film progresses, a primary cast of characters begins to emerge: a man walks slowly through the jungle, watching over his pregnant cow; an older woman searches for fresh eggs to put under her hen in the hopes of eventually hatching chicks; a man rides his bike; and a young woman paints the inside walls of her home with pictures and designs. These diverse glimpses of everyday life are beautifully shot, rich with vibrant color and overlapping aural synchronicity: the slapping of the tortillas in the women's hands becomes the slapping of hands on the knees of young boys exercising on the soccer field, and the sounds of sweeping the street overlap with the clang of a morning bell. Throughout the film, the very full sound space is predominantly composed of natural and human-made sounds as the people proceed through the bodily actions of their day. This changes only when the villagers are sharing the most intense moments of their stories, such as the attacks and escapes. In these moments, the documentary switches to a melancholic film score, a sonic strategy that highlights how these events dramatically ruptured everyday life.

Rarely does anyone look into the camera. They also never once speak to the camera, and only much later in the film do we see them speak to each other. There are only two moments in the film where this dynamic is ruptured: in a sequence at the very beginning of the film, in which the individual characters are each filmed in a moment of stillness in their everyday lives, staring directly into the camera, and again in the final half hour of the film, when the same characters sit motionless in plastic chairs, their stories now shared with the viewer, their ravaging grief in plain sight. However, even though for the vast majority of the film no one addresses the camera, the villagers nonetheless go about their daily activities in the presence of and in collaboration with the filmmaker and her team, and they indirectly acknowledge their presence by allowing themselves to be filmed in what is inevitably a performative, self-conscious way. In so doing, they reflexively participate in the telling of their story.

At a few infrequent points in the film, the villagers are shown speaking to each other, or perhaps singing a song, and thus (especially with multiple viewings) the viewer is largely able to confirm that the voice-over is, in fact, the voice of the person on screen. Initially, though, there is no verification that the voice and the experience the voice shares belong to the visible body. This is a strikingly unusual tactic for a documentary film, particularly for a documentary in the postconflict, human rights genre, in which subjects are often filmed in participatory mode,[12] looking into and speaking directly to the camera (which functions as an intermediary witness) as they share their testimonies, likely because this is how testimony is generally structured in courtrooms and other similar official settings.

In Latin America, there are two related but fundamentally distinct forms of testimony, or testimonio, in circulation, both of which are closely tied to the sharing of individual and collective experience postconflict: juridically informed testimony, such as that of the truth commissions and trials that have often marked political transitions from dictatorship or civil war to a more peaceful democracy, and the literary genre of testimonio. The literary genre of testimonio was at its most popular in the 1980s and 1990s, when it became widely known as a method for raising awareness about social issues and human rights abuses. Testimonio was made famous by texts such as *I, Rigoberta Menchú: An Indian Woman in Guatemala* (*Me llamo Rigoberta Menchú y así me nació la conciencia*, 1987) and has traditionally been defined by several key characteristics: it is a collaboration between the person sharing their story (who is often, although not always, functionally illiterate) and their interlocutor, or the person who receives, records, and later transmits the story. The story, which is of a life or significant

life experience, is told in the first person using the singular "I" by a narrator who is also a protagonist or witness of the story being narrated. While testimonio is an expression of personal experience, it is the personal experience of *collective* struggle against oppression (Beverly 2004, 1–28; Gugelberger 1996, 1–22; Nance 2006, 2). These narratives are intended to shed light on, and intervene in, the oppressive systems in which the authors live. Testimonios are inherently and explicitly political; they function as sites of struggle wherein the disempowered turn toward representational space and the possibility of an outside audience. In places where reconciliation processes were absent or insufficient, testimonio has been another medium through which people's stories could be shared and witnessed.

Although fundamentally different from testimonio in obvious ways, the juridically informed testimony of the truth commissions has similar social justice inflections. It is conceived of as the moment when survivors are given the opportunity to be heard and acknowledged after years of oppression and violence, and it is thus theorized as a form of social empowerment. Ostensibly, it gives the previously powerless a voice and, through that, the possibility of reclaiming their lives and making peace with, or at least understanding, their subjugation. Testimony is often invoked as a mechanism of justice—of knowledge through acknowledgment, of justice through the act of being heard. It is said to provide relief to victims, that the act of telling one's story releases pain, and allows them to move forward (Caruth 1995, 16; Felman and Laub 1992, 58–78). And yet, it is critical to note that from a juridical perspective, individual testimonies are not located in the realm of evidentiary truth but rather are used collectively to compose larger narratives about series of events—generally widespread and systematic instances of oppression, torture, and death. Furthermore, Shoshana Felman and Dori Laub acknowledge the sense of the impossibility of ever being able to *truly* tell the whole story that often permeates testimony, even while the imperative to tell and to be heard can become an all-consuming life task, reflecting that "[n]o amount of telling seems ever to do justice to this inner compulsion. There are never enough words or the right words, there is never enough time or the right time, and never enough listening or the right listening to articulate the story that cannot be fully captured in *thought, memory,* and *speech*" (1992, 78).

While testimony customarily focuses on individual memory (memory experienced firsthand and articulated by a singular person), memory is also always connected and in dialogue with social narratives and cultural memory. As Paul Antze and Michael Lambek describe them, memories are "interpretive reconstructions that bear the imprint of local narrative

conventions, cultural assumptions, discursive formations and practices, and social contexts of recall and commemoration" (1996, vii). They note that, within memory, there is a dialectical relationship between experience and narrative, as well as between the narrating and narrated self: "people emerge from and as the products of their stories about themselves as much as their stories emerge from their lives" (xviii). Memory is thus the process of living the stories that shape our individual and collective lives. Yet, widespread trauma interferes with individuals' and communities' abilities to continue telling their stories, both because of the loss of life—the literal loss of stories and their tellers—and the crippling fear, societal ruptures, and silences that mark the living conditions of those under siege.[13] This is one of the core challenges of testimony—the impossibility of truly telling the whole story. In other words, testimony is an affective, compelling *desire* to fully communicate an experience that exists in a state of unattainable possibility and nonarrival.

In truth, testimony is inherently contradictory. It is enacted in the spirit of gathering evidentiary materials, yet in the context of transitional justice it is given very little individual evidentiary or judicial weight. Testimony is an act of telling, but one in which the act of *witnessing* is seen as almost equally important. To witness, then, is often understood as the primary second-person mode of relating to trauma. As Roy Brand explains, "Witnessing does not mean having an immediate and fully present experience of the event, but rather . . . [t]o witness is to stand in for the absence of experience, but in so doing, witnessing recalls the very absence it attempts to resolve . . . Witnessing is precisely the attempt to make experience communicable, that is, to bring it back to life by reconnecting it with the whole person or community" (2011, 205). Insofar as the viewer of *The Tiniest Place* becomes affectively entangled in the aftermath of trauma, watching the film becomes an ethical act: the viewer is interpellated as witness. And yet, when Huezo Sánchez disconnects voice from body in *The Tiniest Place*, and the gaze of the survivor from the gaze of the witness (in this case, with the camera functioning as surrogate or intermediary witness gaze), she disrupts the equation of trauma, testimony, and witness we have come to expect. By loosening the traditional relationship between the person sharing testimony and the witness receiving it, the testimony in *The Tiniest Place* becomes less transactional, more ghostly, and more affectively intimate—an expression of what Stewart calls ordinary affects. There is a telling, and there is a receiving (and it is important to remember that the director did separately record the testimony with audio equipment); however, transmitted in this way, the testimonies feel less about, or *for*, the wit-

ness and more a description of the events, circuits, and flows that shape the fabric of the individuals' lives. They become the stories of both live and absent bodies, seemingly omnipresent as they float through the landscape. They become, as Avery Gordon writes of haunting, about "that special instance of the merging of the visible and the invisible, the dead and the living, the past and the present—into the making of worldly relations and into the making of our accounts of the world" (1997, 23).

Half an hour into the documentary, an elderly woman sits alone in a dark room lit only by candles on a small altar, which surround a photograph of a young woman. The woman shares, *When I'm sitting alone in my room, my little house, I talk to her, my daughter. I tell her to protect me from evil. Or from any bad thoughts I might think, right? I say to her, 'Daughter, wipe it away. Wipe away the bad thoughts I've had.'* We see the candle flicker, and she continues: *Because when you're alone you think ugly things. God forgive me, there are times I've had evil thoughts, of killing myself. And I begin to talk to her as if I'm talking to her. 'Look, daughter, I'm going to bed. Keep me safe from all evil. Forgive me,' I say, 'because I was rude to you, daughter, because I punished you,' I say to her. But it never occurred to me that she wasn't misbehaving.* At this moment, the camera's gaze rests on the woman's dimly lit profile and her voice cracks, *what she was doing was fighting so we could reach these times.*

After a long pause, the scene shifts to a young man riding his bicycle down a gorgeously verdant path. We hear in voice-over, *The first time you could say I became aware, as a child, a person, was when somebody came to our house and I said to my mom, 'look, they've killed Aníbel.' Aníbel Ávalos was my father. He was assassinated by the troops of the National Guard. From that moment, it was as if my mind came to a really strange conclusion, seeing him dead. His bullet wounds . . . because he'd been shot in the mouth, as if they'd put the barrel of the pistol in his mouth.* He continues riding his bicycle in the beautiful sun, through the jungle. He continues, *Smoke-stained, broken, his teeth were . . . This business alerted me at once to something that was happening and wasn't normal.*

The scene cuts again, more abruptly, to a young woman looking down, vigorously working on something, though we cannot see her hands, so it is not clear what exactly she is doing. We hear, *I don't remember how it happened because I would have been around three maybe. We lived in a house in ruins. We lived in absolute poverty; we had nothing. And we had a bed, two mattresses; that was the only one we had. I remember that all of us were in our houses, under our beds, it was kind of funny and you could hear the bullets whistling all around.* With a few glimpses of her serious, sad face, it becomes evident she is sharpening a machete. *As if the bed was going to protect them. That's the first*

memory I have, of what the conflict was. I noticed there was a conflict, but I wasn't aware of the scope of the problem. She continues to sharpen the large, curved machete.

This interweaving of testimony continues throughout. Stories stop and pick up again later, in the moment in which we left them, as we watch the people going through the everyday actions of their lives. Collective testimonies such as these create maps of connections between events, bodies, places, and temporalities that form the fabric of human life. The *transaction* of testimony matters less than the experience of telling, *how* the story circulates, and what that circulation *does.* By presenting testimony in this fashion, the director works to show how meanings, feelings, and past experiences are actually lived and felt, even as they are difficult to fully articulate and as they vary over time and across bodies. Mapping the relationship between narrative and the senses, or memory and affect, in this fashion demonstrates the degree to which the two are entirely intertwined, and it highlights how traumatic events continue to shape the lives of the living long after the physical violence has ended.

One of the most important threads of collective testimony in the film is the recollection of the day the National Guard invaded the village, forever altering the villagers' lives. A man remembers, *It was five in the afternoon when a child about this high came running for me. 'Don Pablo, Doña Belgini says you mustn't go home!' 'What's going on?' I said. 'Thirty National Guardsmen have shown up . . . They say they've got long lists with the names of all the men in the municipality. Doña Belgini says you mustn't show up or even think of going home.' What? Abandon my house? And we had small children, you see. The impact was terrible.* Other voices join the story, explaining how the men were forced to flee into the mountains. These separately told stories about the same event seem to have been later braided together within the film. *All I remember is I set off along the path, a path, and I saw some highlands and said, 'that's where I'm going to stay.' I couldn't sleep the whole night. How could I sleep? All I could think was 'why has this happened?' That's how we came to the mountains . . .* The man is now walking along on a mountain path; the camera focuses on the ground and his feet as though following behind him. A woman shares, *There were around fifty of us women, left alone in the village. I had eight kids. But the guardsmen came most nights to look for him at home. Under the beds, in every corner. They said if they found him they'd make minced meat of him. They took their machetes to the corn granary. They chopped down everything! And they set fire to the house. Oh god—all my kids were there, all piled up on one bed, scared witless.* Another woman's voice joins in, *They went around hitting the women, killing them and all. Because they said we knew where*

the men were and wouldn't tell. None of us realized what was coming, nobody. Because none of us were thinking about a war. None of us imagined such a thing. The film shifts to images of the house and smoke curling from the fire. The man's voice returns, and the image shifts to the empty interior of a bombed-out church bell tower. *They hit us with an invasion. There were fourteen planes! I felt the bullets landing all around me. I was out with all my children and Toña.* The older woman's voice explains, *They came to kill, see, because when they dropped those bombs, you felt as if they'd fall on top of you. Panic in your body, you felt as if your heart would jump out of your chest.* The young woman chimes in, *And Cinquera disappeared as a village. Bomb after bomb, invasions; it was razed to the ground. Nobody passing through could ever have imagined there'd been a village here.* A new male voice says, *I remember where the dead fell all around me.* And then later, softly, *I've never heard of a peasant who wants to be at war.* This memory narrative is irrevocably linked to place—to their homes, the village, and the surrounding landscape that eventually held the bones of so many from Cinquera.

Throughout, the visual and aural work together to embed the events of the past into the visual landscape of the present, and to convey a sense of overlapping time and place. Each story is unique for its impact on the individual sharing it, yet, when testimony is structured collectively, a broader narrative tapestry begins to emerge as the individual stories give shape to the collective experience of living amid and after violence. Shared in this manner, collective testimonies weave the map of connections that comprises the affective, collective intimacy of being the ones still living, surrounded by so much death. The transmission becomes one of experience but also of affect, the experience of trauma, about how bodies affect one another, and absences and ghosts affect bodies, actively participating in the circuits and flows of everyday life. In this context, testimony's value is not dependent on its acceptance into official historical archives or its usefulness in establishing patterns of violence but in the reality that these stories are the roots from which contemporary structures of feeling grow. This is not to say that art does not take on the burden of making past crimes knowable—certainly, there is an evidentiary component to this documentary film. Rather, it is to highlight the embodied, affective complexities of testimony and its ability to work across different temporalities, populations, and emotional registers. These essential characteristics of testimony are all but elided by official testimonial processes. Memory mapping is a means of shaping a more nuanced, holistic depiction of the postconflict experience, and thus films such as *The Tiniest Place* play an essential role in illuminating that which is otherwise largely left overlooked and unseen.

Later in the film, an elderly woman shares: *When we lived in the village, the civil defense people turned up and took the girls out into the yard and raped them. With the guns here, to their heads. So many young bodies were piled up.* The camera pans across an array of bullet holes and splatters of machine gun damage in cement walls. *That's what made Gladys decide to go. She was the first of my daughters. 'No mom, I'm better off going, [Gladys said]. Instead of getting killed here, getting raped by them, I'm better off going.' 'Don't go,' I said to her. 'They'll kill you there.' 'No,' she said, 'but I prefer to die with something in my hands than to be killed here.' Fifteen years old, she was.* The shared narration continues, with different parents explaining how their children left to join the fight, seeing no other option but to die fighting for their lives. We return to the elderly woman, who continues: *Sometime later she came back. 'Don't stay here in the house,' I told her. 'Because they've already got you under surveillance,' I said. 'No, mom,' she said. 'What are you so afraid of?' 'Oh, child, if only you knew the foreboding I feel,' I said . . . In the morning, we heard three patrol cars arriving.* Brokenly weeping now, she recounts: *'Good morning,' they said to me. 'Good morning,' I said. The man grabbed her and hugged her and said, 'Oh, you're such a pretty one,' he told her. 'But now your time has come.' 'Why's that?' I asked him. 'My daughter's committed no crime,' I said. 'Shut up, you old busybody,' he told me. 'Don't you know what your daughter's been up to?' 'What's going on?' I said to them. 'Get down, you old bitch!' he said to me. 'Or we'll kill you too!' And they took her away.* Later, we hear the end of the story. *When they brought her to me, I didn't recognize her. They'd removed her breasts. There was a stake nailed into her private parts. 'I can't bear it,' I said to myself. She was no longer my daughter. Impossible to bear any more. She was just a bundle, burnt.* Her story is followed by the sobbing voices of other parents, wracked with grief as they tell similar tales of how they lost their children.

Analyzed through a juridical lens, this testimony provides both a basic contextual sketch for why some young people chose to join the guerilla movement and the consequences they suffered if they were caught. Alongside other testimony, it might also help to establish larger patterns of torture, to estimate death count, and to break down torture and death statistics by gender and age group. But what it does not capture is the ongoing affective and social impact of violence, or what Kerry Whigham has termed "resonant violence"—the individually and socially "*felt* experience of violence, which, due to its ability to resonate, is actually much more persistent than the physical violence that leads to torture and death" (2014, 89; emphasis original). Put in conversation with Flatley's structures of feeling, which are the specific sets of affects generated within communities as a

result of experiencing certain events, the concept of resonant violence addresses how extreme violence, such as was experienced in Cinquera, persists to generate structures of feeling in the present. By mapping the relationships between place and individual and collective memory, the film offers viewers a glimpse of these otherwise unseeable structures of feeling, which are very much shaped around the residual effects of past trauma.

Following the parents' story of the murder of their children, there is a jarring shift in cinematography. The individuals we have come to recognize now sit deathly still facing the camera. They could be mistaken for photographic portraits, were it not for the liveness of the grief pouring from their eyes and for their breathing. The moment is a rupture in many ways: their eyes directly address the witness for the first and only time in the film; it is quiet, and their bodies are still, as though the ferocity of the telling of past events has finally stunned the present into absolute stillness. This scene is immediately followed by a scrolling series of black-and-white portraits of villagers killed during the war: a direct reminder of the presence of the dead. This performative rupture in the film mimics the rupture caused by the violence in Cinquera, functioning as a visual metaphor for the incomprehensible nature of such violence. The power of this performance is found in the stillness. When everything stops, the viewer is confronted, face-to-face, with the magnitude of the villagers' loss for the very first time in the film. In this moment, the viewer is interpellated as witness to the trauma. This performative visual point of convergence between memory and affect gives shape to the emotional arc of the film, rendering an essentially incommunicable experience affectively and ethically legible, both through testimony but also by deliberately marking the moment in which the memory narratives become insufficient to fully portray the magnitude of the pain.

As this film demonstrates, the visual functions as an affective contact zone where stories, silences, memories, and ghosts interweave, thus opening up the possibility of a more holistic understanding of the relationship between memory and affect, and of how trauma lives in and is transmitted affectively through bodies. History is narrated with and through bodies. The lived experience of the ongoing effects of violence, and the very burden of *survival*, of being the ones who lived and returned—indeed, chose—to live in the exact physical spaces where that violence occurred, is something that is all but impossible to render fully legible through traditional testimony. Memory is entirely about the dialectic between experience, narrative, and affect, and testimony is the aural narrative that results from memory. And yet, scholarship on testimony has focused less on

affect because of testimony's emphasis on legible, quantifiable experiences, even as we acknowledge just how much is elided by this approach. This is understandable, given the fundamental juridical underpinnings of testimony. Nevertheless, it is also clear that testimony has affective, embodied, and generative dimensions that have been largely overlooked in the broader scholarship. Incorporating affect into the study of memory and testimonial narratives moves us beyond the question of the inadequacies of verbal articulation to the recognition of memory's pervasive, affective presence, one that far exceeds the constitutive boundaries of verbal testimony. Conceptually, memory mapping is a means with which to attend to and represent the complexity of the relationship between past and present, and life and death.

Memory mapping unquestionably shares certain characteristics with the literary genre of testimonio. Both memory mapping and testimonio respond to similar sociopolitical contexts and engage with memory narratives when the state, as a collectivity, completely fails to respond to or acknowledge an experience. They are also distinct in key ways. Testimonio is very much grounded in the politics of authorship and autonomy, and in the individual subject's authority to speak and write about past events. While memory maps are shaped by memories of past events, they are essentially *of* the present and concerned with the ongoing impact of the past *in* the present. Memory mapping is a conceptual framework for understanding how visual texts depict specific sociopolitical moments by visually mapping the affective, temporal, and spatial connections between narratives, objects, landscapes, and bodies that compose the human experience. Indeed, when Huezo Sánchez visited Cinquera, she was struck by how strongly she felt the presence of ghosts, reflecting: "It was a strange and strong sensation. They speak of the dead and of strange things, of a double level of a strange reality . . . Listening to them talking about [and to] the dead in such a casual way, in such an everyday way, something strange, magical—and dark at the same time—starts creeping into you." She also instinctively identified the forest as a principal character in the story, commenting: "The forest was an important element, too. 'The forest is sacred to us,' they told me. 'The forest isn't just any forest but the tomb of our brothers and our parents and our children.' I went back and forth about how to film this forest, and I thought that it could be from the point of view of a ghost, that one had to feel as if one was flying above the forest." This fed into her decision to record only audio while interviewing, because she wanted to record the film "from the perspective of a ghost, because [the villagers] live among ghosts" (Cardenas 2011, n.p.).

Ultimately, whereas testimonio is defined by the relationship between survivor and witness-writer, in which the story told ultimately belongs to the survivor, *The Tiniest Place* is very much the *filmmaker's* film, and not that of the villagers. Huezo Sánchez chose the characters (many of whom were friends of her grandmother's) (Ponce 2011), *how* to tell the story, and, in a very real sense, what story she would tell. For these reasons, it is clear that *The Tiniest Place* is not testimonio but rather is an affective visual mapping of the relationship between memory, bodies, and place that finds fundamental aspects of its supportive structure in testimony.

Mapping Landscapes of Memory

Such visual memory mapping also inextricably binds memory to place, both by highlighting its hidden presence and by extracting it through enacted and embodied practices of remembering. *The Tiniest Place* interweaves aural testimony with the quotidian actions of the villagers' lives: grazing cattle, making pupusas, bathing in the creek, walking well-worn paths through the jungle, resting in their homes, and so on. The actions are the epitome of the everyday; yet, by juxtaposing them with testimony, the film articulates these everyday practices as rituals that are embedded with memory. They become legible both as everyday practices and as practices of remembering the people and events of the past that occurred in those same places. This articulates a profound link between memory and place, rendering the landscape the stage upon which temporality, death, and renewal are performed. The material remains found in the landscape—old boots with plants growing out of them, rotting clothing with mushrooms sprouting from it, buttons, and pieces of bone—all work to performatively evoke ghosts and the ongoing presence of past events.

When the villagers returned to rebuild from the ruins, they chose to actively work to simultaneously remember the past and chart new paths, new webs of connections, and new ways of being *through* bodily practice and their relationship with Cinquera and the surrounding jungle. Consequently, their memory landscape is multilayered. On the one hand, it is physical: composed of walls that list the names of the dead, a diverse array of material residue from the war, bullet-ridden structures, and buildings in various states of ruination. On the other hand, it is affective, for it is wholly defined by the events that occurred there in the past and the people whose blood and bones are now absorbed into the skin of the earth.

The affective web wrought through testimony, which functions to define and construct the survivors' identities in the film, is the connective

tissue throughout. Held in and across multiple bodies, these stories are the affective fabric of their lives, giving meaning to both bodies and landscape. In one searing scene, a man recounts the search for a place to hide in the jungle. He explains how he saw a cliff with a crevice about twelve meters up; he climbed up and saw a large stone hiding the entrance to a little, pitch-black cave. The villagers snuck from Cinquera at dusk so they would not be seen and walked through the night. They lifted people up to the cave with rope, eventually gathering about twenty-five women and eighteen children, who sat quietly in the pitch black. They spent several years living in the cave, sitting in a row, whispering so as not to be discovered. A child cried, a soldier heard, and they were found—and dragged back down to the ground and to the village. The soldiers taunted and threatened the man before inexplicably letting him live. The man returns to the cave for the first time in the filming of the documentary. He stands in the dark, narrow hole, his shoulders tense and a pained look in his eye. It is not a performative reenactment of the flight or of the capture; without the testimony, the audience would have no idea why he was in the cave. But, paired with the testimony, his pain becomes legible, and the cave is converted into a spatial and temporal map of memory.

Throughout the film, we witness both the villagers' efforts to rebuild their community and their complex relationship with the jungle and surrounding landscape, which hid and fed them during the war and now holds the bones of so many of their loved ones. We also witness the everyday negotiation of being affectively surrounded by death and the material remnants of violence. Parents lose their children one after the next, a makeshift family of orphans takes up residence in one small house together, small children are sent to identify the dead, and bodies are found: everywhere, every day. Once the villagers realized the military was killing everyone, they escaped into the dense jungle-covered mountains, where they ate leaves to survive. They describe how the forest became "an ally," "a refuge," and "a blanket that covered them." As the collective testimony continues to unfold, the disconnect between the lush visual landscape and the painful aural narrative slowly fades away, as the spectator is drawn into the visual, temporal, aural folds of what happened *here, then.* Villagers ran from one place to the next, jumping over dead bodies, climbing deeper into the mountains. The film, which has been shifting from one astoundingly beautiful, lush mountain panorama to the next, now focuses in on the overgrown jungle floor. The forest floor is littered with piles of bones, articles of clothing, boots, and undiscovered corpses—the material residue of the dead. Leaves and vines creep over them, and ants crawl across buttons and

shoelaces gradually decaying into the landscape. As the objects slowly become part of the leaves and dirt that feed the jungle's surface layer, the integral role of the landscape in the memory narrative becomes increasingly clear. The material debris of El Salvador's violent past is literally embedded in and part of the landscape, simultaneously marking the ongoing presence of the past and the inevitable transitions brought on by the passing of time.

While the jungle floor collects death and decay, and anchors the survivors' narrative, the landscape also functions as a metaphor for life and renewal in vignettes throughout the film. There is a search for fresh chicken eggs in the beginning of the movie, which incubate as the film progresses and ultimately hatch into baby chicks. A pregnant cow is carefully cared for and triumphantly births her calf toward the end of the film. The sun sparkles on the vibrant green of new plant growth. A fierce rainstorm at the end of the film is paired with uplifting music as children run, laughing. Even the clothing decomposing into the jungle floor is recycled into essential nutrients, from which new growth will emerge. Such images suggest that Cinquera will emerge cleansed from the violence of the past into a new, more hopeful future. Symbolically, these physical elements send a message of renewal, new life, hope, and possibility, suggesting the affective possibilities that memory and regeneration are not incompatible. Life is emphasized in both content and form.

Representing both life and death, the landscape becomes the primary link between past, present, and future. For the inhabitants of Cinquera, the forest was not just any forest but the tomb of their parents, siblings, and children, and their hiding place once they fled the village. Much like bodies, the stories pile up on each other, becoming a cacophony of recollected experiences that paint a collective picture of life under siege and of families separated while their lives are blown apart by inexorable waves of incomprehensible violence. Residues of violence mark the town—buildings have bullet holes sprayed across them, a list of the names of the dead spans the length of the back of a small building, and parts of the town remain in ruins—but the landscape itself holds the most meaning, and it is with the landscape that the villagers seem most connected. Through the dialectic created between the visual imagery and the aural testimony, the jungle legibly shifts from simply a place of natural beauty to a spatial and temporal map of memory and loss. The cyclical temporality of the landscape also speaks to the ongoing importance of memory. The forest continues its cycle of regeneration, sheltering the bones of the dead but also threatening them with oblivion. By painstakingly mapping memory onto and

through the landscape in this manner, the director creates a visually affective and emotionally resonant representation of the survivors of Cinquera and their relationship to past, present, and place.

Ultimately, the visual has the potential to function as a space of "making"—of making places by enabling landscapes and objects to, as Janet Walker writes, effectively speak and be heard (2011, 15). It is not that memory was absent prior to the film—the relationship between memory and place is profoundly important for the individuals we meet in the documentary—it is rather that, on the surface, Cinquera is not immediately recognizable as a "memory" site. Without the contextualizing work of the film, to the outside viewer it is simply a small, remote village. Through a variety of filmic strategies (e.g., separating voice from body, interweaving testimonial narratives, and identifying objects from the past in the present landscape), the director maps memory onto and through the connections she builds between objects, landscapes, bodies, ghosts, and testimony. By working to make the relationship between memory and place legible *through* visuality, *The Tiniest Place* simultaneously investigates and produces the relationship between memory and place, in turn rendering Cinquera legible as a site of memory.

Seen through the lens of mapping, the ways in which visual texts such as *The Tiniest Place* engage with memory takes on deeper meaning. The visual strategies the director employs *as* a process of mapping memory onto and through bodies, places, objects, ghosts, and embodied practices reveal how memory, through the visual, can be used both to illuminate certain contemporary conditions and to propose to viewers a new way of understanding the past and its impact on the present and future. To return to an earlier example, in the scene this chapter opens with, the man goes about his routine task of grazing cattle while his memory narrative is heard in voice-over, conveying to the viewer that, although not visible, the man has severe post-traumatic stress from the war, which impacts his ability to function in the present. Articulated within the broader context, his body becomes a container for memory and a means through which to narrate the ongoing impact of violent imperial histories. Mapping memory in this way is an effort to make sense of the complexity of living among the ruins of history and of the many pasts, voices, affects, and desires buried in the landscape—invisible but still felt. In so doing, the director effectively constructs Cinquera as a memory site *through* the visual, rendering the documentary *itself* as a form of memory site to which spectators may visually and affectively travel.

Ultimately, with *The Tiniest Place*, Huezo Sánchez has created a thick mapping of the polyphonic, thickly layered connective webs between bodies, ghosts, materiality, and place. This map is rendered legible through aural and visual narratives, the invocation of ghosts, and the affective, embodied juxtaposition between the serene beauty of the landscape and the pain and grief the villagers carry inside of them. By mapping memory in this manner, Huezo Sánchez provides a historiographical alternative to the state's investment in artificial narrative closure and its subsequent insouciant approach toward reconciliation (in the name of moving forward postconflict). This film resists such historiographic tidiness. Its form and content demonstrate the persistence of memory, literalized in the evocation of the ghost, the ongoing experience of trauma, and the memory landscape. In so doing, the director enacts a different mode of representing history and trauma that is visual and affective (rather than fact or narrative-driven) and represents the complexities and "thickness" of human experience.

The film also emphasizes the crucial dialectical relationship between performance and visuality. The reenactment of everyday rituals and practices, performed for the camera, anchored in the landscape, and given coherency by aural memory narratives that invoke a sense of affective haunting, in turn calls forth the performance of objects and landscapes, shifting them from backdrop and rubble to things and places richly embedded with affect and memory. And yet, it is the camera and filmmaker, and the resulting film, that shape the performance and give it coherency through framing, and it is *only* through the visual mode that this performance connects with audiences. In other words, I have argued that the visual is inherently performative, both possessing of performative characteristics and essentially visual. In other words, this performance lives *within* visuality. It is made possible by—and shared with audiences through—the visual mode. Consequently, performance and visuality are irrefutably and completely intertwined, and to study one and not the other is to miss the whole picture. Just as Diana Taylor argues that performance is not just about what it is but "what it *does*, what it allows us to see, to experience, to theorize, and its complex relation to systems of power" (2016, 6), analyzing the visual through a performance lens elucidates, on one level, *how* visual texts work to make audiences see and feel, and, on the other, that it is the dialectic *between* visuality and performance that ultimately makes the film affectively resonant. As exemplified by *The Tiniest Place*, and further developed in the following chapter, this performative visuality

coheres into a richly affective memory map through and to which audiences may visually and affectively travel.

In this chapter, I have focused largely on the relationship between memory and affect, and on testimonial narratives, ghosts, and landscape. In the next chapter, I shift my attention to think more deeply about material memory and the performativity of the body as memory mapping strategies in Chilean documentary film. Across these different texts, one of the questions that arises is how to represent the unrepresentable in the aftermath of violence. How it might be represented—shared in some fashion—without doing the individual or event an injustice is a question with no easy answer. Ultimately, *The Tiniest Place* is about a present day so defined by the past that the two cannot be untangled. It is a documentary of existence, but one in which we *view* the incommunicability of trauma while *feeling* its affective force. To attempt to narrate or explain a traumatic experience is to try to explain what by definition cannot be fully grasped or articulated, because trauma is an experience that registers in the human body beyond our ability to fully process it.[14] However, visual texts such as *The Tiniest Place* shift the focus from the inevitability of at least partial failure to communicate to an exploration of the possibilities engendered by the production of memory maps that simultaneously make visible and fabricate a web of constant interaction between stories, memories, ghosts, and place. In so doing, the film begins to address the aforementioned challenge, because it allows for an attentiveness to the ways in which memory is about past experience and trauma, but also about the ongoing experience of trauma, and about the ways that loss and ghosts affect living bodies, and the ways that those living bodies in turn affect one another. It is not the testimony of the truth commission or the courtroom, but it *is* an effort to more fully represent the lives of those who lived in the face of so much death.

Placing an emphasis on the dialectic between affect, memory, place, and testimony, films like *The Tiniest Place* shift attention away from the failure to communicate and toward a mode of attending to the perceptible moments of memory overflow and eruption, of flickers of visibility and audibility, and the ambiguous, contradictory, uncompleted movements and uncertain endings that feed into the memory sphere. The transmission of affect is about how bodies, present and absent, affect one another, as well as bodies' relationship to place and to the passing of time. It is about living a life where the past is as present as today, and where the dead's whisper you hear in your ear reassures you, grounds you, lets you know you have come home. It is a life where to walk in the mountains is to walk where your

children fell, the bones of thousands scattered across the jungle floor as plants grow over them and leaves pile softly on top.

This film is just as much about death as it is about life and existence— about survival, renewal, and beginnings that are simultaneously new, and about returns and continuations of a story begun long ago. It underlines how anchored the people are to the land that saved them and that now holds the bones and ghosts of the dead, and it emphasizes how bodies continue to affect other bodies, even after some of them have died. To map memory in this manner is to focus not on failure but instead on possibility. At the end of the documentary, the elderly woman who opens the film returns to her telling. She says softly:

> When we arrived, so close to dusk, it was already night. All you could see was fireflies all along the road, in the wilderness. It felt so lovely. Souls of children, they have. Yes . . . like children, right? Who gave us guidance, gave us light, to help us come here. For me, it was a joy to find the beloved person I had left there. She felt happy with me. Even though she was a spirit, but she and I, we feel happy now. Yes, my daughter could be a firefly. Because she was a light.

With *The Tiniest Place*, Huezo Sánchez creates a visual memory map that binds together memory and affect in order to interpellate viewers as witnesses, with all the ethical and political responsibilities such witnessing entails. If a politics and ethics of mourning, and of representing loss, hinges on how what remains is animated and sustained—on what becomes of the ghosts—then there is an ethical imperative to also attend to the structures of feeling that, in the aftermath of atrocity, shape the lives of those both living and dead. The task is not to speak for them but rather to facilitate their continued presence and ability to speak for themselves. Visual memory texts that work to map memory, in all of its complexity, allow us to listen and attend to their presence.

The Materiality of Memory:
Touching, Seeing, and Feeling the Past

Just before midnight on October 16, 1998, two Scotland Yard detectives quietly entered the affluent private London health clinic where Chile's former dictator, General Augusto Pinochet, was convalescing following back surgery. The detectives removed his bodyguards from the room, posted armed guards outside, and served Pinochet with an arrest warrant sent through Interpol from Spain for crimes of genocide and terrorism (Kornbluh 1998). This warrant had been written just six days earlier by Spanish magistrate Baltasar Garzón, and the subsequent arrest accomplished what courts in Chile had failed to do since Pinochet stepped down from power in 1990: arrest Pinochet for the crimes committed during his seventeen-year dictatorship. Seen as "one of the most important events in international law since Nuremberg" (Jonas 2004), Pinochet's arrest shook Chilean society to its core. Hundreds from the Chilean political Right and Left gathered to protest or cheer as UK magistrates debated how to proceed. Spanish lawyers fought to have Pinochet extradited to Spain to stand trial, and, although magistrates agreed to do so in 1999, a controversial medical test deemed him unfit to appear in court, and Pinochet was sent back to Chile a free man after just a year and a half after his arrest.

Shortly after his return to Chile, Pinochet was indicted and placed under house arrest; although several more attempts were made to bring him to trial, he remained under house arrest until his death in 2006, never having stood trial for his crimes.[1] Paradoxically, although he was never convicted, Pinochet's arrest and eventual death stimulated a culture of transition in Chile that had never been fully achieved during the 1990 transfer of power, restricted as it was by Pinochet's ongoing power. Change finally seemed possible. And yet, for many, the decades of silence and repression had left their indelible mark. According to Chilean intellectual José Bengoa, the terror of the dictatorship years had produced a "fear of the other" that ruptured basic societal solidarities and eroded national and local community, replacing them with smaller, more closed networks. As a result, even after the dictatorship ended, Chile continued to be a deeply fearful country, with "little capacity for analysis of its recent history, and an inability to express its fears and hopes" (2009, 59; trans. mine). Furthermore, Tomás Moulian describes how the 1990s postdictatorship period in Chile was also a time of forgetting, wherein "obligatory amnesia was decreed so that nothing could perturb the 'virtuous' official memory of the period of military rule" (1998, 16). Whole generations had grown up knowing only the dictatorship, and survivors had long since been exiled or sidelined because their memories and experiences did not comfortably fit the official historicist revisions of Chile's recent past. Memory—places of memory, practices of remembering, and even the importance of memory itself—remained highly politicized. Human rights organizations, victims' groups, and others advocated for the importance of remembering as a necessary linchpin of reconciliation and rebuilding the fractured country. Those on the Right claimed that Chile need not look back but should instead turn the page of history and maintain its gaze toward neoliberal progress.

Whereas the previous chapter focused on the relationship between memory and affect, and on the role of testimony in memory mapping, in this chapter I shift my focus toward a closer investigation into the relationship between memory and materiality and the performativity of the body. I analyze two documentary films by the prolific Chilean filmmaker Patricio Guzmán, both of which employ memory mapping to make historiographical interventions in Chilean cultural memory and the public sphere. Made nearly fifteen years apart, *Chile, Obstinate Memory* (*Chile, la memoria obstinada*, 1997) and *Nostalgia for the Light* (*Nostalgia de la luz*, 2010) mark pivotal junctures in Guzmán's filmmaking. Although in many ways the films are quite different from each other, made in different places and

times and with different goals, they find common ground in their insistence on the importance of memory as sociopolitical intervention, and on the perils of apathy and forgetting. Through analysis of the memory mapping strategies Guzmán employs to intercede in national consciousness and memory during and after Chile's posttransition period, including performative reenactments and returns to the scene of the crime, interviews, and the resuscitation of memory matter, I analyze the ways in which memory can be anchored in, and transmitted through, documentary film. I ask: What is the relationship between memory and materiality? How may memory matter be strategically employed in the service of political historiographies? How can bodies be called upon to performatively map memory?

Dictatorship, Documentary in Exile, and Democratic Transition

In 1970, Salvador Allende became the first democratically elected socialist president in Latin America. Accustomed to holding their own power and opposed to President Allende's socialist project, Chile's conservative and landowning elites accepted the United States' offer to help overthrow the socialist leader and began a series of financial, congressional, and public attacks against Allende's regime (Grandin 2005, 46–67; Moulian 1998, 16). Chile was soon engulfed in protests, strikes, and impassioned sociopolitical struggle. Guzmán, then a young and newly minted filmmaker, sought to document this vibrant era of change. Working with just three friends, a few portable and inexpensive 16mm cameras, and limited film stock, Guzmán's team strategically chose to focus their documentary efforts on the events taking place at the main factories, the universities, and the presidential palace, as these were all major meeting points for the strikes and rallies taking place across Santiago. In what ultimately amounted to roughly twenty to twenty-five hours of raw footage, Guzmán and his crew documented the vibrant euphoria of President Allende's supporters, as well as the growing fear and resentment of his opponents, which manifested in an onslaught of crippling strikes, protests, political undermining, and right-wing congressional blockades. Of this period, Guzmán later stated: "Through the lived experience of the film, we all came to understand what it means to live through a revolutionary process—what ideological struggle really means, what fascism looks and feels like, what it means for the enraged middle class to rise up against the workers, and how invisible imperialism can be" (quoted in Burton 1990, 66).

Although of course unaware of what the future would bring, Guzmán's team ultimately documented the lead-up to General Pinochet's military coup d'état. While filming, cameraman Leonard Hendrickson was shot and killed by the military, and, on the day of the coup, Guzmán and the remainder of the crew were captured and taken to the National Stadium, which became the first of Chile's detention centers.[2] In a dramatic series of events, Guzmán's Uncle Ignacio was able to hide the film reels in a trunk in his home, and then, with the help of Chilean friends working at the Swedish embassy, successfully smuggle them out of the country on a ship headed to Stockholm.[3] Guzmán was released after several weeks of detention and immediately fled into exile in Paris. He met the boat carrying his film reels when it docked in Stockholm three months later. Not allowed to board the ship, he later received a call from the head of the Swedish Film Institute to come retrieve his reels, which had been thrown into a pile on the floor of the institute's basement. Guzmán had carefully numbered all of his reels in Chile, and, miraculously, not one had gone missing.

Guzmán returned to Paris and went to work.[4] The resulting three-part documentary, *La batalla de Chile* (*The Battle of Chile*, 1975, 1976, 1979), is a deeply analytical and political look at President Allende's historic presidency, struggle to remain in power, and eventual fall.[5] Making the documentary gave Guzmán a sense of purpose in exile, and he believed in its importance for himself, the larger diaspora of Chilean exiles, and those still suffering in Chile. Guzmán reflected that it was only when he finished the film that he fully grasped his exile: "I had no country, no topic, nowhere to go. I had no future, nothing . . . When I finished the film, I felt what they felt when they left Chile. I fell into a deep depression that lasted six years" (Avellar 1997, n.p.).

Meanwhile, back in Chile, Pinochet's dictatorship was in full force. During Pinochet's first three months in office, more than 1,200 people were killed or had disappeared, and more than 250,000 were detained for political reasons (Kritz 1995, 454). In the years that followed, hundreds of thousands of Chileans went into exile, more than 30,000 were detained and tortured, and approximately 3,200 were killed by the military and the secret police.[6] Chileans experienced extreme censorship and what Nelly Richard describes as the decimation of earlier frameworks of Chilean identity, culture, and community. Through its surveillance of language and other forms of expression, Pinochet's dictatorship sought to suppress the very production of meaning in Chile (Richard 2004, 17). Artistic practice was either halted or hidden, cultural spaces were shut down and institutions

dismantled, and many artists fled the country, often to make important artistic contributions from exile.

While Guzmán is perhaps the most prolific and well known of the exiled Chilean filmmakers, there exists a rich body of Chilean films made in exile. Some reports estimate that during the dictatorship more than 1.5 million Chileans left the country and lived in exile for extended periods of time. These numbers included scores of filmmakers and artists who continued to produce work, such as Pablo de la Barra, Sergio Castilla, Pedro Chaskel, Beatriz González, Miguel Littín, Marilú Mallet, Alvaro Ramírez, Raúl Ruiz, Valeria Sarmiento, and Helvio Soto, among others.[7] Javier Campo contends, "Chileans have the most films from exile to their credit among Latin Americans and among the most in the world. In just the first ten years of exile (1973–1983), 178 documentary films were made, including long and short films of fiction, animation, and documentaries . . ." (2013, 148). These films were diverse in form and content, and a great many of them were explicitly political, aimed at galvanizing the Chilean exile community and raising international awareness. Films such as Miguel Littín's 1986 documentary *Acta General de Chile* (*General Report on Chile*) (which documents the filmmaker's clandestine return to Chile in order to covertly document life in Chile under the dictatorship) also gained wide visibility. Nevertheless, Guzmán's body of work stands apart not only due to his films' widespread acclaim but also to his unrelenting emphasis on memory, human rights, and the ongoing aftermath of the dictatorship. In addition to *The Battle of Chile* trilogy, Guzmán made numerous other Chilean memory and human rights–focused films over the years, including *En nombre de Dios* (*In God's Name*, 1986), *El caso Pinochet* (*The Pinochet Case*, 2001), *Salvador Allende* (2004), and, of course, *Chile, Obstinate Memory* and *Nostalgia for the Light*.

While Chile's eventual 1990 transition from dictatorship to democracy ended seventeen years of authoritarian rule, Pinochet continued to hold tremendous power. Prior to leaving office, Pinochet declared himself commander in chief of the army for the next eight years, after which he would become a senator for life. He also granted immunity to the military and rearranged the judicial system to ensure that the military had the majority of power. The new democracy was fragile, haunted by the dictatorship and the very real threat Pinochet continued to pose. When Chile's first of two truth commissions, the Comisión de la Verdad y Reconciliación (the National Commission on Truth and Reconciliation), began its work, Pinochet explicitly warned commissioners not to "touch a single hair of a single soldier," or he would retake power. He kept the army battle-ready,

occasionally surrounding La Moneda Presidential Palace with his black beret soldiers (Kritz 1995, 454).[8]

Choosing peace and democracy over justice and accountability, the Rettig Commission, as it was commonly known (after its head commissioner, Raul Rettig), held no public hearings and assigned no perpetrator accountability or individual responsibility. The nature of the truths the commission chose to address sharply limited its ability to comprehensively and legitimately report on the human rights violations that occurred during the dictatorship. The principal acts documented by the commission included torture resulting in death, execution by government forces, use of undue force resulting in death, death of combatants and noncombatants immediately after the coup, and killings for political reasons. The commission did not count crimes such as forced exile, torture not resulting in death, and illegal detention in which the person survived. In other words, in order to be counted as a victim, you needed to die. While such documentation would signal glaring omissions by any commission, it was an especially egregious accounting in Chile, where the overwhelming majority of victims were tortured but lived. As a result, the commission did not acknowledge the majority of survivor experiences; tensions between remembering and forgetting, and acknowledgment and forced silence, dominated the public sphere. The afterlife of violence, which Macarena Gómez-Barris has articulated as "the continuing and persistent symbolic and material effects of the original event of violence on people's daily lives, their social and psychic identities, and their ongoing wrestling with the past in the present" (2008, 5), continued to plague Chile far beyond the official processes of political transition.

In 1996, when Guzmán traveled to his homeland, this was the Chile to which he returned. Although his films were internationally renowned and among the most highly lauded and awarded of Chilean films, they remained undistributed in Chile. Guzmán had never found a distributor willing to promote them, even though the ban on his films had officially ended with the dictatorship. When Guzmán wrote to forty high schools asking permission to show *The Battle of Chile*, and then interview the students, he received almost complete rejection, along with the explanation that to show the film "would be negative, and that it was necessary not to reopen old wounds" (Klubock 2003, 274). Undeterred, Guzmán arranged to informally screen *The Battle of Chile* in several places and returned to Chile for the first time since the end of the dictatorship. *Chile, Obstinate Memory*, a complex documentary reflecting on the role of the past in the present, chronicles this return visit home.

While later in the chapter I examine reenactment as a memory map-
ping and place-making strategy, in what follows I focus on the role of
materiality in memory mapping. As I progressively argue, Guzmán uses
materiality (primarily in the form of old footage, photographs, and objects
that appear in his films) and individual and collective reenactment and
remembering to map for viewers the ongoing impact of the past and the
perils of elision. I contend that material memory serves as a means through
which to bring the past into the present and elucidate lost or marginalized
narratives. As such, it has the potential to function as a critical historio-
graphical strategy, especially in places and times marked by the suppres-
sion of memory. As Guzmán's films demonstrate, when strategically
deployed, material memory objects ultimately can be used to promote
dialogue and increased awareness able to combat the sedimented silences
and omissions of the past.

Memory Matter as Historiographical Strategy

Chile, Obstinate Memory opens to a black screen. City traffic honks and
blares in the background, and the title briefly appears on the screen. The
words disappear into darkness, a car honks twice, and there is complete
silence. Then, a dedication appears:

To my daughters, Andrea and Camila

The screen is abruptly ruptured by pure chaos, filled by the sights and
sounds of screaming fighter jets circling and attacking a large stately build-
ing, causing huge clouds of smoke and debris to swirl wildly in the air.
The raised Chilean flag hanging at the highest point of the building waves
softly in the gusts of the assault, and new words appear on the screen:

11th September 1973
Santiago, Chile

Behind these words, the fighter jets circle and fire at the building again,
and the flag and building disappear into the billowing smoke. The jets
circle yet again, and through the shrieks of its attack we hear the sounds
of the grand building crumbling. For anyone familiar with Patricio
Guzmán's work, this footage is instantly recognizable: it documents the
morning attack on La Moneda Presidential Palace, which began General
Augusto Pinochet's coup d'état and violent and oppressive rule, and the
last day of President Salvador Allende's government and life.[9]

This sequence sets the stage and tone for the documentary, which interweaves black-and-white archival footage from the early 1970s (previously used in *The Battle of Chile*) with new color footage of Chile in 1996. This new material largely takes two interwoven forms: reenactments that occur in the specific locations of past events and interviews with individuals and groups, almost always after staged screenings of *The Battle of Chile* or in dialogue with various forms of visual material, including old photographs and film clips. Guzmán's voice-over narration provides context for these different elements, binding them into a single narrative focused on the preservation, production, and transmission of memory in the present via visual evidence from the past.

One of the undercurrents of *Chile, Obstinate Memory* is the question: What does it mean for a culture to remember, and what are the risks in a culture of forgetting? Much like Huezo Sánchez's *The Tiniest Place*, which focuses on life in the aftermath of the civil war in the small Salvadoran village of Cinquera, the exploration of the impact of the past on the present gives *Chile, Obstinate Memory* much of its affective power. However, whereas in *The Tiniest Place* viewers are presented with a postconflict setting in which the affective filaments between violent past and haunted present cohere into a vibrant and affective document of survival, in 1996 Santiago the role of memory—and remembering—was much more contentious. The students we see in *Chile, Obstinate Memory* belong to what Marianne Hirsch has called the "postmemory" generation—the generation after the one that directly experienced trauma (2012, 4). These students have no firsthand memory of the coup, and because of the pervasive veil of silence thrown over history after the coup and the fractured political sphere during and after the dictatorship, most appear to have learned a heavily revised narrative of the period. By juxtaposing the 1973 *Battle of Chile* footage with the survivors' deep sense of loss and pain in 1996, as well as with the younger generation's lack of knowledge and understanding, Guzmán highlights the disconnect between those who remember and those who came of age in a culture of forgetting. He thus effectively demonstrates how the events of the past continue to impact present-day Chile, including for those who do not remember.

The people Guzmán interviews range from individuals who also appear in the 1973 footage or who played a prominent role in past events (e.g., President Allende's bodyguards) to contemporary conversations and interviews with groups of students after they have watched *The Battle of Chile*. Interviews with both conservative and liberal university-age students, and

slightly younger, middle school–age students are juxtaposed with those of survivors from both sides of the political divide. Guzmán includes an interview with a teacher who in the early 1970s was not an Allende supporter. She sits quietly with her boisterously debating young students and softly reflects:

> At the time, I was in the university. I also participated. I was not from the right wing itself, but in a certain way I agreed that something had to happen in Chile, that things should not continue the way they were. I was wrong, I was wrong. Now, I think differently. To recognize that one has been wrong is very hard, especially once one understands the cost. I can tell you that at the time of the coup, in the morning in which it happened, I was happy, but because I did not have the consciousness at that moment of what it was going to mean later. Two days after the coup, my point of view was different, and when time passed, obviously, it became even more different.

The contrast between the two generations is strong, and her comment offers an important middle ground between the conservative students who argue that the coup was a positive turning point in Chile and the liberal students and survivors who disagree. The situating of individual memories within a shared context (both in terms of the memories of those who remember and those who do not) makes it clear that the legacies of past events—and their attempted erasure—continue to shape the present, affecting daily life with a powerfully tangible force. In so doing, Guzmán conveys to viewers of *Chile, Obstinate Memory* the ongoing fissures that shape contemporary memory politics in Chile and the ongoing need for reparation.

Indeed, the importance of memory and the perils of forgetting, or never knowing in the first place, are emphasized throughout the film. For example, the first movement of Beethoven's Moonlight Sonata is interspersed throughout the film, specifically in moments when Guzmán highlights the importance of the struggle to remember. The sonata does not play through; rather, it is a broken melody, of which the spectator hears the slow sonorous beginning over and over again, seeming to aurally mimic the broken and fragmented state of memory in Chile. At the end of the film, viewers discover the music comes from elderly Uncle Ignacio (the one who hid and then smuggled out of the country the footage that would later become *The Battle of Chile*), the sole surviving member of Guzmán's family. Playing the piano, Uncle Ignacio struggles to remember the full sonata. Guzmán asks him why he hid the film, and he replies: "I knew I had to do it, not only for

you, but for what it meant, for being able to remember after." The film then cuts to one of the more poignant arranged viewings of *The Battle of Chile*. In class with Ernesto, a fevered union organizer in *The Battle of Chile* turned much quieter professor in *Chile, Obstinate Memory*, students watch the film in stunned silence, tears rolling down their faces. While Guzmán has held a number of other screenings prior to this, these students are hit by the film in a way that none of the other audiences were. They express anger at not knowing this history, guilt for not understanding what was at stake, and grief over what was lost. Some sob uncontrollably, inconsolable in their anguish, while others sit silently, tears pouring from their eyes.

By interweaving the scene with his uncle, the memory keeper, with the younger generation, and specifically the group of students most affected by the film (seeming to recognize themselves as part of the damaged aftermath of a brutal but largely silenced history), the film connects the two generations' experiences. It emphasizes that memory is a part of our everyday lives whether or not we know it, and that it is individually and culturally important to remember. Uncle Ignacio fought for memory by preserving *material* memory (the film reels), which the film portrays as heroic. Without him, *The Battle of Chile* would never have been made, and Guzmán's life would have been profoundly different. Moreover, since the story of *The Battle of Chile*, and the history it documents, is so at odds with the official history that was taught under the dictatorship, it is possible that, without this film, the anti-Pinochet version of history would have slowly been erased. In this sense, *Chile, Obstinate Memory* is an extremely cogent argument for the need to employ materiality in the effort to preserve memory, especially in the context of Chile's recent history, which demonstrates that it is possible for a state and society to suppress (for those who lived it) and erase (for the postmemory generation) certain memories. By showing *The Battle of Chile* to both survivors and the younger generation (both sides of the memory coin), and interviewing them afterward, Guzmán generates dialogue about the past and educates younger generations, thereby creating a space for engaged and invested witnessing.

Throughout the film, Guzmán constructs juxtapositions such as these, between then and now, memory and ignorance, youth and age, exile and home, and between what Chile was and what it has become. Chile's present increasingly feels held in the clutches of the past, unable to move forward because the relationship between past and present is so unresolved. When Guzmán interviews the now-elderly Carmen Vivanco, who was identified in *The Battle of Chile* by an audience member at one of the viewings, he asks if it is her in the clip. She says she is not sure—she

"has her doubts." It is unclear if she truly does not recognize the woman in the film or if she no longer identifies with the person she used to be because she is irrevocably changed by past events. Guzmán then asks who in her family was disappeared, and the names come one after the next, five total, including her husband and two sons. The scene ends with a palimpsestic image of the black-and-white footage of the vibrant Vivanco of the past superimposed with the color image of the aged Vivanco of the present, who seems grief-stricken, scarred, and unable to heal the felt rift between past and present.

Situated within a memory mapping frame, the interviews are a tool with which to extract and chart individual memory in order to then develop an affective, visual mapping of broader cultural memory. As isolated stories, interviews shed light onto individual experience; when portrayed as a collective, they form a web of relations, or what Kathleen Stewart has called "the map of connections between a series of singularities" that shape the human experience (2007, 47). The interviews demonstrate the extent to which memory informs who we are, even when that memory is denied or missing. Certainly, much of the film seems to be an effort to understand a homeland irrevocably altered by years of dictatorship, frozen by fear and silences, and haunted by the past. Yet, it is more than that. There is a multifaceted quality to how Guzmán uses the interviews alongside staged viewings of *The Battle of Chile* and other visual memory matter, to map memory. The combination of material memory and dialogue creates a space for him to intervene in contemporary memory politics even as he documents them.

In *Chile, Obstinate Memory*, the memory matter is much more explicitly and strategically didactic than in *The Tiniest Place*, which otherwise similarly engages memory matter to evoke a sense of what has been lost and to convey to viewers a more nuanced representation of the literal and affective landscape in postconflict Cinquera. Here, *The Battle of Chile* and the accompanying photographs function as visual evidence of the past; they document not just historical events but an experience and a series of collective affects, or structures of feeling, wrought by Allende's win and eventual fall. Through structured viewing and dialogue, connections are forged between these historical events and affects and present-day Chile. The visual's ability to function as material memory is profound: it connects audiences to that past. Furthermore, by asking audiences to interact with the film and with each other, the visual functions as an efficacious intervention into the cultural apathy and amnesia Guzmán is fighting against. This intervention happens in two distinct layers: for those documented

within *Chile, Obstinate Memory* and for viewers of the film. By pointedly highlighting the divide between the two generations' understanding, the interviews serve to effectively portray to the viewer the current state of memory politics in Chile.

From certain perspectives, memory and matter (material objects) appear to be oppositional, because memory is subjective, fluid, and open to change over time, whereas the material object appears largely perdurable, typically subject to mutability only through either destruction or decay. And yet, as the case study in the previous chapter and those in this chapter demonstrate, memory and materiality can deeply intertwine. Closer study of the connections between memory and materiality enables us to explore the use of material memory as a historiographical strategy intended, by learning and sharing the stories that the objects are imbued with, to assess and reshape the role of the past and memory in the present. In *The Tiniest Place*, the various matter found in the landscape was not immediately recognizable as memory objects but rather developed as such throughout the course of the film. In that film, the filmmaker remains invisible, ultimately establishing the legibility of the objects through the gradual interweaving of testimony, landscape, and everyday life. In *Chile, Obstinate Memory*, the presence of the director is palpable. Guzmán explicitly uses materiality to call forth the past and also to instigate dialogue *in* the film, while using his personal experience as an organizing and narrative thread for viewers *of* the film. It is a strategy made explicit from the beginning: memory objects are intended to affect those who come into contact with them.

When used strategically, old objects, whether overtly didactic or subtly evocative, are more than mere historical relics: they performatively embody lost stories and lives. These objects become tools through which to visibly and tangibly bring the past into the present, to vitalize and promulgate memory narratives, and to render physically tangible the link between the past and present. In times and places in which the very meaning of the past seems at stake, material memory matter can play a key role in memory's articulation and preservation. In Guzmán's many documentary films, such objects include Allende's presidential sash and wristwatch, half of the pair of eyeglasses Allende was wearing when the presidential palace was attacked, the empty glasses case inscribed with Allende's initials, a Socialist Party membership card, old photographs, documentary footage, bones, boots, spoons, and the walls and physical spaces where past events took place and filmic reenactments are staged. Items such as these are what Barbara Kirshenblatt Gimblett describes as "very powerful eyewitnesses to history" (quoted in Mitchell 2009, 4). She argues that when these

objects are worn or damaged in some way, they testify to the ordeal they have undergone. She writes, "These are objects which, by the dents and tears and rips and distortions and contortions, tell you that something terrible—and something violent—must have happened" (4). The stories that accompany these memory objects give them their significance; conversely, without the objects, the stories would lack the same level of poignancy and irrefutability, because the objects imbue the stories with a sense of tangible immediacy. Through memory mapping, disparate and fragmented stories, objects, and landscapes are gathered into coherent, contextualized, mutually constitutive narratives that are then transmitted to audiences. Similar to the memory matter in *The Tiniest Place*, which took the form of bones, old clothing, boots, and so on, and marked both the graves of missing loved ones and the ongoing presence of the past as time passes, the memory objects in Guzmán's films provoke and *produce* a set of mnemonic effects. However, in the case of *Chile, Obstinate Memory*, contact with memory matter is intended to promote what we might consider *communities* of memory, shaped around the learning, reflecting, and debating inspired by the collective action of viewing and engaging with the film, photographs, and other objects.

The film focuses entirely on memory—on what people remember, how they remember, and what those memories mean—and thus it is striking to note what Guzmán excludes from his mapping of postdictatorship memory politics. Aside from select student interviews, he includes very little from the Chilean political Right. This is perhaps unsurprising, given that his film contests conservative narratives of forgetting. What is surprising, however, is that there is not even a whisper about the politics of the transition period. There is no mention of the Concertación government's neoliberal policies, the ongoing political disputes surrounding human rights violations and the trials of military officers, or the struggles of the memory rights organizations to find those who were disappeared and to build public memory sites. The truth commission, the foremost official memory project of the transition, literally receives *no* mention. This absence is incredibly conspicuous. Why would Guzmán make a film that works to explore and document the state of memory in the postdictatorship period, a film based in large part on embodied and verbal testimonial reflection, and not make *any* mention of the most prominent official memory project? I interpret this decision as a deliberate repudiation of the flawed political transition process and as an argument for the importance of focusing on and emphasizing the individual memories that exist, often overlooked and unrecognized, in the larger cultural memory sphere.

By juxtaposing the individual memory narratives of th
younger generations, the film repeatedly highlights the critica
of memory in relation to social narrative as well as memory'
function as a necessary corrective. The teacher's memories of how ぁぃᴄ ᵢᴄ_
before the coup, and how she changed once she better understood the
impact of the military dictatorship, sharply contrast with her politically
opinionated but naive students, just as Ernesto's memories of the euphoria
of the Allende years, and the enduring devastation that followed, diverge
with his emotionally distraught students. The indirect juxtapositions are
as effective—Carmen Vivanco has experienced so much loss, and her mem-
ories are so traumatic, that she seemingly continues unhealed; meanwhile,
the conservative students' confidently incorrect and cavalier revisionist ap-
proach to history (they make comments such as, "It is true that people
suffered, but less so than what has been said. The country, basically, was
saved from a civil war," and "The best proof that the CIA did not partici-
pate in the coup in Chile is that, from the point of view of the armed forces,
the coup was a perfect success.") demonstrates the degree to which the ab-
sence of open dialogue has impacted younger generations. These juxtapo-
sitions communicate to viewers how disjointed Chile has become from its
recent past, and they emphasize the need for corrective intervention—work
Guzmán documents while simultaneously advancing.

If, as Gómez-Barris has argued, "most modern memory is constructed
from residues" (2008, 18), then material memory functions as a neces-
sary means through which to give form and voice to those residues. On one
level, by showing *The Battle of Chile* and conducting group discussions af-
terward, Guzmán educates the younger generation and creates witnesses
to the past. Certainly, not all the students agree with the politics in *The
Battle of Chile*, but by asking them to watch it and then to think and talk
about the past and its role in the present, Guzmán works directly against
the culture of forgetting and silence. On another level, he uses multiple
techniques to extract and engage with memory in his interviews with sur-
vivors. He shows them photographs and old film footage, and he also stages
returns to specific locations and "scenes of the crime," alternatingly ask-
ing them to remember, reembody, and reenact the past. Like a memory
prism, Guzmán's film takes in diverse, fractured memories and refracts
them sharply outward in narrative form. As a strategic intervention, his
film is designed to work in and on the public sphere, not just passively re-
flecting or elucidating the politics of the times but, instead, participat-
ing in an ecosystem of storytelling and story sharing. By structuring
Chile, Obstinate Memory in this manner, Guzmán also interpolates the

viewer of *this* film as a witness to the past and the present in Chile. It is a marvelous sleight of hand: by looking through the visual lens at staged spectatorship and various performance strategies *in* the film, the film itself, in turn, demonstrates an embodied, performative visuality. Honing in on the very matter of memory—in this case, the 1973 footage and photographs, and the affective resonances they call forth in the subjects of *Chile, Obstinate Memory*—Guzmán both returns to the past and brings the past firmly into the present. Opposed to an analysis of memory matter as static and permanently historical (belonging to the past), this temporal maneuver demonstrates the unique ability of material memory to function historiographically.

Ultimately, as I have argued, when employed in the service of critical inquiry and memory mapping projects, memory matter can assist in the creation of dialogical spaces that illuminate hidden pasts and lost futures, in turn helping to shape and democratize present-day memory politics. In the case of Guzmán's films, memory matter functions alongside his other primary memory mapping strategies (interviews and reenactments) to produce an explicitly political memory mapping project that opposes the official revisionist narratives of national history. In what follows, I turn to an analysis of the performativity of bodies in relation to materiality, places, and temporalities. Specifically, what is the function of reenactment in memory mapping? What do these bodily performance strategies make accessible to viewers that might otherwise remain hidden?

Remembering, Returns, and Reenactments

Interwoven with the interviews and material memory are a series of reenactments and returns to the places where key historical moments occurred. Rebecca Schneider has defined reenactment as "the practice of re-playing or redoing a precedent event, artwork, or act"; they are the effort to redo a piece "exactly the same as a precedent piece . . . to stand again in its footprint, in its precise place" (2011, 2, 16). While I largely agree with Schneider, I also want to make a distinction between reenactment and reperformance. Both reperformance and reenactment engage the body as the archive of movements that transmit meaning based on an original set of movement. However, the difference is one of intent: reperformance is backward looking, whereas reenactment is forward looking. Reperformance attempts to replicate an original as accurately as possible in all ways, in such a way that the reperformance serves to further develop

and affirm the original piece. In this sense, I align with Abigail Levine's reflections on reperformance as a practice of "enlivening the image of the original work" (2010, n.p.). Conversely, reenactment, I argue, is intended to activate new possibilities in the present. Writing on the body's role as archive in dance, André Lepecki proposes that "one re-enacts not to fix a work in its singular (originating) possibilization but to unlock, release, and actualize a work's many (virtual) com- and incompossibilities" (2010, 31). He continues, "Thus the political-ethical imperative for re-enactments not only to reinvent, not only to point out that the present is different from the past, but to invent, to create—because of returning—something that is new and yet participates fully in the virtual cloud surrounding the originating work itself" (35). This differentiation is important: much like reperformance, reenactment is the deliberate repetition of a set of precise movements that derives meaning from its earlier iteration. Both are restaged in a contemporary context. However, unlike reperformance, which is inherently derivative of the original in such a manner that serves to deepen the impact of the original, reenactment is intended to have contemporary effects—to create something new *through* the deliberate bodily invocation of the past.

As demonstrated in the film, reenactments of past events and actions serve to visually and affectively map memory through and onto bodies and spaces. Through bodily movement, reenactments evoke past events and bodies. They evoke their absence; in so doing, they illuminate what is no longer there and/or is hidden, and they give the ghosts of dreams, people, and politics audibility and visibility in the present. Reenactments occur in and with bodies, and the connections they draw, through bodily presence and practice, between places, temporalities, and events. As Maurice Merleau-Ponty proposes, by "remaking contact with the body and with the world, we shall rediscover our self, since, perceiving as we do with our body, the body is a natural self, and, as it were, the subject of perception" (2002, 239). In the context of reenactment, the body makes contact with the landscape and the past in ways that simultaneously identify and locate both body and landscape within a broader temporal continuity. Engaged in specific sets of movements in precise locations, the reenacting body serves as the medium through which memory may emerge. In this sense, reenactments loosen the ties that separate the past and present, aiming to give body and voice to a past that no longer physically exists, except in memory and through representation. In *Chile, Obstinate Memory*, these reenactments map memory onto and into key places in Santiago, illuminating how

memory is linked to place and embodied practice below the surface of visibility. Such reenactments remind viewers that much of memory goes unseen and unheard unless one is given the tools to decipher it.

The first reenactment in *Chile, Obstinate Memory* occurs directly after the opening resurrected footage of the bombing of La Moneda Presidential Palace. The visual and audio of the attack dissolve into the image of Juan, one of President Allende's bodyguards who was at La Moneda on the morning of the coup. Juan begins by reflecting. He remembers that he was unarmed, used as a shield, shot in the stomach, and pushed down the stairs before eventually being transported to and held at the National Stadium, alongside Guzmán and hundreds of others. As Juan speaks, he and Guzmán look at old photographs and footage that show Juan lying in the street after being pushed—a callous act that likely inadvertently saved his life.

Disguised as a member of Guzmán's film crew, Juan returns with Guzmán to La Moneda for the first time since the coup. He carries a tripod camera, which he clutches nervously to himself as though it might provide protection from bullets ripping through an unexpected fold in time. In a hushed, secretive whisper, he recounts to Guzmán where he was standing and moves to stand in that spot. He gestures to indicate the direction from which the soldiers first attacked. Juan recounts how only thirty-six people were defending President Allende, and how most of his best friends died that day. With Guzmán prompting him, Juan recalls how he ran across the courtyard while being shot at from above. He then crosses the courtyard, looking up nervously, as though expecting to again see shooters pointing rifles at him. The revisiting of the past through embodied memory creates a sense of temporal overlap, and there is a sense that Juan is simultaneously living the past and the present, as the emotions brought on by the act of physically remembering and reliving the past threaten to overwhelm him.

The film cuts to a group of other former bodyguards, who thumb through old photographs of themselves. They work to remember, attempting to identify ghostly soldiers and civilians in the faded black-and-white images. Ghosts seem to surround them as they point to person after person and softly remember their fate: shot "that" day, dragged away and never seen again, disappeared. Disappeared. Disappeared. Disappeared . . . The lines between dead and alive, past and present, then and now, are blurry; the individual and collective remembering seem to both give resonance to the survivors' lives in the present context as well as conjure ghostly traces of those who were lost. This multilayered recollection is not about exactly replicating past actions. Rather, it emphasizes the attempt to retrieve and

relive past memories as a form of embodied narration comprising both retrieving and transmitting memory. That this is a shared remembering, as in the case of the conversation between Juan and Guzmán in the palace, and between the group of guards, aids in the retrieval and spreads the burden of the past's return.

Reenactments are inherently repetitious acts—either because the body engaged in the reenactment is replicating its own previous actions or because it functions as a proxy for the original body that performed the action. However, while reenactments are repetitious, they are also new—both because they enable the *viewer* to experience the past firsthand, for the first time, and also because the reenactments inevitably change in each iteration. Whether because the air is cooler, the passersby are new, or the bodies of the actors themselves have aged (or are hungry, or tired, or angry), there simply is no such thing as precisely repeating an action *exactly* as it happened before. Reenactments simultaneously occur for the first time, in repeat, and in rehearsal for future actions. They accumulate layers of meaning—they are *of* the past but take place *in* the present. Because of this, reenactments are an effective strategy both for showing what happened with certain bodies, in certain places, and in certain moments in time, and also for resurrecting those past moments and inserting them into the present. In this sense, reenactments demonstrate how memory lives on in the body—latent but ready to emerge if given the opportunity.

Reenactment is importantly site-specific and overtly performative, in this case intended for a film audience. Reenactment asks the body to communicate an experience, to be an archive of past gestures in a way the verbal cannot. It is the memory knowledge of the body that is powerful here, given legibility and transmissibility through the visual mapping of the film, which puts together all of the fragmented pieces together. This convergence of performance and visuality is especially important. Reenactment results from precise bodily gestures, contextualized by memory narrative and anchored in the specificity of place. Typically, an audience must be present to see the performance. However, in the context of film, audiences may not be physically present, but they are enabled visual and affective contact with the reenactments. Consequently, the film functions as a memory map of bodies, memories, narratives, and places to which audiences visually "travel."

One pivotal reenactment scene opens with the sounds of the anthem of the *Unidad Popular* (President Allende's political party) and the image of bodyguards walking alongside an empty car as it drives slowly down the quiet street. Their hands rest protectively on the car as it moves forward.

The film cuts to black-and-white archival footage of the car of President Allende—anthem playing, the (then much younger) bodyguards walking alongside, while huge cheering crowds fill the streets to watch the president pass. The film returns to the present-day reenactment and the empty car and street. The absence of President Allende and his dreams for Chile deeply haunt this reenactment. The reperformance of the embodied gestures of the aged bodyguards is devastating, as they slip back into practiced movements that seem second nature yet so uncanny and at odds with the absence of the contextual meaning that the president and the pulsating crowds gave their bodies in the black-and-white footage. Unreconciled loss and pervasive surrounding silence seem to inhabit these men and pour out of their bodies as they walk through empty streets and protect an empty car. The replacement of bodies, music, and dreams with emptiness and ghosts points to the presence of absence in the wake of the historical trauma of the coup. This scene simultaneously reenacts the gesture and *also* the enactment of embodied memory, caught in temporal slippage. Their bodies do it again, and for the first time. By emphasizing the practiced nature of the gestures as powerful corporeal remembering and mourning, Guzmán implies that these embodied memories rest, dormant, just below the skin.

By rendering these links between memories, events, places, and bodies visible and intelligible through embodied practice (in the form of reenactment), viewers confront an entirely new understanding of these places and their relationship to memory. Guzmán does not deal solely with the memory of others; in one of the most personal scenes of the film, he turns the practice on himself. Guzmán returns to the National Stadium, the site of his own detention. He goes with his friend Alvaro, who, in the days after the coup, volunteered as a doctor to the prisoners and secretly carried messages to the outside world. As they walk through the cold underbelly of the stadium, Alvaro muses in a hushed tone that it was a sinister, fearful place, full of death and pain. The eye of the camera flickers around the empty hallways and walls of the stadium. The camera view changes to handheld, eyelevel, as the viewer watches Guzmán slowly walk down a ramped hallway toward a large grated door. The doctor recalls that one day he went to the stadium and Guzmán was his next patient. Guzmán asks in a distant voice, "And was I afraid?" The doctor replies gently, "No." The scene then shifts to footage of people in the stadium bleachers while armed and helmeted soldiers walk toward them. Guzmán begins to narrate: "In 1973, thousands of people passed through this stadium. It was the first wave

of terror to wash over Chile." The image cuts to soldiers walking through the stadium, through a door and into a security backroom. They don helmets with face protection and riot gear. This image is intercut with a black-and-white photographic still of police in the same uniform. Except for the color of the image, it could be the same policemen. The photographic still shifts to another, this time of the police standing in the stadium hallway pointing a gun at a young woman, her hands raised above her head. We return to color images, and the police are lined up to begin marching. Guzmán cuts back to black-and-white riot footage from *The Battle of Chile*, and we see the police attack the crowds. Back again to the contemporary footage, the police—almost indistinguishable from the police of the past—circle out into the stadium and stand facing the crowd. It eventually becomes evident they are at a soccer match, seemingly there to ensure the unruly crowd stays contained. There is a strange layering of multiple stadiums in time; the stadium where thousands (including Guzmán) were detained, the stadium that is known as a site of intense horror and violence, and the seemingly unaware youth of the present. As the soccer fans' energy builds, they scream team anthems, climb fences, and throw smoke bombs; their joy feels riotous. There is a staggering uncanniness to how closely the militaristic surveillance, with its undercurrent of potential violence, replicates that of the past. The palpable unease Guzmán seems to feel in the stadium, the site of such personal psychological and physical terror, is amplified by the seeming ignorance of the soccer fans under such heavy police surveillance. Peculiarly, the success of the reenactment comes from the choreographed movement of the anonymous police corps bodies. Contrary to the scene with President Allende's bodyguards, in which it is the specificities of their bodies that give the scene meaning, the viewer does not need to know who the individual police officers are in order for the reenactment to be effective. This discordant overlapping of the stadium in distinct layers of time again serves to point out the divide between the past and present in Chile.

The embodied remembering activated by the reenactments illuminates a powerful form of memory matter felt and expressed within and through bodies, one that is concurrently ephemeral and enduring. Guzmán uses bodily reenactments to call forth ghosts and different time-place intersections; in so doing, he works both in and outside of time, using loss and memory to map memory in and to the present. He blurs the lines between individual and shared memory and knowing, and he exacerbates the sense of dislocation, of existing simultaneously in the past and present. Certainly,

Guzmán is not interested in simply recording the politics of the times; rather, his is a deliberate practice of unearthing, rendering visible and audible, and then broadcasting memory.

Both reenactment and the performance of memory objects are strategies designed to bring memory to the surface—to make memory visible, audible, and felt. Guzmán's multifaceted, sensorial approach to memory, and the ways in which it both lives in and links bodies, images, objects, and places, illuminates how memories, acknowledged or otherwise, continue to have an impact on both the individual and cultural level. His is also a cogent argument for the need for increased dialogue on, and exploration of, the ongoing effects of the dictatorship. The fissures between generations, the cultural silences, and the jarring juxtapositions between past and present created by the splicing archival and contemporary footage all serve to highlight the fractured memory sphere in Chile.

Ultimately, Guzmán gathers diverse and fragmented memories, experiences, forgettings, and fears into a memory map that both documents and intervenes into the absences and silences that mark the public sphere. As an exile returning to his country years later, looking for traces of knowing and being that are *in* the present but are also *of* the past, Guzmán uses memory mapping to create a sense of being simultaneously inside and outside memory, time, and place. Guzmán portrays these three not as ontological and epistemological superstructures but as sites of contention open to competing claims of authorship. This materializing of the past is destabilizing, and, into this opening, Guzmán inserts his truth claim: we are made who we are by our personal and collective histories, yet we are also the makers of our history—something for which, in Chile, one must actively fight.

In certain respects, *Chile, Obstinate Memory* is strangely contradictory. It is strongly grounded in the politics of time and place but also wholly marked by the exiled filmmaker's spatial and temporal dislocation. Guzmán is an insider/outsider, working on the present/past. *Chile, Obstinate Memory* is profoundly based on the experiences of live bodies but intensely focused on ghosts and haunting. It is entirely about memory in the aftermath of the dictatorship yet does not explicitly address any of the official transition processes. Intent on undermining mainstream narrative constructions of history that exclude the full spectrum of Chileans' lived experience, *Chile, Obstinate Memory* blurs the lines between personal, collective, and political. The film positions memory as both borne out of individual circumstances and shaped by collective consciousness and shared social processes. In so doing, it performs the very repositioning and re-

framing of memory it seems to argue postdictatorship Chile so desperately needs.

Nostalgia for the Light was released in 2010, almost fifteen years after *Chile, Obstinate Memory*. It continues Guzmán's focus on the relationships between memory, bodies, and materiality, but the passing of time appears to have shifted Guzmán's perspective. Instead of repeatedly belaboring the importance of remembering as an intervention against the corrosive aftermath of state violence, *Nostalgia for the Light* centers almost entirely on the relationship between memory and matter more than a decade later, when postdictatorship memory politics have faded even further into the past. This film focuses on the passing of time in relation to memory politics and seems to ask what will happen when the memory keepers die and no one is left to search for the truth. The film offers no simple answers but instead ruminates on memory and materiality, cultural apathy, and the passage of time.

While all of Guzmán's films have been well received, *Nostalgia for the Light* stands out. Winner of numerous awards, *The Nation* described it as "stunningly beautiful" and "deeply moving," and *New York Magazine* pronounced it "deeply affecting" (Icarus Films, n.d.).[10] *The Guardian* called it one of the films of the year, stating: "It isn't simply that Patricio Guzmán's Chilean documentary *Nostalgia for the Light* is moving: it has a tragic grandeur that really is very remarkable. It is deeply intelligent, intensely and painfully political, and yet attempts, and succeeds, somehow to transcend politics and perhaps even history itself" (Bradshaw 2012). In *Le Monde*, Jacques Mandelbaum raved: "*Nostalgia for the Light* is not only Guzmán's masterpiece; it is one of the most beautiful cinematographic efforts we have seen for a long time. Its complex canvas is woven with the greatest simplicity . . . the film becomes more than a film. An insane accolade to mankind, a stellar song for the dead, a life lesson. Silence and respect" (2010, n.p.). Culminating decades of making films about memory, time, and the role of the past in Chile's present, *Nostalgia for the Light* also merges Guzmán's two threads of filmmaking, situating his ongoing contemplation of memory in an exploration of outer space, something that, he remarks early on, has fascinated him since he was a child, and the vast and alien Atacama Desert, a salty six-hundred-mile (one-thousand-kilometer) plateau running along the Pacific Coast of Chile.[11] Devoid of humidity or plant and animal life, the Atacama is renowned for its "translucent" sky, which draws astronomers from all over the world to observe the stars, and for its ability to preserve pre-Columbian mummies, nineteenth-century

explorers and miners, and the remains of hundreds of political prisoners who were disappeared by the hand of the Chilean army after the military coup.

The film predominantly concentrates on three intersecting strands of humans working in the Atacama: the astronomers who research the stars, the archeologists studying the remnants of ancient human activity, and the women who search for the remains of loved ones murdered during Pinochet's dictatorship (1973–1990). The work of all three of these groups is anchored by the past—and the search for the meaning of the past via materiality—in different ways. Gaspar Galaz, the primary astronomer in the film, tells Guzmán that, in reality, the present does not exist—only the past. We do not see things in the moment in which we look at them because of the time it takes light to travel (even if it is a matter of millionths of seconds). Galaz continues, "The only present that might exist is the one I have in my mind. My conscience. It's the closest we come to the absolute present. And not even then! When I think, it takes a moment for the signal to travel between my senses. Between when I say 'this is me' and when I touch myself, there is a lapse in time. The past is the astronomer's main tool. We manipulate the past. We are used to living behind the times." The archeologists, tasked with the painstaking unearthing and preservation of ancient human remains, reflect on the paradox of searching out and preserving material remains of the distant past, when the most recent past—the crimes of the dictatorship period—have been so deliberately hidden in Chile. Meanwhile, the searching women walk, slowly, scanning the remote desert horizon, occasionally stopping to scrape away at the hard ground with their small shovels, or to slowly run the dirt through their hands, hoping to find bone shards, fabric, or some residual trace of their loved ones who were taken during the dictatorship and then disappeared, the locations of their bodies never disclosed.

The film's opening scene shows the enormous gears of a massive telescope slowly turning, shifting to point toward the sky as the roof above it slowly opens. The image shifts to beautiful black-and-white photographic stills of the moon's surface, accompanied by classical music. The moon's surface melds into a moving image of the shadows of leaves dancing softly in the breeze. In voice-over, Guzmán begins: "The old German telescope that I've seen once again, after so many years, is still working in Santiago de Chile . . . These objects, which could have come from my childhood home, remind me of that far off moment when one thinks one has left childhood behind. At that time, Chile was a haven of peace isolated from the world. Santiago slept . . . Only the present moment ex-

isted." The image, now of a vibrant green tree in the sun against a brightly colored wall, begins to be overlaid with what appears to be dust particles blowing across it, eventually looking more like a starry night sky. Guzmán continues: "One day this peaceful life came to an end. A revolutionary tide swept us to the center of the world. I was lucky to be a part of this noble venture that woke us all from our slumber. This time of hope is forever engraved in my soul. At around the same time, science fell in love with the Chilean sky. A group of astronomers thought they could touch the stars in the Atacama Desert." Now we are in a house, as the sun-dappled shadow of a tree, spread prettily across the wooden floor, sways in the wind. The house is full of older belongings, perhaps from the pre–coup d'état era. These images, too, are slowly superimposed in stardust. Guzmán goes on: "Some time later, a coup d'état swept away democracy, dreams, and science. Despite living in a field of ruins, Chilean astronomers carried on working, supported by their foreign colleagues." Dusty old artifacts are overlaid both with stardust and real dust, like a field of ruins, lost relics from an abandoned past. "One by one, the secrets of the sky began to fall on us, like translucent rain . . . The air, transparent, thin, allows us to read in this vast open book of memory, page after page."

As becomes immediately evident, the film is also anchored in material memory—the objects, images, shards of bone, and old drawings that signify lost people, places, times, and dreams. The house Guzmán begins the film with could be his childhood home in the 1970s, the possessions in it the things of his youth. Covered in starry dust, the house denotes the passing of time, blurring the past and the present together into the seemingly timeless vastness of the starry universe. Similar to the previous film, material memory is utilized as a historiographical memory mapping strategy intended to assess and reshape the role of the past and memory in present-day Chile. However, in this film, memory matter takes on deeper importance: it is the connective thread *between* and the raison d'être *of* all three groups of humans, and it affectively, temporally, and spatially anchors the film. The material objects—spoons, boots, jackets, abandoned buildings with prisoners' names scratched onto walls—are found in the vast desert that holds the bones of those whose bodies were forcibly entombed in unmarked desert graves. This more recent history rests uneasily below the stars and alongside the more ancient remains.

In one of the most powerful and recurring visuals in *Nostalgia for the Light*, weathered and weary mothers slowly walk, searching the desert, unable to find peace until the material remnants of the bodies of their missing loved ones are discovered (or disclosed, as the government has

Figure 3. Patricio Guzmán, *Nostalgia for the Light*, 2010.

refused to share any information as to their fates and posthumous where-abouts). The mothers are the primary group in the film, but the astrono-mers and archeologists provide important framing for the other ways in which people search for matter in the Atacama. These three groups map for viewers the different relationships between place, material matter, and the past that exist in the Atacama, and they highlight just how disinter-ested the government is in excavating its most recent past. The astrono-mers and archeologists have funding and facilities that support their work, while the mothers wander alone or in small groups through the immensely desolate landscape, sunburnt and windswept, carrying small shovels and peering at the ground, hoping to spot bone shards or disturbed ground that might indicate a previously undiscovered burial site.

There have been successes, though not nearly enough. During the shooting of the film, the body of a disappeared female prisoner was found in another part of the desert. A finger poked through the sand, and we see the body being disinterred, hands tied but not decomposed—someone's search is over. Another woman, Vicky Saavedra, shares the story of find-ing her brother. Guzmán asks, "What did you find of your brother, finally?" She reflects, "A foot. It was still in his shoe. Some of his teeth. I found part of his forehead, his nose. Nearly all of the left side of his skull. The bit behind the ear with a bullet mark." After detailing the forensic analysis of his death, she continues:

I remembered his tender expression, and this was all that remained. A few teeth and bits of bones. And a foot. It seems unbelievable that our final moment together was when his foot was at my house. When the mass grave was discovered, I knew it was his shoe and his foot. That night I got up and went to stroke his foot. There was . . . a smell of decay. It was still in a sock. A burgundy sock. Dark red. I took it out of the bag and looked at it. I remained sitting in the lounge for a long time. My mind was blank. I was incapable of thinking. I was in total shock. The next day, my husband went to work and I spent all morning with my brother's foot in my hand. We were reunited. It was a great joy and a great disappointment because only then did I take in the fact that my brother was dead.

These stories demonstrate that while the women who search the desert are now resigned to the probable death of their missing family members, the drive to discover the whereabouts of their bodies and the details surrounding their deaths continues, because, for them, resolution can only come with the finality afforded by death's materiality. Even as the truth is unknown, these objects—the bone shards, the shoe, and other things and pieces of things that appear at various moments in the film—testify to their existence, and to their absence. The desaparecidos remain disappeared, their stories unresolved. Finding and then reading the bones is the only hope for the women in the face of the military's ongoing refusal to tell the truth. Their walking is not a reenactment for the camera but rather an ongoing act of remembering that is documented and transmitted to a wider audience via the film. The repetitive nature of their bodily actions inscribes and reinscribes the desert as a mass grave, of which the surface has only just been scratched. The very presence of the mothers' bodies reminds us of the ongoing absence of other bodies and pasts that have yet to be reckoned with.

Besides bones, other remnants of the recent past wait to be found in the desert. An old, abandoned cemetery with worn wooden crosses appears oddly out of place in a landscape that is so wholly uninhabitable. Beyond the cemetery, in the midst of the vast emptiness, are the ruins of Chacabuco, the largest concentration camp of Pinochet's dictatorship. The military repurposed an old mining camp from the days when the mining industry in Chile was akin to slavery; thus, there was no need to build a concentration camp. Instead, the military simply added barbed wire and planted landmines in the surrounding area to deter escape attempts (Gómez-Barris 2010a, 2). The houses of the nineteenth-century miners became cells, and prisoners lived for months and years in the old, abandoned

Figure 4. Patricio Guzmán, *Nostalgia for the Light*, 2010.

town. The walls are crumbling, and peeling paint makes it so that the words scratched into them cannot easily be read. We can barely make out, "In this house lived the following political prisoners . . ." followed by an illegible list of names that sprawls down toward the floor. Abandoned shoes, dusty light bulbs gently swaying, sandy boxes of empty bottles, hanging shirts and spoons . . . these objects together now form a haunted sort of wind chime as they shift against each other in the desert breeze. They are the material remnants of the individuals who once occupied that space, no longer present to testify to their experience.

Although shoes, spoons, and bottles are quite different from the bodies and bones the women seek, the memory matter functions much the same: it activates memory and testifies to past events. It articulates the desert and these abandoned spaces as landscapes haunted by past violence and the ghosts of those whose bodies remain missing. For those looking to keep memory alive, or to find points of memory in a changing world, material memory thus becomes especially important. These objects connect us with the people who used them in a different time and also bring that past into the present. In their writing on testimonial objects found and preserved after the Holocaust, Marianne Hirsch and Leo Spitzer reflect: "Testimonial objects enable us to consider crucial questions about the past, [and] about how the past comes down to us in the present . . ." These objects "carry memory traces from the past and embody the process of its transmission" (2006, 353). In the case of the objects in *Nostalgia for the Light*,

the objects found are relatively anonymous—they are not photo albums from someone's own grandparents or other personal objects, and there is no way to know which individual used what object, since they were collectively stored and then collectively left. The names scratched on the walls of the prison are individual names, but, again, the name exists on a wall that encircled many prisoners and was not the sole possession of any *one* person. These memory objects, then, take on a slightly different characteristic than many (but certainly not all) of those studied by Hirsch and Spitzer, because they are not personal but rather collective memory objects. They are memory objects that, until now, have remained by and large forgotten or unknown, their memory significance unseen and unheard until Guzmán anchors them within a memory map that draws explicit connections between past and present, and bodies, objects, and places.

By continually homing in on diverse material remains, Guzmán again asks them to call forth the past. This is the unique ability of memory matter: these different objects, abandoned buildings, and old prisoner-sketched maps together create a dialogical space that illuminates hidden pasts and lost memories, a process that helps them shape and resituate memory and the past in the present. Mapping memory in this manner, the film reconfigures Chacabuco as not merely an old, abandoned site but as a place replete with memory and hidden affects. Memory objects become the evidence for the missing—the proof that they *were* there and that this history *did* happen. In this light, the women's search for the missing memory matter becomes all the more poignant because of what is at stake: the story of a human life. The memory objects are proxies for humans, but they are also just that: proxies. The uncertainty and silence continue unabated in the absence of concrete knowledge. The emptiness of the desert, full of hidden bones and lost objects, becomes a metaphor for Chile's memoryscape. We are reminded anew of Chile's eagerness to look for the ancient past and up into the stars, as well as its refusal to address the stories of the recent past. As one woman remarks, "I wish the telescopes didn't just look into the sky but could also see through the earth so that we could find them . . . We would sweep the desert with a telescope, looking down, and give thanks to the stars for helping us find them." She pauses then states softly, "I'm just dreaming."

It would seem this is Guzmán's dream as well, since his focus on the presence of material remains in the form of old objects and walls emphasizes the absence of human bodies—bodies that might be in the desert but cannot be found, seemingly just out of reach. In this context, the material objects serve to call forth those humans, to speak in their absence. Material

memory objects open up a door to the past and lend a certain liveness to the people who used them so many years ago. It is to say that their bodies *could* and *deserve* to be found. Obviously different from official efforts to leave the past in the past (as communicated through the military's unwillingness to reveal the whereabouts of the graves), Guzmán's counterapproach places the present and absent memories in conversation, merging the memories of survivors with the desperate desire to discover what happened to the missing humans. In so doing, Guzmán creates a larger memory narrative that strongly marks the presence of the disappeared, even as time passes and the numbers of those who search diminish, presenting the possibility that eventually no one will look anymore. Ultimately, by drawing links between those lost humans and those who search for them today, memory mapping serves as a means with which to highlight the unatoned-for crimes of the past and their ongoing impact in the present day. Made accessible through the visual lens of the camera and legible through Guzmán's memory mapping, memory objects and reenactment are galvanized to foster dialogical public memory about the crimes of the dictatorship.

The unrelenting emphasis Guzmán has placed on memory in his many films over the years seems grounded in a belief that a country without memory is broken, unable to heal, and unable to move forward, and that memory is an essential foundation out of which individual and cultural identities stem. And yet, memory is often highly politicized or forcibly suppressed, with one version of history privileged over another. Many of those stories and experiences that shape and give meaning to people's lives go unrecognized and ignored. At the end of *Nostalgia for the Light*, Guzmán reflects: "Those who have memory live in the fragile present. Those who have none don't live anywhere." This is the underlying moral to his tale: memory is an essential component of individual, collective, and national identity; it needs to be honored and brought into the light. Apathy, silences, and refusals to disclose the whereabouts of the missing continue to negatively impact the country, decades after the dictatorship ended. This belief in the importance of memory and in the search for the truth also links the three groups of humans. The astronomers search for the past vis-à-vis materiality in the sky, and the others search on the ground. Gaspar Galaz, the main astronomer, sums up his work as the search for: "Where do we come from, where are we, and where are we going?" Meanwhile, the archeologist reflects that they all converge in the Atacama because the translucency of the sky and the dry climate facilitate access to evidence from the past, and yet the tragedy is that the *recent* past remains completely hid-

den. He reflects, "If my son had been executed during any dictatorship, no matter who I was, my education or my beliefs, I would be morally obliged to preserve his memory. I would never be able to forget. We cannot forget our dead. We must keep them in our memory." When asked what he thinks of the women who sift through the desert for the material remains of their loved ones, the astronomer Galaz responds that trying to find someone in the desert is like looking for someone in the galaxies. Impossible. He reflects, "To compare completely different things, their process is similar to ours, with one big difference. We can sleep peacefully after each night spent observing the past. Our search doesn't disturb our sleep . . . The next day, we plunge back, untroubled, into the past. But these women must find it hard to sleep after searching through human remains looking for a past they are unable to find. They'll not sleep well until they do . . . People say, 'It's in the past, enough is enough!' That's easy to say. Until they find their loved ones, they'll never find peace."

With the passing of time, these mothers will eventually grow too old to continue searching the desert, but the evidence of the government's crimes will still be there, embedded in the landscape as hidden testimonial markers to the unmet demand for redress. When contextualized through memory mapping, and interwoven with stories, events, and embodied practices, materiality is revealed as haunted, affectively embedded with lost humans, dreams, and potential futures that passed without coming to fruition. The landscape becomes legible as a landscape of loss. Memory, invisible and silenced for so long, feels not just pervasive but an essential key to understanding the present.

Through their respective explorations of contemporary memory and human rights politics, *Chile, Obstinate Memory* and *Nostalgia for the Light* testify to how the unaddressed and unresolved crimes of the past continue to have a palpably detrimental impact, even as the search for truth continues. Analyzed side by side, both films demonstrate the powerful role that material and embodied memory play in the production of cultural memory and human rights claims. The diverse memory mapping strategies Guzmán employs—the embodied performativity of memory matter, the performative reenactments, the interviews, and the various places and landscapes—all work toward rendering memory visible and audible, and in turn using that memory to rupture the postdictatorship public sphere. Memory matter becomes proxy for, and evidence of, the missing; it becomes affectively embedded with memories and totemic of the ongoing need for redress. Reenactments also serve to call forth those ghosts; they invoke a

sense of temporal rupture, reminding us of those pasts and of their ongoing presence. Together, they map memory onto, through, and between landscapes, objects, and bodies to articulate for viewers how the physical and affective violences from the dictatorship period continue to impact and shape present-day Chile now decades after the transition.

Guzmán's films study memory and the passing of time; yet, by focusing on the materiality of the historical event, they work to create new intersections among time, space, and matter. As Jacques Rancière proposes, "The dream of a suitable political work of art is in fact the dream of disrupting the relationship between the visible, the sayable, and the thinkable . . . It is the dream of an art that would transmit meanings in the form of a rupture with the very logic of meaningful situations" (2004, 63). By bringing people into experiential and meaningful contact with the past via diverse engagement with material memory (be it film footage, photographs, or old bone shards) and by making them feel a part of it (or, perhaps more precisely, it a part of them), Guzmán's films are, in effect, historiographical memory mapping projects that function as a mode of thinking, seeing, and touching the past. Though they go about this in different ways, each informed by the memory politics of the respective times of their creation and focused on distinct aspects of cultural memory, both films directly condemn the silences and absences in the official narratives of national history and work to bring into the light unresolved crimes and marginalized narratives.

Ultimately, memory mapping provides a conceptual lens through which to ask what it means to live among the ruins of history. What becomes of those lost dreams? How does memory persist in the present through bodies, quotidian practices, and the mnemonic potency of physical objects and spaces? How is memory felt and represented? Can memory function as political intervention? Exploring how certain visual texts work performatively to create a kind of thick memory map of the affective, dialectical resonances between bodies, objects, places, and the ongoing impact of the past in the present enables us to start to address these questions.

The Tiniest Place documents the everyday lives of the residents of a small, remote village deep in the Salvadoran mountains. The delicate interlacing of aural testimony with the visual depiction of the everyday lives of the survivors living in a beautiful but haunted landscape presents the viewer with an intimate view of the individual and collective struggle to physically, emotionally, and psychologically rebuild after mass violence. The film is a powerful contemplation on the meaning of survival. Whereas in *The Tiniest Place*, the role of cultural memory is undisputed, in *Chile, Ob-*

stinate Memory, because of the cultural silences in the public sphere and the fact that many of the sites of horrible atrocity have been repurposed for quotidian activities (e.g., the stadium), Guzmán's task is somewhat different: it is memory mapping as excavation, digging down beneath the accumulated layer of what looks like progress in order to find memory and bring it to the surface. *Nostalgia for the Light* is a reflection on the search for the past in the present, decades after a dictatorship that has ended but continues to scar, even as the passing of time carries it ever further into history, and thus it explores how memory, forgetting, trauma, and loss move with the living through time, and what strategies might be employed to make visible both memory and the gaps and silences where the truth is still unknown.

Ultimately, as Guzmán's films illustrate, there is immense historiographical value in bringing individual memory, matter (including physical space), and official histories into contact and conversation with one another. If official histories, by definition, sublimate and attempt to make transgressive or previously suppressed memories disappear, then the critical role of the artist as historiographer is to investigate the ways in which transgressive memory persists, whether through lived experience, stories passed down through generations, or the mnemonic potency of bodies, objects, and spaces. As they work to narrate places and produce new temporal and spatial arrangements of knowledge, memory, and meaning, memory mapping projects such as these challenge scholars and artists alike not merely to investigate but to question what happens when material memory and embodied memory are made visible and audible enough to trouble official histories and point out the damage wrought by ongoing indifference. What new communities of memory might be created? What new political possibilities might emerge? Guzmán's films demonstrate the malleability of history, the ease with which memory becomes irrelevant, and the historiographical value in bringing layers of audiences into contact with memory, be it through old films, photographs, reenactments, bone shards and other objects, old ruins, city streets, or reperformed corporeal gestures. Memory mapping, as a historiographical project, is about documenting the multiplicity of our pasts and their ongoing impact on the present, and it is also about laying the foundation for alternate futures in which silence is fought against, a multiplicity of memory narratives is represented and valued in the public sphere, and truth is considered a foundation upon which democracy is built. For until then, as Guzmán's films so devastatingly show, even the dead will not be safe.

Performing Archives, Performing Ruins

June 23, 2014. 1:30 P.M. Hexagram Black Box Theater, Concordia University. The audience entered the darkened room and filed up onto folding chairs arranged on risers toward the back of the room. Directly in front of the risers was a small, softly lit desk. A large-scale projector screen stretched across the opposite wall. Once everyone was seated, Julio Pantoja, a prominent and respected Argentine photographer, walked across the room, sat down at the desk, and opened a laptop computer.[1] The laptop screen was projected onto the screen on the far wall, and the audience watched as Pantoja moved the mouse to scroll through his Mac sidebar, clicked on iTunes, selected the soundtrack, and moved the mouse again to open up an extensive collection of photos in Adobe Bridge. As soft acoustic guitar filled the room, a slideshow began to pass across the screen.[2] The first slide stated:

> *The sixth trial for crimes against humanity in the province of Tucumán was held between November 12, 2012, and December 13, 2013. As the trial progressed, the events that had taken place at two clandestine detention centers (the Police Headquarters and the Miguel de Azcuénaga Arsenal) were*

brought to light. Entire families were disappeared, including pregnant women, elderly, politicians, workers, students, youth, police, teachers, activists, workers.

This slide was followed by a second, which listed:

13-month trial
215 victims
7 victims identified in graves and dozens who remain unidentified
41 charged
400 oral testimonies
400 written testimonies
100,000 pages
150 CONADEP files
37 years of waiting
30,000 detained/disappeared comrades present!!!![3]

The remainder of *Tucumán Kills Me, Action #2* (*Tucumán Me Mata, Acción #2*) unfolded in a loose chronology of historical events, beginning with the juxtaposition of images of the disappeared, their names listed in bold alongside the word *Presente!*, and an array of black-and-white archival images of political protests, people being pulled off the streets, military marches, and staged photographs of military handshakes and salutes.[4] The majority of the photographs were taken by Pantoja, although he also integrated historical photographs from various archives, including local newspapers and the archives of Las Madres de la Plaza de Mayo and Las Madres de Tucumán.[5] These images clearly depicted the unrest in Argentina during the early half of the 1970s in the lead-up to the military coup d'état as well as the oppressive, violent military dictatorship that followed. As the slideshow progressed forward in time, so too did the images, proceeding past archival images of Las Madres de la Plaza de Mayo and massive street protests to documentation of the more recent Tucumán trials and the related disinterment of a mass grave. Toward the end of the performance, Pantoja opened Photoshop and merged the image of the mass grave with a photograph of a forest. He slowly and deliberately erased until all that remained was the forest. No longer visible, the bones—the dead— became just a memory.

In previous chapters, I analyze memory mapping in photography and documentary film. In this chapter, I investigate new intersections between visuality and performance and expand the conceptual frame of memory mapping through analysis of live performance and physical memory sites.

I examine Pantoja's "visual performance" (as he calls it), *Tucumán Kills Me*, alongside three other Argentine memory projects: ESMA (Escuela Superior de Mecánica de la Armada / High School for Mechanics of the Navy), the concentration camp turned memory site in Buenos Aires; the renowned Memory Park (Parque de la Memoria), just a short distance from ESMA; and the national Museum of Memory in Rosario, a city roughly 185 miles from Buenos Aires). These projects are quite different from each other in obvious ways, yet they all work to visually map the relationship between memory and place in order to create narrative constellations that capture the ongoing legacies of the past in the present. This chapter is framed around the following questions: How does memory mapping function across performance and a range of memory sites? How do photographs map memory in live performance contexts? What makes a memory site? In the context of both performance and place, what are the ways in which visuality works to affectively impact viewers and induce concern for justice?

Visibility and Terror

While March 24, 1976, marks the beginning of the Dirty War in Argentina, it is more difficult to precisely pinpoint when the portending turmoil began. The story could be said to have begun with ex-president Juan Perón's return to Argentina from exile in 1973, or his overthrow in 1955, or, even earlier, on October 17, 1945, which was the day of a massive labor demonstration in Buenos Aires to demand the liberation of Juan Perón, jailed by the military government on Martín García Island (this day is also considered the foundation day of the Peronist political movement in Argentina) (Robben 2005, xi).[6] In some respects, the foundations for undemocratic regime change were set even earlier, as Argentina has a lengthy history of coup d'états, having endured six in the twentieth century: in 1930, 1943, 1955, 1962, 1966, and 1976. Furthermore, in the years leading up to the Dirty War, there were a series of internal coups, as infighting between military factions led to a succession of military dictatorships: Juan Carlos Onganía (1966–1970), Marcelo Levinston (1970–1971), and Alejandro Agustín Lanusse (1971–1973). As a result, the early 1970s in Argentina was a period of political unrest and protest. Confronted with growing civil discontent, the military government agreed to hold elections in 1973. Although they allowed Peronist parties to participate, Juan Perón himself was banned. The Peronist candidate, Héctor Campora, won with just less than 50 percent of the vote, only to then resign after assuming power in

order to allow free elections to take place. Juan Perón returned from exile and won with 62 percent of the vote.

Increasingly sharp divisions between right- and left-wing factions in the Peronist party marked Perón's third term. Some of the more radical left-wing blocs, such as the Montoneros, became markedly violent, eventually ostracizing themselves from much of the general populace as they fought against what they considered political fascism. Although Perón was widely considered a supporter of the Left and the working class in Argentina, he turned on the Left during this period, authorizing progressively violent responses, including the formation of death squads whose main purpose was to murder left-wing opponents. Argentina experienced another seismic political shift when Perón died of a heart attack at the age of seventy-eight, less than a year after being elected. Upon his death, his third wife, Isabel Perón, assumed power. Easily manipulated, she was largely incapable of managing either the sociopolitical crises or the increasingly dominant military. She was ousted during the military coup d'état of March 24, 1976, and replaced with a military junta composed of three leaders: General Jorge Rafael Videla, Admiral Emilio Eduardo Massera, and Brigadier-General Orlando Ramón Agosti. This junta would go on to remain in power until the end of the dictatorship on December 10, 1983.

This last coup ushered in a period of extreme and unprecedented violence. In his in-depth analysis of the Dirty War, Antonius Robben outlines how the Argentine military was so focused on domination that they were willing to cross legal and moral boundaries in a manner never before experienced in Argentina (2005, 167–171). The military did not, in fact, require a coup to defeat the left-wing "urban guerrilla" groups, because they had already been granted sweeping power in order to do so under the auspices of Operation Independence. (Operation Independence was implemented in the Tucumán province under Decree 261 in February 1975 and gave the military unlimited operating powers; five months later, it was extended to cover the entire country.) However, the coup granted them absolute political control and a level of extreme oppression that was not possible under democratic rule. After the coup, the military suspended all air, sea, and river transport, seized factories, closed schools and universities, and censured the media. Congress, provincial legislatures, and the Supreme Court were dissolved, and political parties, labor unions, and employers' organizations were all forcibly suspended. People were not allowed to congregate in public, and a midnight curfew was put in place. Any violent acts against the armed forces were instantly punishable by death (176–177).

Under El Proceso (the Process of National Reorganization was a strategy intended to root out leftists that ultimately became one of the defining aspects of the Dirty War), the military went to extreme lengths to gather intelligence about social networks and take control of major unions, including interrogations that routinely incorporated horrific physical and mental torture. As a result, the military gained access to lists of workers' names with work and home addresses, and hundreds of union leaders and activists were detained and abducted in the dictatorship's early days. The military also reviewed voter registration records of the 1975 Peronist party (el Partido Peronista Auténtico was known to have included Montoneros) and analyzed photographs of protests in order to identify protesters. They combed through detainees' address books to find more victims. With the goal of catching other potential collaborators, they often attempted to abduct someone on their birthday, when it was likely their friends would be over to celebrate.

By late 1975, military intelligence had gained access to the names and addresses of more than forty thousand supporters of the Montonero party. People were dragged off the street in broad daylight and from homes, classrooms, restaurants, and movie theaters. The Ford Falcon, the car used by the military in these excursions, became synonymous with disappearance and death. Montoneros were hunted down in the street and shot from the back of pickup trucks. The report of the Argentine truth commission, CONADEP (la Comisión Nacional Sobre la Desaparación de Personas), calculated that of all the reported disappearances, 30.2 percent were blue-collar and 17.9 percent white-collar workers. Artists and academics were especially at risk because they were seen to encourage new ways of thinking and in turn could potentially be seeking to change society. Of those disappeared, 62 percent were taken from their homes, 24.6 percent off the street, and 7 percent were taken from work (Hayner 2000). This created what Diana Taylor has described as a culture of fear in which "people dared not be caught seeing, be seen pretending not to see . . . The triumph of the atrocity was that it forced people to look away—a gesture that undid their sense of personal and communal cohesion even as it seemed to bracket them from their volatile surroundings. Spectacles of violence rendered the population silent, deaf, and blind" (1997, 122).

The vast majority of those seized by the military were never seen again. The military deliberately destroyed incriminating evidence during the disappearances; it was exceedingly difficult to trace someone who had been abducted by men in disguise, in unmarked cars, to unknown destinations;

and authorities almost always denied having them in custody. Bodies were usually cremated, buried in mass graves, or dropped from airplanes. Escape was extremely uncommon. Those who were released, often after weeks of interrogation, spoke of horrific torture and abuse.

The exercise of extreme terror and violence served multiple purposes: it functioned as sadistic punishment (even and often when no crime was committed), as a means of interrogation for the military to extract information, and, perhaps most importantly, as reinforcement of the regime's performance of supreme power. In *The Body in Pain*, Elaine Scarry suggests that violence is often used as a means of sustaining the identity of a regime, noting that in periods of sociopolitical crisis "the sheer material factualness of the human body will be borrowed to lend that cultural construct the aura of 'realness' and 'certainty'" (1985, 14). In dialogue with Scarry, Taylor contends that with such violence the role of the spectator is also of central importance. She describes how terror works to destroy both the victim and multiple generations of their families, as in cases in which children are forced to watch the torture of their parents. Taylor argues, "Terrorism and torture are not designed to prove to the *victims* that the regime has the power to exterminate them—such proof is manifested in the violent act itself. The aim of terrorism and torture is to prove to the population at large that the regime has the power to control it" (1997, 129–130). As such, torture's "audience" is localized, but it also extends to those perceiving it from a distance. In Argentina, the deleterious effects of the regime of violence and terror impacted the entire society. In *The Culture of Pain*, David Morris argues that pain is always historical, shaped by the specificities of time, place, culture, and individual psyche (1991, 6). I would also argue that pain has the potential to function as a universally recognizable language across bodies, geographies, and temporalities; nonetheless, it is abundantly clear that certain places and times can be come to be characterized by specific dominating cultures of pain. During the Dirty War in Argentina, the pervasive atmosphere of surveillance and terror as well as the foreboding threat of severe violence and pain heavily impacted Argentine society. And even though the Montoneros were all but decimated by 1978, the violent tactics of the military continued in the service of other, broader cultural objectives of oppression, fear, and the preservation of supreme power.[7]

A number of artistic and public forms of resistance developed in response to the military's violence, including the renowned Madres de la Plaza de Mayo. The mothers' efforts to find their missing children, and

their bravery and insistence on the truth even in the face of violence, were profoundly influential in raising international awareness and stimulating public protest against the gross human rights violations.[8] The group survived military infiltration and the disappearance and death of eight members, including their leader, Azucena Villaflor De Vincenti, along with the deaths of three men and three French nuns who had all been helping the Madres with their protests. And yet, the mothers found safety in numbers, which grew as more and more mothers joined them in the streets. As public protest mounted, so did international attention. The combination of human rights protests, increasing international condemnation, a disastrously mismanaged economy, and the unexpected loss of the Malvinas Islands to Britain led to the fall of the dictatorship in 1983.[9]

Raúl Ricardo Alfonsín was democratically elected to the presidency on December 10, 1983, and five days later initiated the National Commission on Disappeared Persons, CONADEP.[10] On July 4, 1984, CONADEP's preliminary findings were broadcast to the Argentine people in a widely viewed TV documentary entitled *Nunca Más* (Never Again).[11] Two and a half months after the broadcast, seventy thousand members of the public accompanied the commissioners to submit the final report to the president. A shorter, book-length version of the report was also released and became an immediate best seller: 40,000 copies sold on the first day, 150,000 copies sold in the first eight weeks, and, by 2007, it had sold more than 500,000 copies and been reprinted well over twenty times, making it one of the best-selling books in Argentina's history (Hayner 2011, 46). The commission gave its files to the state prosecutor's office, and the amnesty the military regime had granted itself prior to leaving office was swiftly repealed. The information collected by the commission was critical in the trials of senior junta members, and it ultimately led to the successful conviction and incarceration of five generals. However, under threat from the military, further trials were prevented, and those who had already been convicted were pardoned by incoming president Carlos Menem in 1989 (46). Nonetheless, in the twenty-five years since the military regime ended, efforts to obtain justice have continued; as of August 2014, 1,611 suspects had either been charged or were under formal investigation, and 121 trials had been conducted for crimes against humanity, resulting in 503 convictions and 42 acquittals (Human Rights Watch, n.d.).

Much attention has been paid to the military trials of the mid-1980s, when the members of the de facto military government of the dictatorship were put on trial, and for good reason. The 1985 trial is so far the only example in Latin America of a major trial held by a democratic re-

gime against a former dictatorial government of the same country, and it was the first major trial for war crimes since the Nuremberg Trials in Germany after World War II. Although the trials in Tucumán took place on a regional scale, it is nonetheless somewhat surprising that they have not received more attention, considering the prominent role Tucumán played both during and before the dictatorship: San Miguel de Tucumán, the capital of Tucumán province and in the far northwest of the country, is considered the birthplace of the Argentine nation. It has also historically been a key site of struggle, including in labor protests and fighting in the 1950s and 1960s. Argentina's first guerrilla force arose in Tucumán in 1959; ten years later, the PRT (Partido Revolucionario de los Trabajadores/ Workers Revolutionary Party) started a rural insurgency in Tucumán; and, over the years, many small groups of guerrilla fighters developed holds in the hills surrounding Tucumán. Much of the early fighting that led up to the dictatorship took place in Tucumán, and, as I wrote earlier, it was there in February 1975 that Operation Independence was implemented, giving the military unlimited powers to fight insurgents. In late 1974, as part of the upcoming Operation Independence, the first secret detention center was also established in Tucumán (Robben 2005, 244). Consequently, Tucumán is not just the birthplace of the nation but, in certain respects, also the Dirty War, and thus the trials in Tucumán are both politically and symbolically quite significant. The trials, which ended in December 2013 after thirteen months and four hundred witness testimonies, found thirty-seven of the forty-one defendants guilty of crimes against humanity during the dictatorship. *Tucumán Kills Me, Action #2* both documents these trials and frames them in their historical continuity.

Tucumán Kills Me, Action #2

As previously described, the early part of the visual performance is composed of archival black-and-white photographs of violence and protest— of Las Madres marching in their identifying white headscarves and crowds of protesters who visibly become increasingly brave and resolute as time passes and the marches grow in size (the quality of the images also improves as the slideshow advances toward the present day). After roughly five minutes (and dozens and dozens of images), the photographs shift from protest to show a room full of empty seats. A picture of a disappeared person rests upon each chair, with the word "*Presente*" in bold across the top of every image and their name below. These are followed by photographs of another room, again with chairs and photographs,

although now with a cluster of military men gathered in the back of the room. As the photos advance, it becomes evident that these images document present-day military trials, as the images are in color, the accused men are now wrinkled and gray, the mothers are older, and the style of clothing worn by crowd members reflects the contemporary time period. It is unmistakably a big event, with a politically split crowd. Interspersed with the surviving family members of the missing are those holding up signs with phrases such as "Héroes, Viva la Patria" (Heroes, Long live the Homeland), "Abuelito te amamos" (Grandfather, we love you), "Fuerza Abuelos" (Have strength, grandfathers), and "Oremos a María por la Libertad del Padre José Eloy Mijalchyk" (We pray to María for the Freedom of Father José Eloy Mijalchyk).[12] As the accused men take the stand, they seem to respond to the trials with varying degrees of seriousness (one man looks dressed for golf, wearing khaki pants and a short-sleeve shirt with a sweater tied around his neck). At times, the audience is comprised mostly of mothers wearing white headscarves and holding images of the missing; in other images, the room appears packed with survivors. Official-looking white men in suits and military men also stand around the room, alternatingly in standard green or full riot gear, with bulletproof vests and helmets. The seeming nonchalance of the accused stands in marked contrast to the rest of the room, where emotions run high. Even some of the guards appear worked up at times, caught up in the emotions of trial.

The power of *Tucumán Kills Me* comes not from a single image, although many of the images are quite powerful, but rather from the way they work together. Drawing loosely from Julia Kristeva's notion of intertextuality, in which texts operate at the intersection of two axes (a horizontal axis connecting the author and reader, and a vertical axis linking the text to other texts [1980, 69]), both the relationship between artist and audience and the single image in relation to other images are significant here. The meaning of these images originates not just in any single image but in the meaning derived from their collective framing in, and as, a performance in front of an audience. While the layers of information in the images require that the audience possess some background knowledge in order to be fully understood in all their complexity (e.g., that Las Madres can be identified by the white handkerchiefs they wore on their heads), they are presented in a highly coherent chronological narrative that nonetheless renders them quite legible. As a result, even though a viewer might not know the specific details of the Dirty War in Tucumán, the overall message of the piece is quite clear. But, perhaps even more importantly for my purposes here,

Figure 5. Julio Pantoja, *Tucumán Kills Me*, 2014.

Figure 6. Julio Pantoja, *Tucumán Kills Me*, 2014.

when presented in and as performance, these images take on new and more complex meaning far greater than the possibilities of a single image or the more typical gallery space exhibition of photographs.

Many of these historical images exist in other archives, or have circulated in other ways, but *this* particular performative visual archive is unique insofar as it creates a new collection from an amalgam of new and old

photographs. This combination of both historical and contemporary images enables Pantoja to emphasize the affective relationship between the two time periods, the disappeared, the survivors, and the trials; it results in a much richer mode of representation of the trial and its meaning: when experienced as a coherent visual progression, the images convey a strong message about the ongoing significance of past events, the long arc of justice, and the importance of witnessing. The visual performance situates the Tucumán trials in a historical continuity, successfully articulating a coherent relationship between past events and current politics of memory and justice, specifically grounded in Tucumán.

Tucumán Kills Me creates a sense of time passing—the diurnal progression of the trial and people showing up day after day to witness and hold perpetrators accountable. As the pictures continue to transition quickly from one to the next, each image rests on the screen not more than a second, building on each other to tell a story that exceeds the signified frame of an individual photograph. While this slow snowballing of imagery gives the performance its power, the performance initially seems almost visually ordinary. After all, the images of the protests and the disappeared have been circulating publicly for decades; while striking, there is nothing new about them for the educated viewer. Gradually, though, *Tucumán Kills Me* creates a viewing environment that differs from what is afforded by images presented in an exhibition space; in a gallery, spectators can wander, choosing how to long to spend with each image, which to ignore, and the order in which they are ultimately seen. *Tucumán Kills Me*'s audience, conversely, neither controls what they see nor how long they see it for. Short of standing up and walking out, the audience is in the artist's hands and the technology of image circulation that results from Pantoja's performance.

Although the piece depends on digital technology as the medium of communication (including Pantoja's computer and the programs he uses: PowerPoint, Photoshop, and iTunes), this performance is arguably much more about technologies of liveness, because it is entirely about the relationship between seeing and being seen, and about bodies—the audience members', the artist's, and the bodies in and of the images themselves. The repetition of the word "Presente!" in the slides of the disappeared conjures the dead, insisting that they are present, even in their absence. *Tucumán Kills Me* both renders their absence visible and directly links their absences to the accused, who are in turn identified by, and in, the images not as a faceless, systemic enemy (a generic "armed forces") but rather as specific individuals who have committed specific crimes against humanity. While

the disappeared cannot attend the trial in corporeal form, the embodied knowledges of the crimes committed against them are embedded in the photographs. The juxtaposition of the live body of the artist and the wizened bodies of survivors and perpetrators magnify the absent bodies, manifested instead in flickering, ghost-like photographic form. A relational, bodily constellation is formed between the bodies present in the images, the artist, and the audience members who witness.

The insertion of the body of the maker in *Tucumán Kills Me* is unusual, all the more so for photography. Pantoja did not have to be there. Someone else could have done it, or he could have sat out of sight or off to the side. He could also have chosen not to show the process of opening up the files on his computer. In other words, he could have been invisible—as, in fact, photographers usually are in relation to their images. In most cases, photographs do not rely on their maker for meaning but rather on the subject they capture. A performer's primary function, conversely, is to be seen. Pantoja later explained that he chose to position his body facing the images in order to mimic, or performatively reenact, his relationship to his images. In turn, the spectator is positioned behind the artist, thereby including the artist in our spectatorial gaze. We observe his relationship to the images, but we also are framed in the same relationship to the images as he is and framed in relationship with *him*. Thus, the audience's relationship to the images is layered—they have a visual relationship with the images, the performance, and the artist as performer. Through the performance, the audience is witness to Pantoja's experience, and we accompany him on his journey of remembering.

Through the deliberate insertion of his body into the piece, the photographer-performer's body becomes a technology of performance alongside the digital technology he controls, rendering the performance deliberately and explicitly about the process of making, the role of the maker, and the relationship between the maker, what they make, and those who watch. As a result, this technology-based performance was unexpectedly, but wholly, defined by liveness. For the piece to succeed, the audience had to be there to see, and the artist had to be there in order for the images to be seen—this completed the piece: the trinity of audience, artist, and images. Each was essential; all had to be "Presente!"

Roughly eighteen and a half minutes into the performance, the photographs shifted to focus on a dilapidated and abandoned brick building. It became evident that this building was a detention center, used during the dictatorship to hold, torture, and murder people. Shown in the present day, the building is surrounded by holes dug into the ground, suggesting the

Figure 7. Julio Pantoja, *Tucumán Kills Me*, 2014.

exhumation of graves. The photographs depict elderly survivors walking down the center of the building, peering to each side as though to imagine those lost here and what they had endured during their final living hours. The slideshow then transitioned to the exhumation site of a large mass grave. Easily visible in the image were at least thirteen identified skeletons, the red dirt brushed away from them so cleanly and carefully that they were strangely and strikingly beautiful.

At this point, the rapid shifting of images ceased, and we paused on this mass grave image for almost a minute (see Figure 7). For the first time in twenty minutes, Pantoja reentered the performance. As the audience watched, Pantoja clicked back to Adobe Photoshop. An image of a small white bench against a verdant green backdrop of tall trees and lush ground-cover appeared on the screen. Pantoja clicked back to the image of the partially exhumed mass grave and, with the eraser tool, started to slowly brush back and forth over the image of the mass grave so that the trees and the bench began to faintly appear in the now-doubled image. Gradu-ally, the two images became one—a ghostly blend of trees, sky, soil, and skeletons, with the small white bench facing us all the while.

Figure 8. Julio Pantoja, *Tucumán Kills Me*, 2014.

As Pantoja erased, the green trees became more and more prominent, until the skeletons were barely visible, with only the bright-blue tags marking each body to differentiate them from the landscape. The faint presence of the red soil remained, until it too gradually faded. All that remained visible to the audience were the trees and the bench sheltered beneath them. Pantoja then opened up a text box and typed in:

> *Memory Forest, Tucumán 2014.*
> *We do not forget. We do not forgive.*
> *30,000 comrades detained and disappeared.*
> *Presentes!!!!!!!!!!!*

The piece ended. It was minute twenty-seven.[13]

By ending the performance with the slow erasure of the mass grave into the forest—and not just any forest but specifically the memory forest in Tucumán, the performance asks the viewer to reflect on how memory and past trauma, whether visible or hidden, form a part of both the literal and cultural landscape. The landscape in the photograph is in fact a memory forest that was created in 1996, when the Permanent Assembly for Human

Rights, in collaboration with the Madres of the Plaza de Mayo, received permission to develop the forest on a biological reserve owned by the university. Each family of the disappeared was given the opportunity to plant a tree for their missing loved ones. In *Tucumán Kills Me*, the forest thus serves as a powerful visual and place-based metaphor for how memory persists, even as it grows and changes with time. And yet, the visual performance is left open to multiple readings. Is it a commentary on the gradual erasure of memory as time inexorably marches into the future? Or, is memory always present, deeply embedded in the landscape in ways that are both visible and beyond the scope of vision? Does memory grow and change with time, essentially connected to place, bodies, and everyday practices and rituals of remembering? What is to become of memory? Ultimately, these are the questions the audience is left to ponder.

Mapping memory in this manner, Pantoja articulates clear connections between the past and the present, connections that are firmly anchored to place. Through the creation of a visual-performative modality, he redistributes the visual, giving the images new life and new context in relation to audiences and contemporary events. The trials are situated as one point within a much thicker memory mapping of the interrelations between time, landscapes, bodies, affects, and trauma. Already a memory landscape, the forest is made accessible to viewers through the performance and situated within Pantoja's broader map of memory. Like the bones in *Esclarecimiento*, the skeletons in the mass graves remind audiences of all those who were lost, and the corollary and ongoing need for justice in the present. These narrative constellations allow audiences to understand the ongoing impact of the past in meaningful ways. Mapping memory through a combination of archival and contemporary images presented as performance, *Tucumán Kills Me* draws connections between the hidden, embedded knowledges in both landscapes and images, and invokes audiences as witnesses to Pantoja's remembering and, in turn, to the past itself.

Mapping Memory, Remaking Place

Pantoja's performance joins a rich constellation of artistic and public projects that aim, in diverse ways, to investigate the aftermath of the Dirty War and the ongoing role of memory in public spaces and in civic dialogue. Examples of these projects can be found across film, photography, performance, and a range of public interventions. Many of them explore the loss of loved ones, such as Albertina Carri's acclaimed 2003 film, *Los Rubios*, which investigates the disappearance of her parents during the Dirty War,

and internally renowned artist Marcelo Brodsky's photographic project *Buena Memoria* (2003), which is built around an old school photograph of his classmates taken before the Dirty War, onto which he has scrawled notes as to their respective whereabouts, circling the faces of those who were disappeared. This class project is accompanied by an even more personal exploration of the disappearance, torture, and death of his brother Fernando, the last known photo of who alive was taken by military officials during his detention at ESMA. Other projects have taken a more collective approach to remembering, such as the Rosario artist collective En Trámite's art installation *Descongesta*. On March 24, 2000, the twenty-fourth anniversary of the coup, they embedded old shoes in forty blocks of ice, which they then placed on the street corner directly in front of a former center for clandestine torture and detention, now a fancy bar. The ice melted, leaving pools of water on the sidewalk, until that too evaporated, leaving nothing but abandoned old shoes lying on the sidewalk. Another public art installation, *Siluetazos*, which first took place in Buenos Aires in 1983, similarly played with the idea of calling attention to the disappeared, albeit on a much bigger scale. Conceived by three visual artists (Rodolfo Aguerreberry, Julio Flores, and Guillermo Kexel) in conjunction with Las Madres, Las Abuelas, and other human rights organizations, this project gathered thousands of people to make life-size silhouettes and mount them around the city. Made of simple craft paper, these silhouettes took the form of men, women (including pregnant women), children, and babies. Well after the initial intervention, these silhouettes continued to haunt the city over the years, appearing, slowly fading, only to appear anew. Other public memory interventions have taken on life and meaning beyond the initial installation itself, such as Fernando Traverso's 2001 installation in Rosario, in which he spray-painted 350 images of bicycles in public spaces throughout the city to commemorate the more than 350 citizens who were disappeared (bicycles were a common form of transit for activists in Rosario, and during the war an abandoned bicycle leaning against a tree or on the ground was often an indication that its rider had been seized by the military). The "bicis," as they are called, eventually spread across Argentina and beyond; similar to how Hernández-Salazar's angels have traveled, the bicis can now be found throughout the Americas and Europe, taking on new and different meaning in each location.

This brief sampling of projects is by no means exhaustive, but it is indicative of the visibility and robustness of Argentina's memory politics. There are a number of reasons for this. Certainly, Argentina's transition

from dictatorship to democracy took place more than three decades ago, and thus the country has had time to debate, organize, and execute a wide range of memory initiatives. More important than time, though, is the fact that the military was so thoroughly discredited during the transition, because this allowed for more of an opening for public dialogue than is often the case in other countries (e.g., Chile). Moreover, whereas in other countries (e.g., Guatemala and Peru) the victims predominantly came from ethnically, racially, and geographically marginalized groups, in Argentina many of the victims were from the urban middle class. Due to these combined factors, when the Dirty War ended, the survivors had a great deal more agency than has often been the case elsewhere. As a result, since the transition, Argentina's memory politics have been front and center, with impassioned debates about how, why, and what to remember.

Up until this point, I have primarily grounded my conceptual development of memory mapping in predominantly visual forms—photography, film, and hybrid visual performances—and how they map complex temporal, spatial, and affective relations. Yet, the question of how to map memory—how to visually represent the complex relationship between past and present, anchored within the specificities of place—is equally as relevant for physical sites. How do specific places wield memory and visuality to "become" sites of memory? Conceptually, what happens to memory mapping if I rotate my analytic axis to study memory, visuality, and place through the lens of place itself? How does analyzing *Tucumán Kills Me* alongside a range of other diverse memory projects shed light more broadly on memory politics in contemporary Argentina? In what follows, I analyze three prominent memory sites in Argentina: the Escuela Superior de Mecánica de la Armada (ESMA) and the Memory Park in Buenos Aires, and the Museum of Memory in Rosario.

ESMA is located on Avenida del Libertador, a busy street that runs along the Río de la Plata in Buenos Aires. Sprawling over forty-two acres, ESMA comprises more than thirty buildings built in the neoclassical architecture style, with white facades and orange tile roofs, many of which still remain in disrepair. Surrounded by apartment buildings in a posh residential neighborhood, ESMA was one of the most infamous detention and torture centers in Buenos Aires during the dictatorship. ESMA functioned as a military academy throughout the dictatorship, with officers continuing to live in the Officers' Quarters even after ESMA became a detention and torture center. When the dictatorship ended, ESMA maintained its status as an active naval site for more than fifteen years, until 1998, when then-president Carlos Menem decided to move the academy to another

site in order to destroy ESMA and install a memorial plaque and tree. This plan was met with community opposition and eventually scrapped, but it was not until six years later, in 2004, when then-president Néstor Kirshner declared that ESMA would be turned into a memory museum.[14] This gratified the range of human rights organizations that had been lobbying for years to turn ESMA into a memorial site but was met with resistance by others. The faction of the Madres led by Hebe Bonafini feared ESMA would become a museum that people would visit once and never return to and instead advocated for a cultural space for shows, exhibitions, and other public events. ESMA's significance—both in terms of what it had been and what it would be in the future—was at the heart of these debates.

Marcelo Brodsky put out a call for proposals for what to do with ESMA, and he also requested conceptual think pieces from a range of prominent memory scholars. These essays were subsequently published alongside photographs and excerpts or the entirety of the different proposals in Brodsky's book *Memory Under Construction/Memoria en construcción: el debate sobre la ESMA* (2005). The book reveals the extreme differences in ideas people had for what ESMA could become, productive tensions that remain present in the site today. As Kerry Whigham describes,

> Before ESMA was re-embodied as a site of memory, it underwent a
> process of alteration, destruction, and evacuation . . . When the
> military left ESMA, they took with them anything they thought could
> be used against them in future trials. Even more, the perpetrators
> sought to alter the space architecturally in an effort to debunk
> survivor testimonies of what the center looked like. Faced with the
> remnants of destruction and alteration in ESMA and other similar
> sites, those involved in the re-composition of these sites must decide
> how to respond to this emptiness. How will they fill the literal and
> figurative absence that has been left behind? (2014, 90)

Although in some respects ESMA is still in the process of attempting to answer this question of how to effectively and ethically resurrect the site, and there are ongoing plans to repair many of the remaining dilapidated and unoccupied buildings, much progress has been made. The renovated buildings now house a staggering number of prominent Argentine postdictatorship human rights organizations, including the Grandmothers of the Plaza de Mayo, the Mothers of the Plaza de Mayo, the H.I.J.O.S. (Sons and Daughters for Identity and Justice and Against Forgetting and Silence),[15] the National Memory Archive/Secretariat of the Human Rights

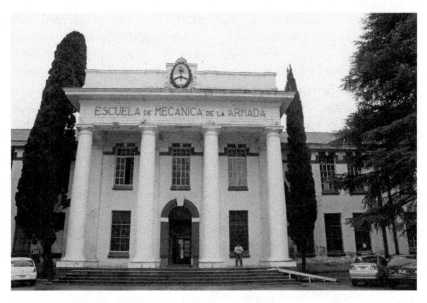

Figure 9. Kaitlin M. Murphy, ESMA, taken July 2015.

of the Nation, and Memoria Abierta (Open Memory), a coalition of human rights organizations.

The majority of the crimes that occurred at ESMA during the Dirty War took place in just one building: the Casino de Oficiales (the Officers' Quarters). Often held for years, the majority of prisoners did not make it out alive; many were dropped, drugged but alive, into the Río de la Plata to drown. Those who had been abducted were imprisoned upstairs in small cells, physically and psychologically tortured, and habitually forced to perform slave labor.[16] For years, the Officers' Quarters had only been accessible via private tour, but in May 2015, the building opened to the public as a powerful, immersive memory site. One of the most sophisticated memory sites of its kind in Latin America, the site is designed to be a multimedial and sensorial experience.

I first took the tour in July 2015. The small, guided tour began in a darkened, empty room to the right of the front entryway.[17] Once everyone on the tour had entered, archival footage began projecting onto three of the four walls. Accompanied by loud audio (a combination of old speeches, protests, and dramatic original score), the videos described the tumultuous years leading up to the coup and the oppression and violence that followed. With the sound and light coming from multiple angles, it was all but

impossible to quickly skim through the words and images on the walls. Instead, the viewer was positioned to absorb the images and sounds as they came. We were then led through a smaller transitional room with maps and explanatory historical information covering the walls, and up to the third floor where the bulk of the prisoners were held in tiny cells. Here, signs described the inhumane living conditions endured by the prisoners, including not being allowed to use the bathroom for hours, beatings, and enforced silence. The space is designed to affectively immerse the viewer in the proverbial shoes of the prisoner. As I stood in the quiet, cramped room, staring at the small cells and imagining what it must have been like to spend hours, days, weeks, months, and even years locked behind those walls, I found this room to be the most powerful of the tour.

We progressed through the small attic where the worst of the torture took place, into the rooms where the pregnant women were held until they gave birth, and through the rooms where the staggeringly large piles of spoils from looting had been stored (images of those items were projected on the walls and included everything from jewelry, books, and fans to large appliances, such as stoves and refrigerators) and back downstairs through the main officer residence. Devoid of furniture, this space called upon the visitor to imagine and reflect on the surreality of an officer living in the building, with his children, while people were being brought in every day to be detained, tortured, and killed. The final section of the exhibit was "El Sótano" (the basement), which the military called Sector Four. This was the first place prisoners were brought upon arrival, and it was the last place they saw if and when they left. Permanently lit by harsh florescent lights, it was also the site of violent interrogations and the departure site for the "transfers," as the flights were called that dropped drugged victims alive into the river to drown. Multiple multimedia screens lined the walls; each of these panels included the name and picture of one of the accused military officials who worked at ESMA, a description of their crimes, and their current status (in prison or otherwise). The images projected onto these panels rotated, and each change was marked by a loud click reminiscent of someone pressing angrily on the keys of a typewriter. Dramatic, almost cinematic classical music played in the background. This room markedly differed from the rest of the exhibit, as it was the only room that did not exclusively focus on past events that occurred in that particular space. Instead, by identifying the criminals, the room highlighted the ongoing lack of justice and accountability. This room is both the affective culmination of the tour and the bridge into the present. Because it comes

at the end and registers on a different temporal and emotional key than the rest of the building, it significantly shapes the impression with which the visitor departs.

ESMA creates an affective and sensorial experience for visitors, using the walls and shadows of the building itself to induce visitors to imagine what it must have been like to be a prisoner; how much pain, fear, and despair permeated the building; and how eerie and haunted it must have been in its previous iteration. Experiencing this while physically present at the site of these atrocities, the viewer is both affectively and visually confronted by the unfathomable extent of the military's sadistic inhumanity and forced to consider that horrible things could occur in such a prominent building, one so close to other structures, and on such a busy street. There is simply no way that passersby and neighbors were unaware of the goings on at ESMA, a fact that is reinforced by a testimony that plays on repeat on a small television in one of the rooms of the residence. In the clip, a friend of the daughter of the officer whose family resided in the building recalls how, on a social visit to the house, she saw prisoners with hoods over their heads being led up and down the outside stairs. Details such as these are a reminder that while ESMA may have been a clandestine center of detention and torture, it was not hidden.

Today, the building itself seems to stand as visual testimony to the importance of memory and in recognition of the ongoing resonant violence[18] that permeates the physical and affective landscape of Buenos Aires. In this sense, as a memory site, ESMA is affectively and pedagogically quite successful. It is obviously still a work in progress, and aspects of the site feel undeveloped and undetermined. And yet, its unfinished nature only adds to its affective power, emphasizing that the building is still caught between past and present, ruination and reactivation, actively grappling with questions of what and how to remember, and the implications of those choices. As Whigham argues, "[I]t is never the spaces themselves, but rather the practices that transpire within these spaces and through the process of transforming the space from a site of atrocity into a site of memory that influence the constructive processing of past violence. They do so through their ability to make people re-encounter and re-activate the past in the present" (2014, 88). The Officers' Quarters tour induces the viewer to hear and see the past but, even more so, to imagine and feel it. Moving through such spaces thus aids in the remembering of the past and reinforces the importance of such remembering. It also resignifies the space, carving out a new relationship to the past and redefining its role in the present. Similar to *Tucuman Kills Me*, the Officers' Quarters tour is guided by perfor-

mative audio and visual elements; here, they make legible the embodied knowledges and memory narratives embedded in the walls of the haunted building. Yet, whereas *Tucumán Kills Me* establishes an almost exclusively visual connection with audiences (with music serving to strengthen the affective impact of the images)—in other words, the viewer simply sits there—the Officers' Quarters tour requires visitors to come into tactile contact with the site. In order to experience it, they must walk *through* it—and not freely but on a tour, which dictates the duration, the order, and the nature of the information presented about the site. And yet, it is interesting to note that both the interventions of *Tucumán Kills Me* and ESMA hinge upon an element of liveness to succeed. In the case of the former, it is the trinity of audience, artist, and images; with the latter, it is audience, guide, and site. In other words, both of these projects necessitate a "being there"—whether in the performance space of the images or in the performance space of the building—that ushers visitors' bodies into affective, visual, and sensorial contact with place, trauma, and memory.

There are obvious and not-insignificant disparities in form and accessibility: the visual performance can travel, whereas a visitor must be in Buenos Aires to access ESMA. Thus far, the performance has been staged only once, and it was staged internationally and thus attended by a largely international audience; barring any political or financial issues that would result in its closure, ESMA can be accessed again and again by foreigners and Argentines alike. There are other differences, too. *Tucumán Kills Me* integrates the faces of the disappeared into the images of the trials to create a layered tapestry of witnessing; the primary witness of the Officers' Quarters tour is the building itself. However, and regardless of these differences, across medium, both memory projects work to shape the public's understanding of and relationship to the country's recent past by transmitting a visual and felt sense of memory's ongoing presence in the landscape, in buildings, and in bodies and bodily practices; furthermore, both memory projects draw explicit links between past atrocities and calls for justice in the present. Finally, both *Tucumán Kills Me* and ESMA seem to work from the premise that what matters is not just a question of what we see but how that seeing makes us *feel*, and the affective webs of witnessing that are wrought as a result of that seeing, experiencing, and feeling. This is arguably a sound premise, but it brings up important questions about the capacity for memory sites to testify or successfully transmit specific narratives that are in turn intended to produce certain effects in viewers. This has been one of the tensions surrounding the Memory Park in Buenos Aires.

The Memory Park is just a short distance from ESMA, although it is not accessible on foot due to the large highway that runs between them. Located near the northern campus of the University of Buenos Aires, the park is a sprawling green space set against the sparkling backdrop of the Río de la Plata. The estuary, 143 miles wide where it merges with the Atlantic Ocean, is the pivotal natural asset for Buenos Aires, which was founded as a port city because of the estuary. It is also the site where many victims were dropped from planes just offshore to drown during the Dirty War. Long an industrial waterfront, there are few public access spots down to the river, although people fish from and walk along the pedestrian esplanade that buffers the busy Costanera Avenue from the Río de la Plata.

Designed by the firm Estudio Baudizzone-Lestard-Varas and associate architects Claudio Ferrari and Daniel Becker Nancy, and formally inaugurated in 2001, approval for the Memory Park resulted from the successful confluence of several factors, including a change in city government, a push to develop the riverfront area, and human rights organizations in need of space for the Memory Park. As Nancy Gates-Madsen explains, the city passed Law No. 46, which mandated construction on the park with very specific terms: "on the coastline of the Río de la Plata, a space designated as a public walkway where a monument and group of sculptures will be located in homage to the victims who were detained, disappeared, and murdered by State Terrorism during the 1970s and 80s, until the reestablishment of a State based on the Rule of Law." In order to manifest this vision, "[a] Pro-Monument Commission was formed to oversee the project, consisting of the vice-president of the city legislature, eleven city reps (one for each political party), four members of the local executive branch of government, a representative from the University of Buenos Aires, and one member from each of the ten human rights groups involved" (2011, 154).

The resulting park is composed of a diverse group of commissioned sculptures and public artworks, and an obscured human rights archive (it is essentially underground). The most iconic installation is likely the *Monumento a las Víctimas del Terrorismo de Estado* (Monument to Victims of State Terror), a four-hundred-meter-long wall (designed to resemble the Vietnam Veterans Memorial in the United States) that is embedded in the landscape and zigzags through the center of the park. Of the thirty thousand individual concrete plaques that make up the wall, roughly nine thousand list the names and ages of the victims (the monument is deliberately left open to the incorporation of additional names as they are discovered and thus is considered incomplete). The park also holds seven additional permanent public artworks commissioned from a diverse range of promi-

Figure 10. Kaitlin M. Murphy, *Carteles de la memoria*, taken July 2015.

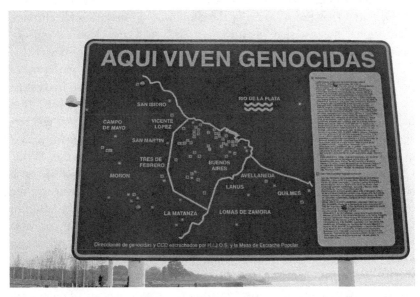

Figure 11. Kaitlin M. Murphy, *Carteles de la memoria*, taken July 2015.

nent international artists, and there are plans to install more artworks in the future.[19] The majority of the works are large-scale, interpretive, contemporary sculptures that directly engage with themes of human rights and loss. Aesthetically, the sculptures tend more toward the abstract than the didactic (though they are accompanied by a short descriptive plaque), but there are two that noticeably buck that trend: Grupo Arte Callejero (Street Art Group/ GAC)'s *Carteles de la Memoria* (*Memory Signs*) and Claudia Fontes's *Reconstrucción del Retrato de Pablo Míguez* (*Reconstruction of the Portrait of Pablo Míguez*).

Carteles de la Memoria consists of a series of oversized street signs running the length of one of the main park walkways. Because the piece is composed of what at first appear to be regular street signs, it melds seamlessly into the landscape. (On my initial visit, I walked past the first few signs before realizing what they were and retracing my steps to read them from the beginning.) Upon closer examination, it becomes evident that these signs are designed to call attention to past atrocities and current issues.

One sign, entitled "Aquí Viven Genocidas" (which roughly translates as "perpetrators of genocide live here"), is a map of places GAC has conducted *escraches* with the H.I.J.O.S. Another sign lists the amount of Argentina's foreign debt. Lorena Bossi, one of the founding members of GAC, stated that the purpose of the signs was to "make visible through institutional means what institutions hide." As Gates-Madsen reflects, the street signs are "part of the official, invisible structures of power that we rarely consider," and "GAC's work both implicates the structure of power in the attempt to ignore or forget past crimes, and also makes the viewer consider how the movement of his or her body through the city is mediated by such invisible power structures. In other words, it encourages viewers to consider how everyday actions constitute a 'performance' of obedience to authority" (quoted in Gates-Madsen 2011, 169). While Gates-Madsen argues that much of the power of *Carteles de la Memoria* comes from the deliberate interpellation of the viewer as participant, she questions whether GAC's work will succeed as a fixed art installation in the park, or if it will "appear out of place rather than provocative," thus losing its "subversive framework" (169–170). Yet, while every other artwork is focused on remembrance and memorialization, I found that the aesthetic form of many of the other sculptures was almost uniformly overpowering compared to any meaning the respective works purported to convey. Not that all artwork need be overtly didactic, but, in this visual field, GAC's work is unique: it is explicitly political, it links past atrocities to the present day, and, relative to the other artworks in the park, its form

Figure 12. Kaitlin M. Murphy, *La Reconstrucción del Retrato de Pablo Míguez*, taken July 2015.

is highly irregular. This makes it relevant and necessary. Rather than "out of place," it seems perfectly in place; furthermore, its unconventional nature makes it stand out in a sea of underwhelming, oversized sculptures that would have been equally at home in any urban commercial courtyard.

La Reconstrucción del Retrato de Pablo Míguez (*Reconstruction of the Portrait of Pablo Míguez*), by Claudia Fontes, takes almost the opposite approach. A polished statue of a male figure stands out in the water on a small base, almost as though he were standing on a flat rock. He faces away from shore, startlingly lifelike as he stares out at the horizon.

Pablo Míguez was one of the five hundred children abducted with their parents during the dictatorship. Fontes, who would have been the same age as Míguez had he lived to the present day (he was fourteen when he was taken, and his whereabouts remain unknown), was interested in constructing a possible contemporary portrait of Míguez. Viewing it as an exercise in collective memory-building, the artist worked with Míguez's relatives and friends to ultimately arrive at the figure of the man with his back to the shore, with the idea that the spectator has to activate the memory of his or her own "desaparecidos" in order to reconstruct Míguez's face. The man, who faces out into the watery mass grave, literally reflects his

surroundings, and thus the nature of his visibility shifts depending on the weather and time of day. The piece is perfectly executed, understated but somehow enormously emotionally evocative. Positioned just three hundred meters from the airport from whence the death flights departed, the man looks out into the water where bodies were thrown from planes drugged but alive, perhaps even his own. His face is seemingly just out of sight, his body just beyond reach of shore. He gazes upon the site of so much death, watching and waiting. Similar to Pantoja's piece, spectators are again positioned as witnesses to the figure's witnessing, to his role as the one who sees, and who remembers, when all the others are gone. Both more realistic and less assuming, the affective resonance of the quiet piece stands out against the other sculptures in the park.

The Memory Park is a beautiful public green space, and, on multiple visits, I observed a range of human engagement with the park, including joggers, school groups sketching the sculptures, couples snuggled together on the grassy knolls, and people quietly gazing at the water or napping on park benches. It would seem, based on these visits, that the majority of visitors do not frequent the park explicitly in order to remember (with the possible exception of student groups, for whom a visit to the park is likely a structured pedagogical activity) but rather because it is quiet and picturesque, with a panoramic view of the water. This impression was reinforced in Katharine Hite's article on Argentine memory sites, in which she notes that there have been "painful, angry discussions among park and human rights representatives regarding this picnicking dimension, reminiscent of similar tensions in Berlin around the memorial to the murdered Jews of Europe" (2015, 43). The human rights representatives have expectations for how such a site should be used or interacted with by the public; the use of the park as a recreational space is contrary to their desires that it be engaged with specifically as a place of remembrance. The question then becomes: what is the role or responsibility of memory sites to structure experiences that produce certain affective witnessing effects in viewers? How do memory sites form such a relationship between memory and place? These questions strike at the core of a more essential one: what makes and maintains a site as "a memory site"?

Spaces do not themselves autonomously remember but rather are constituted through affective, corporeal practices of remembering. In other words, as outlined in the Introduction, bodily practices and rituals related to memory reaffirm a space as a memory site. Yet, if people go to a memory park but do not engage in acts of remembering, does it cease to be a memory park? The answer is, obviously, no. However, it calls attention to

how critical it is to analyze memory sites via the ways in which desires and memory are mapped onto and through them by bodies, objects, corporeal movements, narratives, and representational practices. Space, after all, is but one part of a much larger process of meaning making with regard to memory in the present. Material places and landscape (e.g., Pantoja's reference to the memory forest and ESMA's highly place-based tour) highlight the role of memory mapping in making past human rights abuses seen and felt.

By many standards, the Memory Park is a success: it is an expansive public greenspace and sculpture garden that provides magnificent views of the water. It is used in a variety of ways by diverse sets of visitors. They can choose to explore the sculptures, leaning in to read the small signs that explain each artwork's intended meaning with regard to memory, or they can simply enjoy being in the pretty park. There is no singular narrative, and peoples' experiences are not scripted but rather theirs to create for themselves. Aside from the *Carteles de la Memoria* and the unfinished nature of the *Monumento a las Víctimas del Terrorismo de Estado* wall, there is not much there to obviously or explicitly link the park to present-day memory and human rights politics. The park is visually idyllic, but beyond the tiny informative plaque that accompanies *La Reconstrucción del Retrato de Pablo Míguez* and the statue of his witnessing body as proxy for all of the absent bodies, the park does not actually draw explicit, didactic links between the landscape and the mass murders that occurred just beyond its shores. It is largely a space of reflection, seemingly not explicitly intended to turn idle spectators into active witnesses, either through the performative visuality of the sculptures or the greater greenspace. Perhaps we might say that, in order to have an impactful memory-based witnessing experience, a visitor must deliberately seek it out. Indeed, the extent to which a memory site will be able to create strong enough narrative links between bodies, events, and place to produce affective memory effects in the viewer is certainly not guaranteed, as is demonstrated by the Museum of Memory in Rosario, a city roughly four hours (or 186 miles) from Buenos Aires by bus.

Located in Rosario, the third largest city in the country, with well over a million inhabitants, the Museum of Memory is the first official, nationally sponsored memory museum in Argentina. Whereas the Memory Park in Buenos Aires was the result of changes in city government, an interest in developing the area, and need for a space for the Memory Park, the Museum of Memory was created via a local Rosario City Council ordinance. The museum initially opened in 2004 in a municipal building, and, in 2010,

after much debate, the city took possession of a large and beautiful build-
ing on the prominent San Martín Square in downtown Rosario. This
building had been the military's regional operational and bureaucratic base
for more than twenty-five years, making it a fitting location. The museum,
which is grounded in the regional context but national in scope, combines
permanent and rotating exhibits with an interactive education exhibition
space, a small archive, and a video library.

When approaching the elegant old white mansion, the first thing the
visitor sees is the striking sculpture installation in the side yard, which is
composed of a row of large cylindrical metal columns with the names of
victims etched onto them. Upon entrance into the museum, visitors walk
into an open, high-ceilinged room with smaller peripheral rooms con-
nected to it. The building still possesses a trace of its old residential feel,
although the museum itself oddly feels somewhat sparse and disconnected
from place—not from Rosario, because that was apparent (one of the ex-
hibits gave a time line of events and included maps of all of the detention
centers in the region), but from the specificities of the building itself and
what occurred within it during the dictatorship. In certain respects, the
Museum of Memory shares elements in common with the Officers' Quar-
ters tour at ESMA, insofar as it is located in a building with layers of his-
torical significance, marked by the symbolic act of reclaiming it from its
recent use by the military, and resurrected as a symbol of defiant survival.
However, whereas the Officers' Quarters call upon the intimacy of the
building itself to perform, the Museum of Memory is not grounded in the
story of the building that houses it but rather centers around a range of
exhibitions. When I visited in July 2015, there were several modest but
thoughtful exhibits on the first floor, the most prominent of which was
comprised of hanging identification cards and other small memorabilia pre-
sumably meant to bring to mind those victims who had once used these
objects. The second floor is dedicated to rotating exhibits; during my visit,
it was a lackluster photographic exhibition on the missing women of Juarez,
Mexico. Aside from the clumsy and problematic effort to gesture toward
a shared experience or transnational problem of disappearance, many of
the moveable black partition walls were empty, and the few photographs
that were on the walls seemed rather generic and resembled many I had
seen before. Much like ESMA and the Memory Park, the memory museum
is considered unfinished, and the welcoming and friendly museum staff
enthusiastically spoke of desires to continue to grow and develop it.

In some respects, the Museum of Memory combines the most elements
from the memory projects studied in this chapter: it is housed in a resur-

rected military space (ESMA), it has a side yard with a large-scale sculpture installation (Memory Park), and it uses visual lists of the names of the missing (Memory Park, ESMA, and *Tucumán Kills Me*) and photography (ESMA and *Tucumán Kills Me*) to both illustrate for the viewer what was lost and gesture toward the ways in which these issues continue to have contemporary global impact. Yet, these various elements are not coherently linked—the connections between memory, place, bodies, and events did not, at least in this iteration, coalesce into an affective narrative or takeaway. Perhaps as a result of this, the space lacks a certain specificity, as well as an intelligible institutional narrative or memory proposition. This lack of narrative is significant.

In the case of the Memory Park, it perhaps functions exactly as it was designed to. However, not everyone is in accord with the corresponding ways in which visitors use the space (e.g., human rights representatives may take issue with picnickers who do not engage with the sculptures or archive). Indeed, lacking stronger narrative links between bodies, events, and place, the park falls short of creating a dynamic in which seeing and experiencing results in specific forms of feeling and knowing—the park fails to script experiences or produce certain memory effects in viewers. In other words, it does not map memory in any coherent way—nor, seemingly, is it intended to. The Museum of Memory, conversely, although it ostensibly should have a much more focused objective in terms of the authoritative role and function it will play in society, fails to effectively communicate its specific contribution, why a national memory museum would be located in Rosario (as opposed to the much larger Buenos Aires), or why the country might need a national memory museum at all. Much of the affective power of memory sites such as ESMA (or Auschwitz-Birkenau in Poland, or Villa Grimaldi in Chile) comes from thick, sensorial memory narratives that are designed to envelop visitors in the reality that *this* happened *here*. Memory sites that are not developed on the specific sites of past events must find other ways to cohere into a memory site. They must, in other words, figure out how to map memory's relationship to place by creating affective constellations of events, place, stories, bodies, and memory. Unfortunately, on my visit, the Museum of Memory fell short of accomplishing this.

As I have been progressively arguing, one of the powers of the visual in relation to memory is to make audiences *feel*—to make *seeing* memory a sensorial, affective experience (to make contact with, or "touch," memory). As these various case studies demonstrate, this is an expansive seeing, not limited to visual forms such as film and photography. ESMA, for

example, incorporates photography—it bookends the tour and serves as powerful evidence of the sheer magnitude of the military's looting—but the success of the site comes from the visual and sensorial engagement with the building itself. The tour participant, who straddles the space between witness and spectator, can gaze upon the fingernail-scratched walls, which affectively invoke the ghosts of those who made the marks. As ESMA demonstrates, the specificities of place *do* matter—because the affective resonances of past events that live on through memory and narrative are anchored to the specific places where events occurred. Site anchors memory just as memory ontologically affirms site, because memory is embedded into a specific site in the same instant that it is extracted from it. And yet, it is also clear that place is just one component of a much more complex process. A place does not become a site of memory on its own—to state the obvious, there are many locations where events have occurred that do not become memory sites. Ultimately, a memory site is made by how the relationship between memory, event, and place is visually and narratively mapped onto and through it. The relationship between memory and place must be strategically signified and resignified. Much like visuals texts or performances such as Pantoja's, memory sites are propositions, suffused with affect and the many desires, fears, and hopes that humans embed in them. A memory site becomes a memory site because humans want certain things of it—they ask it to perform in particular ways. Any study of memory sites should thus be grounded in an analysis of the constitutive memory mapping practices that take place within, and in relation to, the site itself. Memory mapping sites (and not just any site labeled a memory site) produce memory by weaving affective, narrative webs that position memory as inherently dialectical with place.

How memory is mapped onto and through bodies, images, and specific places matters, as does how a story is recuperated, the efficacy of its transmission, and what connections are drawn to the present. While this is true regardless of form, I am specifically interested in the visual because of its unique ability to transmit a sense of proxy—of standing in for, and of making contact with, what is represented. There are other forms of sensory contact: to be in the building, to see the scratches, to touch the walls is immersive; to hear someone give their testimony is a form of contact. Sensorial contact gives things an immediacy, and, in a certain sense, it brings them to life. Yet, there are times in which the visual may be the only form of contact available to us. We cannot always go or return to certain places, or travel back in time, or talk to the dead. In lieu of being able to establish other forms of contact, the visual functions as a way to

bring people into contact with events, bodies, and landscapes. It is an essential conduit.

In the case of *Tucumán Kills Me*, the liveness of the performance, and the role of Pantoja's body as guide, provided an additional contact with the visual, because audience members were guided into a structured, intimate viewing experience. If affective links are successfully constructed between different sets of images, it is possible to draw connections between a wide range of events, bodies, temporalities, and landscapes. These connections become coherent through a narrative context. In *Tucumán Kills Me*, the narrative is largely visual—the performance incorporates a few words at the beginning and end that give important contextual framing; yet, the meaning comes not from any singular image or location but instead from the ways in which they are interwoven through visually and temporally mapping.

Memory mapping is an artistic or curatorial practice of creating thick, affective, performative visual mappings of the relations between past and present, and images, archives, bodies, objects, and places. These maps function as memory-based constellations of connections that are intended to shape how audiences understand and change how they feel. In the case of *Tucumán Kills Me*, the piece performatively redistributes the visual, using images to inscribe meaning onto, and draw connections between, the trials, the memory forest and the mass graves, and the living, dead, and disappeared. The potential for images in, and as, performance is thus profound. *Tucumán Kills Me* maps by making links that otherwise would not be visible or necessarily even accessible. ESMA maps memory by creating a rich, sensorial experience of place, which draws on visual forms to tell the story of a past that happened *here*. Such projects (whether visual performance or officially recognized memory sites) find roots in the events and places of the past but are very much of the present moment. In other words, they create a space for sensory contact with the past. They create a space in which audiences may *see as a form of feeling*—the kind of seeing that is required for the recognition of human rights. The next chapter brings us in even closer contact with the urgency to both see and feel by conjuring the ghosts of an ongoing, and devastatingly unrecognized, crisis.

The Politics of Seeing:
Affect, Forensics, and Visuality
in the US-Mexico Borderlands

The hybrid documentary film *Who Is Dayani Cristal?* (2014) opens with a man's voice reciting "The Migrant's Prayer":

> *The journey towards you, Lord, is life. To set off . . . is to die a little. To arrive is never to arrive until one is at rest with you. You, Lord, experienced migration. You brought it upon all men who know what it is to live who seek safe passage to the gates of heaven. You drove Abraham from his land, father of all believers. You shall remember the paths leading to you, the prophets and the apostles. You yourself became a migrant from heaven to earth.*

The camera pans from the crucifix hanging on the wall to famed Mexican actor Gael García Bernal, who sits on the edge of a bed, hunched over, reading off of a small prayer card. A woman's voice calls out: "Yohan? They're looking for you outside." He grabs his things and rushes out, climbing into the back of a white van that drives him, along with a handful of others, toward the US-Mexico border. The driver advises them to grab their water and be ready to move quickly. The small group climbs a ladder hanging from the border fence, and, within a matter of seconds, they are over the wall and into the United States.

The scene shifts to the arid Sonoran Desert of southern Arizona. The date is August 3, 2010. Sergeant George Economidis of the Pima County Sheriff's Department's Search and Recovery Unit drives through the desert on his way to recover a body. He locates a decomposing male face up in the shade of a cicada tree in a small arroyo. The body is blackened, swollen, and swarming with flies. Economidis and his colleague examine the man's body, but his worn backpack and clothing reveal little in the way of identification. The main clue comes in the form of a large tattoo that stretches across the man's chest: the words *Dayani Cristal*. After documenting the corpse with a small digital camera, they wrap the body in a white plastic sheet and strap it onto a medical stretcher. The stretcher is then tied onto the back of an all-terrain vehicle and driven away. In voice-over, we hear García Bernal reflect: "[I]n life, he was considered invisible, an illegal. Now in death he is a mystery to be solved."

These two scenes highlight the slippage between documentary footage and fictionalized reenactment that shapes *Who is Dayani Cristal?*, and they set the stage for the complex interplay between affect, memory, forensics, bodies, and visuality that follows. The juxtaposition between the two scenes is striking and destabilizing—the opening scene is clearly dramatized (García Bernal, possibly the most internationally famous contemporary Mexican actor, is immediately recognizable), and yet the subsequent scene, with the Search and Recovery Unit and corpse, reads very much like a documentary. Directed by Marc Silver and starring García Bernal, *Who Is Dayani Cristal?* combines the real-life forensic attempts to identify a deceased migrant with the fictional retracing of his steps along the migrant trail from Honduras, through Guatemala and Mexico, and up to the deadly stretch of desert known as the "Corridor of Death" in southern Arizona, where his body is ultimately found. García Bernal plays the part of the migrant; however, he does not pretend to *be* Yohan (the deceased border crosser) precisely but instead performs a sort of embodied, imagined retracing of Yohan's journey, representing and experiencing firsthand the life of an undocumented border crosser (henceforth UBC) into the United States. On the one hand, it seems evident that by giving a face to the faceless migrant, *Who is Dayani Cristal?* works to humanize a figure that political rhetoric often dehumanizes. Furthermore, García Bernal's star power draws audiences to the film, increasing both its reach and profitability. On the other hand, the film also raises important questions about mobility and visibility. García Bernal (and the global wealthy more generally) may study and reenact the plight of Yohan and other economic migrants, but we must question whether they will be able to ever *fully*

inhabit or depict their circumstances or desperation. As I have argued in previous chapters, reenactments—repetitious acts that serve as a means through which to see and feel past events, actions, or bodies—can be a key strategy of memory mapping, in that it visually articulates a relationship between embodied practice, memory, and place. However, in this instance, does the reenactment of Yohan's journey constitute a form of memory mapping that successfully provokes empathetic identification? Or, does the casting of García Bernal (who, in his "real" life, is a successful movie star who can cross the border with ease, presumably on an airplane, and not through the desert on foot) run the risk of rendering the migrant even less visible? Furthermore, we must also consider the implications of an interest in dead bodies over living ones. Why artistically resuscitate the story of an anonymous *dead* man? Relatedly, how do dead bodies perform, and what are the implications of asking them to?

Throughout the course of this book, I have focused on visual projects operating in specific national public spheres and in the aftermath of large-scale conflicts such as dictatorship and civil war. In this final chapter, I turn to a pressing contemporary issue that is ongoing and involves multiple nation-states: undocumented immigration through and across Mexico and into the United States. Undocumented border crossing has been occurring for decades; however, ever-increasing drug- and gang-related violence across Mexico and the Northern Triangle (El Salvador, Guatemala, and Honduras) has resulted in a major shift in the makeup of northerly migratory flows. The staggering levels of violence in the region are paradoxical, as not one of these countries is officially engaged in an actual war. Yet, as Ioan Grillo (2017) points out, in Mexico alone, at least 1,400 bodies were recovered from mass graves across the country from 2009 to 2014, and police have counted more than 176,000 murders over the last decade. This level of violence vastly exceeds that seen in other Latin American countries infamous for horrifically violent periods of conflict (e.g., Argentina's Dirty War, as discussed in the previous chapter). And yet, the Mexican government continues to deny that there is an armed conflict going on in Mexico. Grillo contends that the conflict is not a civil war, nor is it only crime; rather, it is a new, hybrid type of organized violence that stems from exceedingly powerful drug cartels, a broken justice system, and complicity and corruption at official levels. And it is not just Mexico: El Salvador, Guatemala, and Honduras are also besieged with violence and rampant crime. The result has been tens of thousands of refugees fleeing for their lives.

Central American immigration into the United States is not a new phenomenon—in the 1980s, fragile nation-states, civil wars, and economic

instability drove significant numbers of Central Americans northward. However, even after many of these political conflicts ended in the 1990s, the ongoing violence and political and economic unrest, combined with some of the world's highest homicide rates and rampant organized crime, have resulted in El Salvador, Guatemala, and Honduras consistently ranking among the most violent countries in the world. From 2012 to 2015, the number of people coming from the Northern Triangle and officially seeking asylum in the United States increased fivefold, with unaccompanied minors accounting for the majority of requests. Asylum seekers from all three countries cite forced gang recruitment, extortion, violence, poverty, and a lack of even the most basic level economic opportunity required to survive as their reasons for leaving (Labrador and Renwick 2018). (It is important to note that these numbers do not represent the total numbers of migrants attempting to cross or live undocumented in the United States; indeed, given that for many migrants being denied refugee status or getting deported back to their countries of origin would effectively be a death sentence, and also how difficult it is to successfully get asylum status in the United States, many elect to attempt to travel to, and live in, the United States under official radars.) According to the Migration Policy Institute, while Mexican immigration into the United States has steadily declined since 2009, the size of the Central American immigrant population in the United States has grown nearly tenfold from 1980 to 2015 (to 3.4 million Central American immigrants in 2015), with immigrants from El Salvador, Guatemala, and Honduras accounting for almost 90 percent of the total population growth.[1] Ultimately, although at other points in time south-north immigration was predominantly economic in nature, and shaped by US efforts to meet low-wage labor needs with a Mexican workforce, today this is simply no longer true. South-north immigration into the United States has changed; the majority of those making their way toward and across the border are refugees fleeing for their lives.

And yet, in mainstream US media and political rhetoric, this broader refugee picture is often overlooked. Because south-north migration into the United States has been so strongly framed in economic and criminal terms, migrants are often perceived of in terms of their potential participation in the US economic (and the closely interlinked) legal system. Consequently, migrants en route to the United States tend to be ontologically identified as potential, or *future*, labor and as criminals. While this framing is often also layered with racist tropes of criminality and opportunism, the nature of migrants' potential relationship to the US economic system has historically been the enduring ontological thread (essentially,

they will make money, or they will take, and therefore cost, money). These tropes are perpetuated by visual economies that dictate the ways in which certain bodies enter into circulation—the moment at which they are allowed to become seen, how they become seen, and how that seeing (or what might more aptly be considered an enabled "unseeing") occurs. In the case of south-north migration into the United States, this scripted "unseeing" arguably allows audiences to ignore the fact that although at other points in time south-north immigration was predominantly economic in nature, the majority of contemporary migrants making their way toward and across the border are refugees fleeing from deeply unsafe circumstances (circumstances the United States has directly fomented through decades of opportunistic intervention and exploitation across the Americas). Their deaths—including those that happen on US soil, often well within reach of potentially life-saving aid—are largely ignored. In other words, the *trauma* of migrant (as *human*) death is still largely invisible and unacknowledged, and the human rights violations continue.

Thus far, I have largely focused on *what* memory mapping is and *how* it functions. In this final chapter, I turn my attention to the question of *why*. I take seriously the proposition put forth by *Who Is Dayani Cristal?*: that highlighting the humanity of migrants will make viewers see and feel the inherent violence of both the underlying economic situation and the border policies that claim migrants as faceless victims. The question then becomes: Can memory mapping challenge mainstream representations and make certain subjects *seeable* in new ways—can it, in other words, redirect the gaze toward new ways of seeing and feeling?

In order to address this question, I begin with a brief overview of the US-Mexico border region, immigration, and the politics of visuality surrounding migrant bodies. This provides the necessary context for an analysis of how *Who Is Dayani Cristal?* works to document, reimagine, and memorialize a deceased migrant's journey. I juxtapose this with an overview of how immigration and the US-Mexico border are predominantly depicted in mainstream visual culture before turning to the question of how memory mapping participates in these broader economies of visuality as a means to challenge why certain lives are rendered visible, and thus grievable, and others not.

The Politics of Visibility and the Risks of Border Crossing

In 2013, 54 million people in the United States self-identified as being of Latino origin, making Latinos the largest ethnic group in the country.

According to the Migration Policy Institute, the vast majority of Latinos in the United States are native-born; of the 54 million self-identifying Latinos, 19 million (or 35 percent) were legal immigrants (Mexican immigrants are in the majority, accounting for 11.6 million, or 28 percent of this group) (Zong, Batalova, and Hallock 2018). An additional estimated 11.4 million *unauthorized* immigrants reside in the United States, the majority of whom are from Mexico and other Central American countries (8.1 million, or 71 percent of the total unauthorized population). In other words, the vast majority of Latinos in the United States are legal residents. And yet, in US mainstream media and conservative political rhetoric, these nuances are often erased. Subsumed into a larger immigrant category and subjected to discrimination and harassment, Latinos are often *hypervisible*.

Hypervisibility is a form of visual scrutiny that is based on a perceived difference, and it occurs when a subject comes to symbolize or stand in for a larger group, place, or set of cultural conceptions and misconceptions. Hypervisibility renders people visible not as individuals but instead as a monolithic "other" or unknown, which can be perceived as threatening. Hypervisibility is not just to be looked at but to be scrutinized and judged— in effect, it is to be *overly* visible, always the subject of the gaze of others. Groups that are hypervisible are often the focus of attention in the media and in political rhetoric, but instead of being able to speak for themselves, they are largely depicted through stereotypes that reinforce specific, often negative, tropes. Hypervisibility tends to be a characteristic of life for immigrant and Latino communities in the United States, where Latino bodies are often racialized and classed in specific, alienating, and derogatory ways. This was exemplified in Donald Trump's June 16, 2015, presidential campaign announcement speech, during which he proclaimed that Mexican immigrants were drug smugglers, criminals, and rapists.[2] And yet, it is also important to note that certain bodies function simultaneously in a space of both hypervisibility and invisibility.

Indeed, while on the surface invisibility may seem to be the opposite of hypervisibility, it is not uncommon to be both invisible and hypervisible at the same time. In some cases, invisibility may seem preferable to hypervisibility, because it proffers a semblance of safety. To be identified as undocumented puts individuals at immediate risk of incarceration and deportation. Consequently, undocumented immigrants typically strive to remain unnoticed and unidentified. Thus, as a group, undocumented migrants are both hypervisible, socially constructed through political rhetoric and mass media, and invisible, both systemically and as a survival

skill. What all of this makes patently clear is that the politics of visibility that surround immigrant bodies are deeply perilous. And this is once they have successfully crossed. Prior to this, UBCs traversing the southern US border are hunted by border patrol and preyed upon by border vigilantes, bandits, and smugglers. They must also survive the natural dangers of the border region, such as wild animals, difficult terrain, and extreme temperatures (high and low).

The United States–Mexico border is 1,933.4 miles long and traces a line east from the Pacific Ocean in California, past Arizona and New Mexico, to end in Texas at the Gulf of Mexico. Much of the border region is rural, remote, and wild, stretching across and along wide rivers, steep ravines, craggy mountains, and desolate desert.[3] These desolate landscapes make for difficult border crossing conditions; thus, prior to the 1990s, most undocumented migrants tended to take the relatively easier routes through the neighboring border cities of Tijuana / San Diego (California), Nogales/ Nogales (Arizona), and Juárez / El Paso (Texas). Although the contemporary human rights crises in Mexico and Central America have resulted in unprecedented waves of refugee crossers, undocumented border crossing has been a defining characteristic of the United States–Mexico border since its delineation, both because the region continued to be closely linked even after the dividing political line was drawn and also because Mexican migrant labor has long been a foundational part of the US economy.

Large-scale, low-wage labor migration from Mexico to the United States was formalized in 1942 with the Bracero Program, which was intended to fill labor shortages during World War II. Over the two decades that the Bracero Program ran, more than 4.5 million individual contracts for temporary employment were approved, and an interdependent relationship between Mexican workers and US employers was established. When the Bracero Program was terminated in 1964, workers continued to cross into the United States seeking work, and they continued to be hired, only now without legal status. Although Congress had passed an act in 1952 that made it illegal to harbor, transport, or conceal illegal entrants to the United States, the employment of undocumented migrants was conspicuously overlooked in a concession to agribusiness interests. As a result, employers were under very little legal risk, and they were in a position to take advantage of the undocumented Mexican workers no longer protected under the auspices of an official worker program.

Over the next several decades, unauthorized immigration continued to rapidly increase with little official response from the United States. Things sharply changed in the 1990s with then president Bill Clinton's declared

military "crackdown" on the border and the passing of the North American Free Trade Agreement (NAFTA) on January 1, 1994. Although NAFTA was ostensibly designed to eliminate trade barriers between the United States, Canada, and Mexico, the immediate result for Mexico was an economic crash, due in part to the influx of subsidized US corn that put millions of Mexican farmers out of work and upended centuries-old ways of life for rural Mexicans. As a direct result of NAFTA, under which the United States profited and Mexico suffered, this newly unemployed and impoverished low-wage workforce began making its way toward the United States to find employment, either in the maquiladoras flourishing along the border or across the border into the United States. This wave of migrants coincided with a dramatic increase in the militarization of US border control. From 1993 to 1999, the Immigration and Naturalization Service (INS) budget was expanded from $1.5 billion to $4 billion, with much of that money allocated to border enforcement. Border Patrol more than doubled, from 3,389 agents in 1993 to 7,231 in 1998. Called Prevention through Deterrence (PTD), the INS's border control strategy included physical barriers, surveillance equipment, and additional militarized agents. Designed to deter illegal entry (as opposed to searching for undocumented migrants once they were already in the country), PTD was based on Operation Blockade, which was implemented in El Paso in 1993 and involved 450 agents who were paid overtime to cover a small twenty-mile stretch of border. Unsurprisingly, this drastic increase in border security resulted in a sharp decrease in attempted illegal entry in that particular twenty-mile stretch. Although studies found that the people deterred by Operation Blockade were generally "commuter migrants" (those who walked across the border to work service jobs in El Paso and then back again), and even the government reported that "smugglers and illegal immigrants heading for cities beyond the border circumvented" the blockade "by shifting to areas where more traditional tactics were in use," Operation Blockade was seen as a great success, and there were immediate efforts to replicate it in Nogales, Arizona (1994); San Diego, California (1994); and Rio Grande, Texas (1997) (Andreas 2013, 295–310; Cornelius 2001, 662–663; Ewing 2014).

Ultimately, the increase in border militarization had the likely unintended effect of encouraging migrants to stay in the United States (as opposed to the more circular migration that had previously been the norm under easier crossing conditions), and it did not actually stop undocumented border crossing. While border apprehensions decreased in areas with augmented surveillance, they increased along the rest of the

US-Mexico border, clearly indicating that when one stretch of border became difficult to cross, migrants simply attempted to cross elsewhere. Migratory flows shifted away from the major ports of entry toward the Arizona desert, and, by 2000, Arizona was the main gateway for migrants seeking to cross into the United States, even though a Sonoran Desert crossing involves some of the deadliest crossing conditions of the entire border.

There was also a substantial surge in the economy of illegality and violence surrounding the border more broadly. Ironically, the smuggling (of goods and humans) flourished in the face of changing US strategies.[4] When migrants were pushed to more difficult, remote crossings, the use of a *coyote* (human smuggler) to guide the way became more necessary. However, this puts migrants at the mercy of *coyotes* who often have economic arrangements with the cartels that operate in these border regions and the bandits who make a living robbing border crossers. Even if a migrant lucks upon an "honest" *coyote*, there is no guarantee of managing to both survive the physical dangers of the crossing and make it past the corruption and violence in Mexico and the US Border Patrol. In other words, actually making it all the way into the United States is exceedingly difficult and dangerous for undocumented migrants. And yet, although undocumented immigration is often understood as the moment one illicitly crosses the US-Mexico border, it is important to emphasize that for many migrants, the journey starts miles and months earlier. And, as Salvadoran journalist Óscar Martínez has painstakingly chronicled, the hardest part of the journey for those emigrating from Central America comes far before they arrive at Mexico's northern border (2013, 2016).

The journey across Mexico is exceedingly dangerous. Not only does Mexico deport more migrants than the United States, but rampant corruption and violence on the part of both the armed forces and the massively powerful gangs that control much of Mexico put migrants at near-constant risk of robbery, sexual assault, torture, kidnapping, and death. In *The Beast: Riding the Rails and Dodging Narcos on the Migrant Trail* (2013), Óscar Martínez provides an extensive overview of the hellish violence and relentless precarity migrants endure as they make their way north, ultimately portraying a migratory gauntlet so sadistic that it is all but impossible for migrants to emerge unscathed.

As depicted in *Who Is Dayani Cristal?*, many migrants travel north through Mexico toward the small town of Altar in Sonora, Mexico. Just hours south of the border with Arizona, Altar is one of the primary border crossing staging grounds. Arid and sunbaked, Altar has been described

as "a wilderness Walmart offering guides, transport and supplies ranging from boots to snake bite kits . . . Organized crime groups routinely extort, kidnap and kill migrants, turning the town and surrounding desert into a high-stakes gamble. One roll of the dice gets you into the US. Another leaves your bones bleaching in the sand" (Carroll 2015, n.p.). From Altar, crossers make their way north across the Arizona border, often toward a predetermined pickup point on the US side before continuing on to their final destination in the United States.

Alternating between desolate desert and craggy mountains, this crossing is full of dangers. A thriving rattlesnake population, vast landscapes that are easy to get lost in, dehydration, heatstroke, and both hyper- and hypothermia are all dangers endemic to a Sonoran Desert border crossing (temperatures range from 120 degrees Fahrenheit during the day to below freezing at night). In addition to the UBCs, Border Patrol, drug smugglers, and *coyotes*, there are other characters at play in the border region. Bandits make a living robbing border crossers; minutemen and US border vigilantes independently arm themselves to defend the border; residents and ranchers live along the border, as does the Tohono O'odham Nation (the second largest Native American landholding in the United States, seventy-four miles of the border fall under tribal jurisdiction); and numerous faith-based and secular humanitarian organizations offer various forms of aid to border crossers. This complex border region is known as "the killing fields," with one eighteen-mile-wide corridor on the Tohono O'odham Nation considered the deadliest migrant trail in the United States. And, while migrant apprehensions in the Tucson and Yuma sectors rose from 160,684 in 1994 to 725,093 in 2000 (US Department of Homeland Security, 2010), so did migrant deaths. Between 1990 and 2012, the Pima County Office of the Medical Examiner (PCOME) processed the remains of 2,238 migrants, the vast majority after the year 2000.[5] Yohan, the subject of *Who Is Dayani Cristal?*, was one of these bodies.

If Bones Could Speak

Shortly after the early scene in which the body is found in the desert, the white cadaver bag arrives at the Office of Medical Examiner in Tucson, Arizona. Unzipped, it reveals the shirtless, blackened, and distended body. Charles Harding, medicolegal death investigator, blots the dead man's face with a white hand towel as Lorenia Ton-Quevado, missing persons investigator and liaison for the Mexican Consulate, hovers above him, snapping pictures of the corpse with a small digital camera. Harding notes, "At the

time that Dayani Cristal came in, we were knee-deep in border crossing deaths already." He wipes a number off a whiteboard on the wall, updating it to read 1,560. Ton-Quevado carefully rifles through the dead man's worn backpack and pants pockets, searching for clues to his identity. Eventually, the body is returned to its bag, which now has the name John Doe and an identification number jotted in black on it. The body is lifted up into refrigerated wall racks of similarly bagged and tagged corpses and left.

This forensic storyline, which is composed entirely of documentary footage, continues apace, until it arrives at the eventual point of identification of the corpse. Ziploc baggies of the sundry material effects found with bodies are carefully examined, and the cadaver's hands are cut off in order to "plump up" his fingertips to procure prints. These moments highlight just how difficult it is to identify bodies. Fingerprints are only useful if they are already on file; the same goes for DNA samples and dental records. Dr. Bruce Anderson, forensic anthropologist, and Robin Reinecke, coordinator of the Missing Migrant Project, both at PCOME in Tucson, Arizona, explained that before the year 2000, there were about nineteen deaths recorded per year (it is important to note that these numbers represent only the remains that have been recovered; there is no real way to count the deaths that go undiscovered). Since the change in US policy, there have been about two hundred regional border deaths per year—a tenfold increase. Chances of positively identifying bodies are dishearteningly slim, and of the 2,238 migrant remains that PCOME examined between 1990 and 2012, more than one-third remain unidentified (Martinez et al., 2013). These individuals will not appear in the US databases that typically handle missing persons—as non-US citizens, they often have no official trace. PCOME collaborates with the Mexican, Guatemalan, and Honduran Consulates, but there is no guarantee that an individual will show up in any foreign database either. If the person has been convicted of a crime in the United States, or was previously detained and deported, they should show up in Immigration and Customs Enforcement (ICE) or Border Patrol databases—but not necessarily under the correct name or with complete information.

As Anderson and Reinecke explain, for all the scientific protocols they use, much of their success comes down to luck. For example, someone reports a twenty-five-year-old Mexican female, headed from Altar toward Tucson, who went missing within a certain time frame and who was wearing blue jeans, a blue striped shirt, a black baseball cap, and Nike sneakers, and was carrying a black backpack. If a body is found that matches that description, there is a good chance a match can be made. Since identifica-

tion is often made based initially on material effects, those material objects need to be documented and made available as visual evidence. To that end, the Colibrí Center for Human Rights, which grew out of the Missing Migrant Project seen in the film, developed a confidential, nongovernmental system for reporting people who go missing while crossing the Mexican border into the United States. These missing persons reports are then compared with all of the UBCs in PCOME's database, which includes a visual archive of material remains. Accessible to the public via Colibrí's website, this visual archive includes photographs of various forms of visual markers, such as shoes, shirts, hair clips, scraps of paper, and tattoos.

Matches do happen, but the majority of cases remain unsolved. However, in the case of Yohan, PCOME got lucky. About a month after finding his body (which they were calling Dayani Cristal because of the tattoo, hence the title of the film), PCOME heard back from Border Patrol. They thought he was a Honduran man named Carlos Sandres who had previously been detained for a minor drug offense near Portland, Oregon. In following with standard procedure, prior to deportation, he had his photograph and fingerprints taken. At the time of his arrest, he told the authorities he had crossed the border more than ten times—the first time when he was fourteen. Because *coyotes* advise people to leave all identification behind when they cross in case they are captured, officials doubted the name he had given was real. The Honduran Consulate contacted the Foreign Ministry of the Honduran government, which then ran a listing in the national Honduran newspaper *La Tribuna* with his photo and a notice that if anyone recognized him to please contact them immediately. Yohan's wife's aunt in Tegucigalpa called his wife to say that she had seen his photo in the paper; his father then went to the Office of Foreign Affairs to say he recognized the photograph. Although the name was incorrect, the chest tattoos served as final, irrefutable proof. Dilcy Yohan Sandres Martinez was from the small town of El Escanito in the Francisco Morazán Department of Honduras. He was a husband and a father, and he had emigrated in order to find work so that he could pay for his young son's leukemia treatments. The documentary storyline eventually ends with the cardboard casket carrying the body being flown back to Honduras, where Yohan is grieved and finally buried in his village.

Much of the documentation of the forensic analysis was done prior to the filming of the other strands of the story, which could only have been developed once the body had been positively identified. While the forensic analysis thus functions as a sort of skeletal structure from which the other two storylines build, the reenactment of his journey and documentation

of his family's process of remembering and mourning him work conjointly to perform another form of forensic reconstruction of Yohan, albeit one based on imagination, memory, and affect. Through the "reading" of Yohan's bones, and the material objects he carried with him on his journey, combined with the gathering of familial memories and the embodied retracing of Yohan's steps, sleeping where he slept, talking to people he talked to on his journey, and imagining how he felt and what he endured, dreamed, and desired, the film produces an affective, thickly layered memory map of the undocumented migrant experience.

The forensic analysis and narrative reconstruction together perform a peculiar sort of resurrection of the dead man, much in the vein of what elsewhere has been called the "forensic imaginary." Forensics is about the application of the scientific method, but it is also "about the *presentation* of scientific findings, about science as an art of persuasion. Derived from the Latin *forensic*, the word's root refers to the 'forum,' and thus to the practice and skill of making an argument before a professional, political, or legal gathering" (Keenan and Weizman 2012, 28). Thomas Keenan and Eyal Weizman reflect that because objects are not able to speak for themselves, they require "translation, mediation, or interpretation between the 'language of things' and that of people. This draws from the concept of *prosopopoeia*, in which a speaker artificially endows inanimate objects with a voice" (28). In other words, forensics involves "a relation between three components: an object, a mediator, and a forum. Each of these categories is elastic or dynamic. Everything in these interactions is essentially contested, and nothing goes without saying" (28). The concept of the forensic *imaginary* was developed by Susan Schuppli, a member of the Forensic Architecture Project at Goldsmiths, University of London in order to address how "nonscientific materials such as artworks can be provoked into offering a counter-testimonial to the historical narratives into which they had previously been written" (2014, n.p.). For example, while in forensic science the scientist is the mediator; in *Who Is Dayani Cristal?*, it is the filmmakers who function as mediators for the object: Yohan's body. The film gives voice and meaning to a body that cannot speak for itself—functioning, in a sense, to creatively resurrect it. Schuppli writes, "Contrary to scientific conceptions of forensics as the means of uncovering the unequivocal truth of what transpired, the term forensic imagination is predicated upon enlarging the field of enunciation through the creative retrieval and mobilization of affects. Rather than a search for empirical truths, its objectives are oriented towards an expansion of the object's or artifact's expressive potential" (2014, n.p.). Both forensic analysis and forensic imaginary func-

tion as key forms of memory mapping in the film. Yohan's bones lead the filmmakers to his identity; in so doing, they lead him to his friends and family back home, who share with the filmmakers their memories of who Yohan was, why he left, and the route he took. Following the trope of prosopopoeia, the film gives voice and body to the deceased man by seeking out and rendering visible the ghostly traces Yohan left behind. This combination of forensic and narrative reconstruction ultimately serves to visually and affectively resurrect the deceased man, and it also functions as an effective form of mapping of the constitutive relations between bodies, narrative, affect, and place.

Even though early on in the film García Bernal narrates that he is retracing the steps of Yohan's journey (thus making explicit that he is not pretending to *be* Yohan), there are moments of significant slippage between the two. The distinction between García Bernal's and Yohan's respective journeys is blurry, and the posthumous and performing bodies seem to merge. For example, we see García Bernal, as Yohan, reading "The Migrant's Prayer" in the beginning of the film (confirmed by the woman's call for "Yohan"); later, Padre Alejandro Solalinde, who runs the "Brothers of the Road" shelter in Ixtepec, Mexico, gives him the prayer to carry with him as he crosses. While the film does not make explicit whether we can know if Yohan reread the prayer prior to crossing, it nevertheless seems clear that we are seeing Yohan's journey in these scenes, and not García Bernal's. At other moments, it is unclear who García Bernal is representing— himself, Yohan, or simply an anonymous migrant. For example, at one point in the film, García Bernal joins a group of men riding atop the infamous La Bestia, the name given to the network of Mexican freight trains that are used by US-bound migrants to quickly traverse Mexico. Fellow migrants demonstrate how to climb on and how to jump off and land on your feet so as not to be pulled underneath the train. García Bernal reflects, "At first, it is loud, and powerful, but then you fall into its rhythm, like riding a horse for the first time. It's dangerous but beautiful, and then makes you relax. You climb up with your food and water, and you feel happy." The men covering the vast length of the train's roof make for a very striking image. García Bernal continues, "I have rarely felt as alive as when I was on top of that train. It wasn't because the fear of death was there along the way, but the feeling of fraternity we shared on that endless trip." García Bernal interacts with other migrants atop the train as though he is also a migrant, and obviously a film crew was present (and it is not hidden camera work, because the quality of the image is quite high). And yet, as I watched, I could not help but wonder not only if it was feasible that the

other migrants did not know who García Bernal was (possible but unlikely) but also whom the *viewer* was supposed to think he was in this moment. Following this scene, the film cuts back to Yohan's family, who tell us that Yohan felt a lot of pressure to make this trip. His young son Yohancito had leukemia, and the family was unable to pay the medical bills. Even if García Bernal is not entirely pretending to *be* Yohan in all of these scenes, by splicing together the reenactment of Yohan's journey with the family's memories of him, the film ultimately visually resuscitates a ghostly version of Yohan on his journey. In the process, the film works to portray Yohan to the viewer as a fundamentally good human being forced to migrate in order to secure a better life for his family.

Even though we cannot know *Yohan's* memories (after all, the bones are incapable of speaking for themselves), the memories of his family, both of who he was and also what he told them about his journey along the way, allow the filmmakers to recreate his experience. Combined with these familial memories, García Bernal's embodied personification of Yohan functions to resurrect him, much like the work that forensic analysis does to translate or mediate the object; in so doing, the film gives the corpse a voice that can be heard by "the forum." Keenan and Weizman write that the forum "provides the technology with which such claims and counterclaims on behalf of objects can be presented and contested. It includes the arena, the protocols of appearance and evaluation, and the experts. The forum is not a given space but is produced through a series of entangled performances. Indeed, it does not always exist prior to the presentation of the evidence within it. Forums are gathered precisely *around* disputed things—because they are disputed . . ." (2012, 29). In so doing, they deliberately shift the migrant body out of geopolitical terms (i.e., its definition in relationship to the US economy and illegality) and reframe him as a husband, father, son, friend, and brother. By working to give story to the corpse, using the memories of those who loved him and imagining the man's corporeal and affective journey, the filmmakers work to create forums—to gather forums around—the plight of the undocumented migrant.

As the splicing of memories and reenactments progresses, the film develops a fuller image of both Yohan and his journey. For example, we see García Bernal cross the Suchiate River from Guatemala into Mexico on a small makeshift raft. The border crossing is short and easy. There are no guards, no checkpoints, and no passports necessary—he simply negotiates the price and gets pulled across. As he does so, García Bernal wonders in voice-over if Yohan crossed here, who he was with, and how he felt. The

scene then shifts to Yohan's mother and then to his brother, both talking about what a loving and kind man Yohan was. We see his village, which is portrayed as tranquil and scenic but poor—a place one might have to leave in order to make money. We switch back to García Bernal, who is exchanging Guatemalan quetzales for Mexican pesos. He narrates that Yohan had to travel with enough money to pay the smuggler—$1,500.00, probably all of the money he had. We switch back yet again to Yohan's brother, who explains that Yohan was in debt and heading north to make money so that his family could have a better life.

While García Bernal's journey is the primary narrative strand of the film, these memories imbue it with meaning and affective significance, rendering it all the more poignant through the immanency of Yohan's death, which is foretold from the first scene. Much like the other visual texts explored in this book, in this film there is no way to access the direct memories of the missing; rather, the missing must be reconstructed from the material, memory, and affective remains they left behind. By thinking through—and strategically depicting—the mnemonic and performative potency of bodies (both dead and alive), visual and physical objects (bones, tattoos, prayer cards, and photographs, among other things), and place, the film ultimately produces an affective, visual memory mapping that renders legible the resonances and connections between those bodies, landscapes, and objects; the presence of absence of those lost; and the life constantly being shaped around that loss. In so doing, the filmmakers ask viewers to see Yohan's choice to migrate as the act of a loving father and the border region not as a landscape determined by faceless bodies, death, and crime but rather as a space of hopes, dreams, and, above all, fellow humans.

The memory mapping done in this film is clearly different from the memory mapping analyzed in other chapters: instead of exploring individual and collective memory in the aftermath of large-scale conflict, this film focuses on the life of a single man in order to make a much broader commentary on an ongoing political issue. Yet, the film demonstrates the same investment in the affective power of visually mapping connections between memory, the dead, landscapes, and the lived experience of loss as a means through which to impact how audiences perceive of, and feel about, an unresolved injustice. The layers of mapping in the film—the literal mapping of the body's route through the landscape that is produced by the ghostly retracing of Yohan's journey, with García Bernal's body as translator, and the affective mapping and conjuring of ghosts that occurs as a result of both the familial memories and forensic mapping—combine to affectively and visually represent and lay claim to a specific narrative about

the border, immigration, and the plight of the migrant. This narrative deliberately functions as a counterpractice to mainstream rhetoric on undocumented border crossing by challenging how the border region and immigration are typically represented.

Drugs, Gangs, Violence, and Victims of a Larger System

Although undocumented immigration is a fraught political issue in the United States, images of migrants engaged in the actual process of south-north migration are surprisingly scarce. Mexico and the US-Mexico border region tend to be broadly defined by visual economies that emphasize—arguably even glorify—ghastly, senseless cruelty, but it is quite rare for the migrants themselves to be the focus, as though migrants do not really exist until they arrive in the United States. Archival searches in Arizona, Texas, and California for images of Latino migration and migrant labor were largely fruitless; the majority of archival images of migrant labor I was able to find were of predominantly white laborers migrating within the United States during the Great Depression.[6] To a certain extent, this makes sense: these photographs were produced under the Farm Security Administration's photography program, which ran from 1935 to 1944 and funded the work of famed photographers such as Dorothea Lange, Walker Evans, and Gordon Parks, resulting in an expansive, collective body of work. It is also fairly easy to find a selection of images of laborers who came into the United States as part of the Bracero Program, but these images all document workers once they are already in the United States (men working in fields, waiting for transport, standing in line to be fingerprinted, and being fumigated with DDT, as well as a smattering of individual and family portraits). There are slight exceptions to this: Leonard Nadel's photography of the Bracero Program resulted in striking images of braceros walking over the Reynosa-Hidalgo Bridge that connects Reynosa, Tamaulipas, to Hidalgo, Texas, but while they document the bodily action of crossing the border into the United States, they also effectively reinforce the idea that these migrants are allowed to enter the United States because they are workers, and they still only render migrants visible once they have crossed into the country. Beyond the Bracero Program, I found a few other sets of images of Latino laborers in the United States, including of worker protests, such as Paul Fusco's images of the 1968 California Grape Strike. It is also worth noting that images of migrants migrating may be difficult to find in archives because the form of migration seen in the film is a relatively new phenomenon. As noted earlier, before the border was milita-

rized, the borderlands were much more fluid, and migration more circular, with people moving in interconnected webs; it was only after the 1990s that migration shifted to the unidirectional flows we see today. It is thus also feasible that although images of migration are largely absent from larger and national archives, photographs of pre-1990s migrant workers would exist in smaller community and family archives, having traveled back with migrants as documentation of their journeys to be shared with loved ones.

Looking beyond photography for documentation and visual representation of south-north migration, there is a range of contemporary films that focus on border politics and migration. The majority of border films focus on the often intersecting tropes of drugs, gangs, and violence, but there are other important, usually smaller-scale, contributions, albeit with overlapping visual tropes. Migrants are often framed as victims of a larger system, including in *El Norte* (1983, dir. Gregory Nava), an independent drama that portrays two indigenous youth who flee persecution in their home country of Guatemala and migrate through Mexico, eventually arriving in Los Angeles, California; and in *The Other Side of Immigration* (2009, dir. Roy Germano), a documentary that explores the root causes of immigration, for which the director reportedly interviewed more than seven hundred families in Mexico about why people felt the need to migrate. Other notable contributions include *Which Way Home* (2009, dir. Rebecca Cammisa), which investigates immigration from the perspective of Honduran children traveling through Mexico atop La Bestia in hopes of reaching the United States; *Norteado* (2010, dir. Rigoberto Perezcano), a fictional rendering of a young Oaxacan man who gets stuck in Tijuana while repeatedly attempting to cross into the United States; and the surreal science fiction film *Sleep Dealer* (2009, dir. Alex Rivera), which is about a young Mexican man forced to migrate north for work, only to get stuck at the border working in a strange, digital factory where his body is connected to a robot in the United States.

Other films portray the challenges immigrants face after arriving in the United States, including their struggle to find work, their lack of rights, and the hostile reception they receive. Examples of this theme include *A Better Life* (2011, dir. Chris Weitz), which focuses on the lives of undocumented Mexican workers living in Los Angeles, and *Crossing Arizona* (2006, dir. Dan DeVivo and Joseph Matthew), which explores a range of perspectives on migration, including those of ranchers, humanitarians, political activists, and the armed minutemen who patrol the border. The only film in this category that mainstream viewers are likely to have seen is *Babel* (2006), made by famed Mexican director Alejandro González Iñárritu's and

starring Brad Pitt, Cate Blanchett, and Gael García Bernal. This film is composed of three intersecting storylines, one of which is of an undocumented Mexican nanny working in the United States who takes the children under her care with her back to Mexico without their parents' permission. A series of unfortunate events ensue, and she is criminalized and unable to return to the United States. This list is not exhaustive—there are other examples of films that challenge the hegemonic tropes about the migratory journey, including a number of small-budget, independent documentaries, but the vast majority of mainstream popular culture films (both fiction and documentary) represent the border and migration through the lens of drugs, gangs, and violence.

The specific angle varies from film to film: some, including *Cartel Land* (2015, dir. Matthew Heineman) and *Kingdom of Shadows* (2015, dir. Bernardo Ruiz), focus on the drug wars, whereas others center on the cross-border impact of the drug trade (see, e.g., *Traffic* [2000, dir. Steven Soderbergh] and *Maria Full of Grace* [2005, dir. Joshua Marston]). Other films, such as *Señorita Extraviada* (2003, dir. Lourdes Portillo), *Sin Nombre* (2009, dir. Cary Fukunaga), and *Narco Cultura* (2013, dir. Shaul Schwartz), highlight the sociopolitical ramifications of unchecked drug- and gang-related violence. The latest mainstream Hollywood hit to focus on these themes, *Sicario* (2015, dir. Denis Villenueve), was considered so "extreme" in its depiction of the "cruel and disturbing world" of drug- and gang- related border violence that the Tribeca Film Festival published a list of five other "informative movies" to help viewers "prepare" to watch *Sicario* (they recommended *Cartel Land*, *Kingdom of Shadows*, *Narco Cultura*, *Maria Full of Grace*, and *Traffic*) (Martinez 2015).

As this brief list of films makes clear, although south-north migration is all but missing from image archives, there is nevertheless an existing and broad economy of cinematic representation that constitutes it in specific ways. It is also important to note that, in almost all of these films, the dead bodies of migrants are not the focal point but rather the fallout of the violence and corruption that comprise the actual focus. Even *Narco Cultura*, in which one of the main narrative strands follows the men who work as crime scene investigators for, according to the film, "the busiest forensic department in the country and world" (SEMEFO, Servicio Médico Forense / Forensic Medical Services in Juárez), pays no attention either to the individual lives of the victims or to the afterlives of their bodies. That film notes that out of every one hundred cases, only three advance with investigation, which means that 97 percent of the ten thousand murders over the past four years have not been investigated. Yet, there are no inroads

into the implications of this shocking breakdown in the system, nor is there any demonstrated interest in the dead bodies as individual lost humans or in the families that mourn them. Border crossing factors into the film, especially as many of the crime scene investigators live in fear for their lives and believe they and their families will only be safe if they move to the United States (this is a well-founded fear, as they are slowly being targeted and picked off by the cartels, even though the crime scene investigators wear masks to hide their identity while they work); however, glaringly missing from this documentary's exploration of drugs, violence, and the US-Mexico border is any mention of the demand side of the drug war and the impact drug users in the United States have on drug-related violence in Mexico. This is a somewhat bizarre oversight given the subject matter of the documentary, but it serves to reiterate what this quick overview of films makes clear, which is that there is an investment—not just in political rhetoric but also in mainstream visual culture—in perpetuating conceptions of the border region as violent and corrupt, and the migrant as either criminal or victim (although the films mentioned were made by both US and Mexican directors, the films themselves are largely geared toward US audiences).

There are, of course, other examples of visual works that push back against these tropes to remind audiences both that the Latino immigrant experience is far more complex, and that the border is a vastly more heterogeneous region than is typically represented. For example, several contemporary television shows have made efforts to undermine immigrant stereotypes in humorous ways, such as *Jane the Virgin*, which follows the life of a young and pregnant Latina with an undocumented grandmother at risk of deportation, a single working mother, and a telenovela star father; and the short-lived *Bordertown*, which takes place in the fictitious town of Mexifornia and focuses on the relationship between two neighbors, one of which is a border agent and the other a relatively recently arrived immigrant (although it must be said that these shows stand out precisely because they are the exception in mainstream media).[7] Similarly, while beyond the scope of this chapter, there are important examples to be found in music and literature as well (Anzaldúa 2012, Brady 2002, Fregoso 2003, Kun and Montezemolo 2012, and Ngai 2014).

That this visual economy is largely dominated by popular culture representations that tend to focus on or glorify drugs and violence is perhaps not entirely surprising, given the pervasive ramifications of the malignant hornets' nest that is NAFTA, US border and immigration policy, weak and corrupt Mexican and Central American states, and what is commonly

referred to as narcoculture (*narcocultura*), or the narcomachine. Nonetheless, these are the complex and overlapping systems these visual texts stem from and operate within, it is the visual economy migrants get caught in and defined by, and it is in this broader visual economy that *Who Is Dayani Cristal?* operates.

Changing the way certain bodies and places are seen and understood is thus no easy task, but it is also a necessary one. *Who is Dayani Cristal?* is one example, but there are also interesting and relevant interventions to be found in independent visual, performance, and new media art. For example, Yoshua Okón's 2015 piece *Oracle*, based on the "Arizona Border Protectors" militia's protest of the entrance of unaccompanied Central American children in the United States, and Guillermo Gomez Peña and his performance collective, Pocha Nostra, who have produced numerous works, including their 2008 performance *The Mexorcist 3: America's Most Wanted Inner Demon*,[8] that explore the construction of the border as a zone of armed vigilantism intended to exclude certain bodies in the name of the rights of others. Ana Teresa Fernández's *Borrando la Frontera*,[9] a project in which she literally paints over various sections of the border wall that began in 2011 and continues today, and Postcommodity's 2015 land art installation *Repellent Fence*[10] both work to challenge concepts of the border as an impenetrable divide. Two new media projects—Ricardo Dominguez and the Electronic Disturbance Theater 2.0/b.a.n.g. Lab's 2010 Transborder Immigrant Tool and John Craig Freeman's 2012 Border Memorial: Frontera de los Muertos—use cell phones as a form of creative intervention into migratory movement, life, and death. All of these various projects are examples of the ways in which the border and immigration are explored and/or contested through creative practice. They raise important questions about how we can, materially, and should, ethically, interact with space and place, and the bodies that move through, and are constituted by, those spaces and places. While taking a profoundly different approach than *Who Is Dayani Cristal?*, the Transborder Immigrant Tool and the Border Memorial are also both examples of creative interventions that explore how the movements of bodies through space can redefine and produce alternate mappings of specific places, regions, and landscapes.

The Transborder Immigrant Tool was born of the question of what widely available and affordable technology could be used to help migrants en route find the water caches humanitarian groups leave in the Southern California desert. The group settled on twenty-dollar cell phones, onto which technology could be installed that provided both poetry for encour-

agement and GPS (which does not require service and has free global coverage, courtesy of the US government) that would lead immigrants to the closest water cache (Dominguez 2011). The project was supported by Water Station, Inc. and Border Angels, two NGOs that have been leaving water caches along the Anza-Borrego area of Southern California for more than a decade, and it was with their support that the Electronic Disturbance Theater 2.0/b.a.n.g. Lab was able to create the locative map points to which the Transborder Immigrant Tool navigates its users. The Transborder Immigrant Tool was hugely controversial, resulting in the artists involved being investigated by three Republican Congress members, the FBI Office of Cybercrimes, and the University of California, San Diego, where Ricardo Dominguez works as an associate professor in the Department of Visual Arts. Although all of the investigations were eventually dropped, attempts were made to strip Dominguez of his tenured status, and the artists endured vitriolic attack from right-wing media, in particular Fox News and Glenn Beck, who claimed that their poetry would "dissolve" the nation (Nadir 2012). The potential "illegality" of the project rested on the question of whether it was art or activism. Dominguez states very clearly that "[a]ll the members of EDT 2.0/b.a.n.g. Lab anchor their being and becoming as artists and every gesture that we make as an aesthetic gesture," ultimately arguing that while activists may break the law, Electronic Disturbance Theater makes art to change the conversation by performatively, or theatrically, disturbing the law (Nadir 2012). This dichotomy is a fairly shaky one, especially because it is patently evident that this work inherently functions at the intersection of activism and art, or what elsewhere has been called artivism (see, e.g., Ensler 2011; Sandoval and Latorre 2008); however, in this case, the point Dominguez is making by deliberately articulating such a distinction is both provocative and essential to the piece itself. Under current immigration law, crossing the border without the appropriate documentation is illegal; a political (activist) project that aids and abets such behavior is consequently, under law, *also* illegal. However, the direct relationship between political action and legality is undermined when the ontological status of the project is defined as fundamentally creative, not because artists are exempt from the law (obviously, they are not) but because it changes the question from "Is this illegal?" to "Should or should not this project be considered illegal?" or, better put, "*Why* is this project potentially illegal?" From there, the door is opened. The Transborder Immigrant Tool demands that audiences ask themselves why helping people in need of finding water would or should be illegal, and it points

to an exceedingly ugly truth: the stakes of the question are found not in the thirst itself but in which, and whose, bodies are in need of lifesaving water. It forces audiences to recognize that undocumented immigrants are seen as less than human, better left to die than helped to live. A consideration of the legality of the Transborder Immigrant Tool thus results in viewers being confronted with their own potential discrimination and apathy toward the lives of others.

The Border Memorial: Frontera de los Muertos similarly places audiences in the position of the active witness by requiring their presence—a "being there" in order to experience the piece. The Border Memorial asks audiences to think about how the lives and deaths of immigrants are conceived in the social imaginary, although it focuses not on the bodies of migrants in need but instead on those found already dead. Described as "an augmented reality public art project and memorial dedicated to the thousands of migrant workers who have died along the U.S./Mexico border in recent years trying to cross the southwest desert in search of work and a better life" (Freeman 2012), the Border Memorial is a mobile application built for use on an iPhone, iPad, or Android device. Once the application is downloaded and launched, users aim their device's camera at the landscape along the border and in the surrounding desert. Using geolocation software, the application marks the GPS coordinates of each recorded border crosser death with the image of a skeleton, in a clear reference to the calacas used in Day of the Dead celebrations. No details are given about

Figure 13. John Craig Freeman, Border Memorial: Frontera de los Muertos, screenshots produced on location in Southern Arizona; Coyote Mountain 32.0406, -111.4672; Maish Vaya 32.16615, -112.12512; Mt. Wrightson, 31.80965; and Yuma -110.71124, and Yuma 32.722793 -114.540194. Courtesy of John Craig Freeman, 2012.

the dead—not their gender, age, when they were found, or if the person has been identified. The skeleton is the same no matter what kind of body it is and where or when it was found. This is in striking contrast to other geospatial maps of migrant mortality, such as the Arizona OpenGIS Initiative for Deceased Migrants (www.humaneborders.info/app/map.asp), a web map with search tools that enable users to search by decedent name, gender, year of death, cause of death, county of discovery, land corridor, and land management (e.g., air force range, wildlife refuge, Bureau of Land Management, Forest Service, Reservation and First Nation lands, and land owned by the city. Among other reasons, this matters because each of these lands operates under different jurisdiction, and thus the procedures with regard to found bodies vary).[11] On this map, the location of each body is marked by a red dot; a click on the dot opens a small box with information on all that is known about that particular death.

The amount of information that is available for each body varies, but the Arizona OpenGIS Initiative for Deceased Migrants mapping project overall provides both an archival overview of migrant death in the region and a bird's-eye view of both the sheer immensity of death and how embedded it is in the desert landscape. From the perspective of the user, this form of migrant death mapping is in contrast to the intervention of the Border Memorial, which, like the Transborder Immigrant Tool, requires users to be physically present *in* the landscape in order to use the maps that lead to the calacas that function as ephemeral cenotaphs. Consequently, both the Transborder Immigrant Tool and the Border Memorial deliberately shift the position of the audience/user. Passive viewing is not an option. The spectator is inherently an active participant in the intervention and thus also the landscape.

Just as *Who Is Dayani Cristal?* revolves around the politics of visibility in relation to particular bodies and their ultimate survival, both the Transborder Immigrant Tool and the Border Memorial Project similarly focus on the ways in which subject positioning ultimately defines one's right to life. By highlighting how contentious it is to provide dying migrants with water and the reality that humans die unnoticed on the US side of the border, often just minutes from potentially lifesaving care, both effectively foreground for viewers the jarring lack of human rights or even basic human decency afforded to humans once they have been defined by the act of undocumented migration. The ways in which each of the projects integrates migrant bodies vary: Whereas *Who Is Dayani Cristal?* relies on the individual identity of the migrant crosser to make its claim, in the case of the Transborder Immigrant Tool, because the project is designed to engage

with migrant bodies as potential users of the app and, in their precarity, as representative of the broader sociopolitical issues, the individual identity of each migrant is ultimately irrelevant. The Border Memorial pointedly leaves migrant bodies anonymous, effectively placing visual markers at the site of each individual death while still acknowledging how the invisibility and dehumanization that so often defines the undocumented migrant experience follows the bodies into death. In so doing, the project marks the landscape as haunted and reminds viewers of what surrounds them just beyond the edges of the visual. If the Transborder Immigrant Tool asks audiences to consider why only some bodies are deemed worthy of being saved, in visually resuscitating their deaths, the Border Memorial asks how so much migrant death could be invisible and thus reminds audiences anew of the direct correlation between visibility and political recognition and subjecthood.

The interventions these works make varies, but the underlying tension across all of these projects is similar: the question of why some bodies are deemed to matter and others are not. In order to address this question, all three projects work within the politics of visibility that surround undocumented migrant bodies and the perils of their migration journey. They highlight the mutually constitutive relationship that exists between places and bodies, and they work to provide spaces for alternate readings and possibilities. Visual texts such as these thus make a crucial contribution to how the border and undocumented migration are conceived of in the social imaginary. They have the potential to either affirm or challenge the political rhetoric and visual economies that work to regulate certain bodies and affirm the performance of state power that occurs on and through the border and the bodies that traverse it.

The implications of this have the potential to be profound. As Hastings Donnan and Thomas Wilson (1999) have argued, the state is most visible at the border, and as such it is also where the state's power is most tested. In response, state power is performed through security apparatuses and the adjudication of which bodies are allowed entry and which are not. Undocumented migrants are defined in the eyes of the state by their act of unauthorized crossing, just as the border region is both constituted and contested through those same actions. On the one hand, undocumented crossing *affirms* the border's role in demarcating separate sovereign states and their ability to determine which bodies are allowed entrance and which are not; on the other hand, undocumented crossing also *undermines* the state's performance of power at the border by demonstrating that the bor-

der is not an impermeable wall of power but rather something that bodies that have not been authorized by the state nonetheless continuously surmount. While this correlation between US citizenship and its corresponding rights is a gross oversimplification that borders on fallacy (the extreme inconsistencies in the ways in which citizenship rights are upheld for bodies of different colors, religions, sexualities, and genders make blatantly obvious that citizenship does not guarantee the implementation of equal rights), one of the interpellative concepts that undergirds the very idea of statehood is that certain bodies belong and others do not. The bodies that belong to the state ostensibly have rights that nonbelonging bodies do not, a differentiation that both criminalizes bodies that have entered the country unlawfully and calls into question the legality of giving them lifesaving water. However, at least insofar as undocumented immigration is concerned, the state consequently either fails to make adequate distinctions between citizenship rights and human rights or is set up to neglect human rights in a deformed defense of citizenship rights, because the human rights of undocumented migrants are continuously and systematically overlooked. This is why the politics of visibility surrounding migration are so important. If undocumented migrants remain both hypervisible and invisible, they stay faceless and dehumanized, and thus their claims to human rights similarly remain unseen and overlooked. But, if they are rendered visible—recognizable—as fellow humans, then they are also recognizable as subjects worthy of being saved and worthy of being grieved when they are not saved. In other words, when migrants are recognized as fellow humans with the corresponding claims to human rights, it is no longer (in theory, at least) acceptable to violate those rights. The question of visibility in relation to migrant bodies, then, is the question upon which everything else builds, and it is why projects that work to challenge mainstream representations and make migrants and migration seeable in new ways are so crucial.

As this brief overview highlights, there are many ways in which visual texts both participate in the visual constitution and contestation of the border and work to make interventions into the politics surrounding migration. The memory mapping that occurs in *Who Is Dayani Cristal?* is one such example: the film works to provoke empathic identification in viewers by giving the faceless migrant a face and grievable story. However, as noted earlier in the chapter, the film's work to make Yohan, and, through him, the undocumented migrant, seeable in new ways is complicated by the choice to have him played by Gael García Bernal. We must ask whether the extreme visibility of a movie star ultimately further erases the migrant.

Furthermore, if the filmmakers wanted to represent the experience of undocumented migration, why did they choose to do it from the perspective of someone who was already dead? In the context of visibility and grievability, what can dead bodies do that live bodies cannot? The final section of this chapter turns to these questions.

The Politics of Visibility and Grievability

Gael García Bernal is a prolific and well-known actor. At age thirty-nine, he has already starred in dozens of films and won numerous awards; he co-runs his own film festival, and he has sat on the jury of other prestigious international festivals.[12] While it is certainly possible that García Bernal will be unfamiliar to some audiences, his star power in both Mexican and US films makes him a widely recognizable actor. The benefits of this visibility are fairly straightforward: his participation in the film gives it a wider funding and audience reach than it might otherwise have had. However, this visibility in turn makes García Bernal less convincing as an undocumented migrant, all the more so in a *documentary* film. Furthermore, because his delicate facial bone structure, light eyes, and fair skin mark him as being of mixed European descent (which, due to the colonial legacies of Latin America, is traditionally associated with the upper classes), he also *looks* phenotypically different than Yohan's family and the other migrants in the film. His portrayal of an undocumented border crosser is thus unavoidably problematic.

If one's viewing experience is dominated by recognition of García Bernal—in other words, if the viewing experience is filtered through the awareness that the person embodying the role of the migrant is indisputably *not* a migrant—the resulting consequence may be that the "extra" visibility of García Bernal inadvertently serves to effectively erase the migrant even more. The migrant remains faceless and unknown. Alternatively, there is also the possibility that the tension between his extreme visibility and the ongoing erasure of the migrant has the potential to be productive. An audience's ability to identify García Bernal and recognize that he is *not* an undocumented migrant could remind viewers that there are humans who *do* endure those conditions who remain unknown and unseen. In this equation, the inability to fully "see" the migrant thus highlights for audiences the simultaneous hypervisibility and invisibility that surrounds the migrant body and induces them to reflect on their own participation in the visual regimes that reinforce these visual dynamics. Audiences are reminded that Yohan was a specific individual, now irrevo-

cably gone, and that ultimately no creative reenactment will suffice to somatically bring the man back to the world of the living. The problem, of course, is that in order for this visual equation to succeed, an undue amount of responsibility is placed on the viewer to make the appropriate cognitive associations: to think critically about the tensions between visibility and invisibility, one's own participation in visual regimes, and the relationship between visuality and power. This is perhaps too tall an order.

This is one of the challenges of celebrity participation in human rights advocacy. While such involvement inevitably brings greater attention to a cause, there is always the risk that the celebrity presence will overshadow the issue they are working to represent. When thinking through the potential for visual texts to challenge mainstream representations of undocumented migrants and the US-Mexico border, and intervene in how they are perceived in the public sphere, such considerations must be taken into serious account, for they shed light on how visual texts inadvertently run the risk of reinforcing certain discriminatory narratives and structures of power even as they seek to undermine them. Ultimately, it *is* unsettling to have a celebrity weave in and out of the personification of a dead migrant in a documentary film, even given the purpose the dead body served. Furthermore, *were* Yohan alive, it would bring up uncomfortable questions about why he was not allowed to speak for himself (and why *his* particular story was the subject of such interest). However, I argue that it is not Yohan's particular life experience that is the most important but rather that it is his death that makes him significant.

Returning to the concept of prosopopoeia, because a dead body cannot speak for itself, in order for it to "speak," someone else must speak for it. This makes dead bodies a particularly useful tool. In *The Political Lives of Dead Bodies*, Katherine Verdery reflects that one of the most important properties of dead bodies is that they "do not have a single meaning but are open to many different readings. Because corpses suggest the lived lives of complex human beings, they can be evaluated from many angles and assigned perhaps contradictory virtues, vices, and intentions" (1999, 28). As a result, a dead body's "symbolic effectiveness in politics is precisely its ambiguity, its capacity to evoke a variety of understandings" (28). Because Yohan is dead, the filmmakers are able to use his body to make broader comments about migration and the border that would not be possible if he were still alive.

Furthermore, a dead body is grievable in a way that a live body simply is not. In *Precarious Life*, Judith Butler explores what makes certain lives grievable, writing, "[T]he differential allocation of grievability that decides

what kind of subject is and must be grieved, and which kind of subject must not, operates to produce and maintain certain exclusionary conceptions of who is normatively human: what counts as a livable life and a grievable death" (2004, xiv). This grievability is determined in the public sphere, but, she continues: "To produce what will constitute the public sphere, however, it is necessary to control the way in which people see, how they hear, what they see . . . It is also a way of establishing whose lives can be marked as lives, and whose deaths will count as deaths" (xx). Butler contends that in order for a life to be considered grievable, that life must be recognized as a fellow subject: each partner in a "struggle for recognition" must "recognize not only that the other needs and deserves recognition, but also that each, in a different way, is compelled by the same need, the same requirement" (43). *Who Is Dayani Cristal?* works to establish this recognition over and over again: Padre Alejandro Solalinde, the priest who gives Yohan (and García Bernal) the prayer card, reflects: "The migrants are heroes. They are like rays of light, shining on things we must change. They are heroes who fight not only for their families; they are fighting to change the story of the US and Mexico . . . *How can you ask them to not want what we all want?*"[13] Shortly thereafter, Robin Reinecke underscores the importance of this recognition: "We haven't given them any choice but to try to survive . . . I think we would want to be human before we would want to see them as legal or illegal."

Using memory mapping as a strategy to construct a specific narrative about the border, immigration, and the plight of the migrant, and in turn to render the life of a migrant grievable, the filmmakers are striving to, in the words of Jacques Rancière, "sketch new configurations of what can be seen, what can be said, and what can be thought and, consequently, a new landscape of the possible" (2010, 103). By asking why certain lives are rendered visible, and thus grievable, and others are not, the film functions as a challenge to visual regimes and discourses that dehumanize migrants. Through the careful and methodical mapping of the dialogical relations between landscape, bodies, memory, narrative, materiality, and visuality, the film works to provoke empathetic identification in audiences both by identifying the migrant as human, with the same claims to human rights as everyone else, and by making viewers see the inherent violence of both the underlying economic situation and the border policies that claim migrants as faceless victims. Whether the filmmakers succeed is, of course, harder to determine, in part because impact and social change are both difficult to quantify.

The impact of documentary films is generally framed as a linear, or expansive, equation: a compelling story leads to increased public awareness; this leads to increased public engagement, which results in strengthened social movement, which in turn leads to social change (McLagan 2012, 312). The filmmakers of *Who Is Dayani Cristal?* were explicit about their desire for the film to have a social impact. The filmmaker's notes on the film explain that brainstorming began in 2008 between Gael García Bernal, Marc Silver (director and executive producer), Thomas Benski (producer), and Lucas Ochoa (producer). They knew they wanted to tell a story about migration but were unclear what form it should take, so they created an online platform where people could submit stories related to the theme of migration. One issue that really stuck out was the "demonization" of migrants all over the world. Knowing that their fundamental challenge would be "making people care about an issue which is so often buried in rhetoric and politics," the filmmakers sought to tell a story that would transcend politics and "inspire audiences to ask themselves what they would have done for their own family if they were in a similar situation." Ultimately, they aimed for two kinds of impact: direct community impact and broader shifts in perception with regard to migrants (www.whoisdayanicristal.com, press pack). Along with several NGO partners, the filmmakers embarked on a three-year relationship to explore how to improve well-being and thus lessen the need to migrate. They also worked with migrant rights' advocacy groups and national rights organizations that identify and repatriate bodies, and they designed digital engagement tools intended to "educate and humanize around a selected set of systemic migration issues," including the right not to migrate, repatriation, detention and deportation, and US labor demand (www.whoisdayanicristal.com, impact assessment). The centerpiece of this public education aspect of their campaign was an educational website and e-book, both of which combine research with reflection and migrants' stories. The film was also screened at the State Department's Western Hemisphere Affairs section, and it has been made widely available to US and Mexican and Central American audiences through various digital platforms, including Netflix in the United States and Canana, Ambulante, and Mundial in Mexico.

The film undoubtedly led to increased public awareness among its viewers, but whether or how it will contribute to quantifiable social change remains to be seen. Indeed, the filmmakers report that *Who is Dayani Cristal?* did not reach as wide of an audience as they had hoped, and some of their promotion efforts failed (e.g., the Central American distributor

failed to release the film at all in Honduras, so all screenings were private, foundation-supported events). In addition, their efforts at policy reform (in collaboration with the Washington Office on Latin America) resulted in no legislative change (www.whoisdayanicristal.com, impact assessment). There is also no data on how many people have seen the film, or if it has changed their perspectives on migration. Ultimately, even though we have more data on the impact of the film than is usually available, the ultimate impact in the public sphere is still unclear.

On its own, the film may not be enough to subvert deeply embedded and continually reinforced ideological structures. However, there is still substantial value to be found in its attempt to intervene in the highly saturated and heavily signified visual economy that surrounds the border region and immigration. The film confronts viewers with the reality that there is, in effect, a mass grave in the United States, one into which bodies continue to fall. This mass grave is the direct result of years of US policies that have: undermined and destabilized economic and sociopolitical conditions in Mexico and other countries across the Americas, resulted in subsequent waves of migration to the United States, and dehumanized and criminalized migrants once they arrive. Yet, the harsh realities of the United States' role in perpetuating these dynamics tend to be concealed behind the visual tropes of gangs, drugs, and violent lawlessness that are used to justify the continuation of these cycles. When framed in this broader context, the importance of a visual text that works to make viewers see and feel the inherent violence of the underlying economic situation and the border policies that claim migrants as faceless victims cannot be underestimated (along these same lines, the filmmaker's decision to use an actor who would give the film a wider reach than it might otherwise have had also seems the obvious choice).

Ultimately, the question of how to make people care is not easily answered. The visual works explored in this chapter, and, indeed, the book as a whole, work from an equation that triangulates seeing, feeling, and knowing. They work to shift the spectatorial gaze from one of indifference or elision to one of *affective seeing*. They do this in different ways. New media projects such as the Border Memorial and the Transborder Immigrant Tool ask similar questions about why some bodies are deemed to matter and others are not, and they position spectators to reflect on their own participation in the perpetuation of cycles of violence. Conversely, *Who Is Dayani Cristal?* uses memory mapping, and what makes this strategy relatively unique is its ability to convey a holistic narrative in ways that

rely on the visual but extend beyond it into affective, ephemeral realms. The three strands in the film—the forensic analysis, the familial memories, and the retracing of Yohan's journey—function in a relationship of dialectical constitution: the forensic analysis of the bones leads us to Yohan's family, memory provides the narrative that gives the film its affective resonance and its narrative coherency, and it is only through this memory that the retracing of the journey is able to occur. Finally, together with the bones and memory, the embodied retracing of the journey functions as a means through which to ultimately complete the reconstruction—who Yohan was, where he was from, why he crossed, and how he came to die in the Sonoran Desert. Yohan's haunting presence, the importance of "reading" his bones, and García Bernal's embodied retracing of his journey cohere into a performative space in which the mnemonic and performative potency of bodies (both dead and alive) takes center stage. These bodies are situated in direct dialogue with materiality: Yohan's physical remains are the anchor around which the film is built, but it is the photograph of Yohan that functions as the tangible material means to track his identity, and it is his tattoos—the visual imprints he has made on his own body—that ultimately identify him to his family. Other material objects (prayer cards and photographs) assist to anchor these three strands to each other and to the landscape. By charting the connections between bodies, objects, memories, affects, and place, the film effectively creates an affective, visual mapping of the deceased migrant as a grievable, relatable human whose loss continues to impact the living, and it does so in order to shape what audiences see, how audiences understand, and, more importantly, to change how they feel.

As I have progressively argued in this book, memory mapping makes legible the ways in which the past and the dead are integrated into the everyday life of the living and the landscapes we occupy. In those moments when other forms of contact are difficult or impossible to access, memory mapping visually and affectively establishes sensory contact with past bodies, events, and places. This approach is intended to create a context in which *seeing* functions as a form of *feeling* and idle spectators are turned into active witnesses to the injustices of the past and the ongoing need for redress in the present. Memory mapping is a technology through which people's relationships to place, event, time, and each other can be performed and transmitted, and it serves as a means through which to hail witnesses and to firmly anchor injustices to specific bodies and landscapes. Memory interventions are successful when they create spaces for

audiences to see *with*, and *through*, other people's experiences, and to rec-
ognize how much of the past, its ghosts, and its material and affective resi-
dues continue to impact and shape the world we live in today. They seek to
stimulate empathy and foster witnesses. This is the desire embedded in
these texts. This is also their promise: through the intersections of affect,
visuality, and memory, social change is possible. Whether, when, or how
this happens is, of course, up to us.

Conclusion

What is the precise moment, in the life of a country,
when tyranny takes hold? It rarely happens in an instant;
it arrives like twilight, and, at first, the eyes adjust.

—EVAN OSNOS, 2016

In June 2017, as I was finishing the revisions for this book, I was fortunate to attend a seminar at Auschwitz-Birkenau, the former Nazi concentration and death camp turned internationally renowned memorial site. Run by the New York–based Auschwitz Institute for Peace and Reconciliation, the Lemkin Seminar draws leaders from across Latin America to the small town of Oświęcim, Poland, for a weeklong training on genocide and mass atrocity prevention. The first several days of the workshop were spent immersed in site-specific learning about the Holocaust, including in-depth tours of both camps, before transitioning to the Latin American context in the latter half of the week. The decision to ground the training in place-based learning was a masterful stroke: participants come to learn about genocide prevention at what is often framed as the limit case of human evil. Everyone understands what evil is in this context. No one argues to justify the actions of the Nazis—and how could you, so steeped in the learning of the memorial site, surrounded by the vast piles of hair, shoes, and other belongings of those individuals who were either killed immediately or slowly starved and abused until death became an almost near certainty. Instead, seminar participants are brought to understand *how* such an

atrocity could come to be—that it did not happen overnight, that it built on years of racism and prejudice, on weakened state forms, and on people willing to stand by as evil progressively flourished. After several intensive days of learning, and freshly equipped with knowledge about early warning signs, risk factors, and triggers for genocide and mass atrocity, the analytic lens then shifted to the participants' own countries.

Newly positioned to consider their *own* perspectives, prejudices, and potential complicity, some participants were perceptibly less comfortable than others. While the purpose of the seminar was not to identify perpetrators within the group of participants but rather to educate and create both state and regional networks of support and accountability, this was an immeasurably powerful experience to observe. As I watched seminar participants learn about mass atrocity and the possibilities for its prevention, literally and figuratively situated in this greater context of human apathy and evil, I spent a lot of time thinking about the power of place, and the past, to teach us. *Why* does it matter to remember? *How* do we remember? And what does that remembering *do*?

In many respects, these questions have been the undercurrent of this book. Daniel Hernández-Salazar's *Esclarecimiento* is both an act of memory and an act of protest. It demonstrates the performative, mnemonic potency of visuality and maps a direct connection between the violent atrocities of Guatemala's recent past, those in the present willing to stand by, and the survivors' demands for justice and accountability. When used as the cover image for the report, carried in protest, and pasted up on city walls as a form of public intervention, *Esclarecimiento* embodies the anguished voices of the dead who call upon the living to remember.

The Salvadoran documentary *The Tiniest Place* (*El lugar más pequeño*, 2011), examined in Chapter 1, depicts the ongoing impact of past violence, the challenges of rebuilding, and the relationship between memory, place, the living, and the dead in the small jungle town of Cinquera. Memory, transmitted via aural testimonial narrative, provides the film's narrative anchor and temporal drive. By focusing specifically on the lived intersections of affect and memory, I argue that if memories are the stories of past events and experiences that shape who we are, affect is what gives color and texture to memories, and what keeps memories alive, circulating in the present. Affect is about unseen but felt—*sensed*—connections; it is the *feeling* and *doing*, the acting and being acted upon, the way of being in one's life that is brought on by the ongoing act of remembering. Incorporating affect into the study of memory and testimony moves us beyond the question of the inadequacies of verbal articulation to the recognition of mem-

ory's pervasive affective presence, which far exceeds the constitutive boundaries of verbal testimony. Furthermore, I argue that films such as *The Tiniest Place* have the potential to function as necessary and targeted intervention in the face of visual economies in which whole communities (of dead and living) are all but invisible, their stories unheard, their memories ignored. The film brings these stories to light, preserves, and transmits them. In so doing, the visual has the potential to function as a space of "making" of memory and place—not because memory was absent prior to the film—the relationship between memory and place is profoundly important for the individuals we meet in the documentary—but rather because, on the surface, Cinquera is not immediately recognizable as a "memory" site. However, by way of memory mapping, the director effectively constructs Cinquera as a memory site *through* the visual, rendering the documentary *itself* as a form of memory site to which spectators may visually and affectively travel.

Chapter 2 builds off of this study of memory and affect but shifts to a closer investigation into the relationship between both memory and materiality, and the performativity of the body, grounded in the analysis of two documentaries made by Chilean filmmaker Patricio Guzmán: *Chile, Obstinate Memory* (*Chile, la memoria obstinada*, 1997) and *Nostalgia for the Light* (*Nostalgia de la luz*, 2010). I argue that memory "matter"—both in the sense of objects that are immediately recognizable as memory objects, such as old personal belongings and photographs, and that which is not immediately recognizable as material memory but rather is constituted as such throughout the films—can be called upon to performatively embody lost stories and lives. Memory matter thus functions as a strategy through which to visibly and tangibly bring the past into the present, to vitalize and promulgate memory narratives, and to render physically tangible the link between the past and present. Similarly, I argue that reenactments are a tool through which to evoke past events and bodies. Reenactments illuminate what is no longer there and/or is hidden, and they give the ghosts of dreams, people, and politics audibility and visibility in the present, effectively reminding viewers that much of memory goes unseen and unheard unless one is given the tools to decipher it. Ultimately, I assert that through various mapping strategies, these films work to challenge official silences by documenting the hidden stories and multiplicities of our pasts, and their ongoing impact on the present.

In Chapter 3, I turn my attention to live performance and physical memory sites. I analyze Argentine photographer Julio Pantoja's visual performance *Tucumán Kills Me* alongside three other Argentine prominent

memory projects: ESMA, the concentration camp turned memory site in Buenos Aires; the Memory Park, just a short distance from ESMA; and the national Museum of Memory in Rosario, a city roughly 185 miles from Buenos Aires. Through close investigation of how the relationship between memory and place is cultivated across live performance and physical memory sites, I argue that, through performance, the images gain new meaning in relation to audiences and contemporary events, and the human rights trials are situated as one point within a much thicker memory mapping of the interrelations between time, landscapes, bodies, affects, and trauma. Ultimately, I assert that by mapping memory through a combination of archival and contemporary images presented as performance, *Tucumán Kills Me* draws connections between the hidden, embedded knowledges in both landscapes and images, and invokes audiences as witnesses to Pantoja's remembering and, in turn, to the past itself. In examining how specific places "become" sites of memory, I argue that because spaces do not themselves autonomously remember but rather are constituted through affective, corporeal practices of remembering, it is critical to analyze memory sites via the ways in which desires and memory are mapped onto and through them by bodies, objects, corporeal movements, narratives, and representational practices. Because one of the powers of the visual in relation to memory is to make audiences *feel*, to make *seeing* memory a sensorial, affective experience, *how* memory is mapped onto and through bodies, images, and specific places matters, as does how a story is recuperated, the efficacy of its transmission, and what connections are drawn to the present.

Finally, in Chapter 4, I turn to the contemporary human rights crisis of Central American migration in order to ask: Can memory mapping challenge mainstream representations and make certain subjects *seeable* in new ways? Can it redirect the gaze toward new ways of seeing and feeling? Grounded in analysis of the hybrid fiction-documentary film *Who Is Dayani Cristal?* (2014), which I examine alongside a range of other visual interventions, I explore how these diverse visual texts work to shift the spectatorial gaze from one of indifference or elision to one of *affective seeing*. Ultimately, I argue that memory mapping makes legible the ways in which the past and the dead are integrated into the everyday life of the living and the landscapes we occupy. In those moments when other forms of contact are difficult or impossible to access, memory mapping visually and affectively establishes sensory contact with past bodies, events, and places. This approach is intended to create a context in which *seeing* functions as

a form of *feeling* and idle spectators are turned into active witnesses to the injustices of the past and the ongoing need for redress in the present.

Across these diverse case studies, I have progressively defined memory mapping as the creation of thick, affective, visual maps of the relations between temporalities, developed through images, archives, bodies, and objects, and anchored within the specificities of place. Analysis of how memory can be used to challenge visual economies and power structures that neglect or attempt to render invisible certain people, abuses, and memory and human rights narratives demonstrates the potential for memory to function as a powerful form of political intervention. It highlights the ongoing need not just to learn from the past but also, as Walter Benjamin, who died while fleeing from the Nazis, would perhaps remind us, to fight for the very past itself.

On one hot afternoon at Birkenau, also known as Auschwitz II, I paused for a brief moment in the dappled shade offered by the tall green trees dividing the vast rows of mostly destroyed prisoner barracks from the sauna where prisoners were processed and disinfected, the remains of Krematorium IV, and the small nearby pond into which the ashes of tens of thousands of victims were discarded. With a jolt, I thought instantly of the Sonderkommando photographs, which depict perhaps the very same trees I stood under. The Sonderkommando photographs are the only four photographs known to exist that portray the actual process of mass killing at Auschwitz. Two of the images were taken inside the gas chambers and two outside; shot clandestinely from the hip and without precision, one photograph is of naked women being led into the gas chamber, two depict the cremation of corpses, and the last one is an image of tall shade trees, presumably because the photographer aimed the camera too high. The photographs were secretly taken by a member of the Sonderkommando and later smuggled out of Auschwitz in a toothpaste tube by the Polish resistance. They are shocking, irrefutable. And yet, even with these images, even with the existence of the site itself and all of the other sites, the hundreds of thousands of survivor testimonials, and masses of other evidence, there are those who continue, against all logic, to deny the Holocaust occurred. A fight for the past is not an effort to change the events of the past. We know of no such possibility. Rather, it is the effort to remember, to engage with, and to learn from the past, with all of the complexities that such an endeavor entails, in order to foment the conditions for more just and safe futures, futures in which such mass atrocity finds no fertile ground from whence to emerge.

ACKNOWLEDGMENTS

During the years I worked on this book, my life underwent momentous changes, some of them expected, others not. Much like life, writing is a process of searching, of grieving and loss, and of finding and transformation. There were moments when this book felt like a resented tether, but it has also been a much-cherished refuge and source of joy. As I prepare to release my hold on this project, I find that I am both eager to turn the proverbial page and reluctant to let go. I am also immeasurably grateful to the family, friends, artists, scholars, mentors, and activists who have walked with me for all or part of the journey of writing. That many of you fall into most, if not all, of these categories is a testament to the incredible beauty of the community I find myself a part of. Your brilliance and generosity has inspired and nurtured this project.

In many respects, the roots for this book can be traced back to my time as a doctoral student in the Department of Performance Studies at New York University. Although it is not my dissertation, many of the questions raised here grew out of the process of its writing and the conversations, travel, and learning of those years. It is not hyperbole to say that my life has been changed by my relationship with my doctoral adviser, Diana Taylor. Her commitment to working at the intersection of academia, art, and activism serves as a model for the kind of scholar I strive to be, and I am grateful for the years of friendship and mentorship. My time with the Hemispheric Institute of Performance and Politics, then as a graduate student and now as a member of the Executive Committee, has both helped shape me into the kind of scholar I am today and led to some of my most cherished friendships. Macarena Gómez-Barris has served as a model for brilliant, ethical, and fiercely committed engagement inside and outside the academy, and I deeply value her support and friendship. I also benefited tremendously from the mentorship of Mary Louise Pratt, Karen Shimakawa, Jill Lane, and Barbara Browning.

I was fortunate to find a group of intelligent, inspiring, and wonderful friends in graduate school, including those in my cohort: J. Deleon, Dasha

Chapman, Vivian Huang, Ariane Zaytzeff, Kathleen Tracey, Ertug Altinay, and Tuo Wang. Over the years, Naomi Angel, Danielle Roper, Nathalie Bragadir, Marcos Steuernagel, Kerry Whigham, Leticia Robles-Moreno, Cristel Jusino Diaz, and I have laughed until we cried, brainstormed over red wine into the wee hours of the morning, and danced the night away. We have also grieved, raged, and lost together. That many of these friendships have continued to deepen and grow is a source of great joy.

I thank my colleagues, students, and staff in the Department of Spanish and Portuguese and beyond at the University of Arizona. Faith Harden, Anita Huizar-Hernández, Anne Garland Mahler, and Bram Acosta have read different parts of this manuscript, and I am thankful both for their feedback and their friendship. Judy Nantell and Antxon Olarrea have been invaluable mentors and friends. Adela Licona and Jamie Lee are magical humans, and their friendship has made my life immeasurably better. Special thanks to Brigette Walters, who worked as my graduate research assistant when the book wasn't much more than rough pieces loosely stitched together. I am also extremely grateful for the other relationships I have cultivated since moving to Arizona. Although there are too many to possibly mention here, special thanks are due to Colleen Jancovic, who read almost every word of this book and provided generous and thoughtful feedback. Thank you, also, to Annie Farnsworth for being a light in the darkness when I needed it most and for helping me grow into the person and scholar I am today.

I was born into a large family of intelligent, creative, and loving individuals. Leading by example, my parents instilled in me a love of exploration and learning, grounded in a deep commitment to social justice. I can never thank you enough. Over the years, I have shared many adventures with my fiercely smart, funny, and kind sister, Colleen, and I look forward to many more. My brothers and their families, and my extended family of cousins, aunts, uncles, and grandparents, remind me every day of what it means to come home. Lastly, my Aunt Marcia has been a consistent and beloved source of strength and support. Over the many years they taught at UC Berkeley, she and my Uncle Randy provided me with a model of what it means to be a truly engaged scholar, mentor, partner, and citizen. The genuine interest they take in life, food, art, the environment, and community is contagious in the best way possible.

I thank all of you from the bottom of my heart.

INTRODUCTION

1. It is interesting to note that Guatemala's truth commission, which ran from February 1997 through February 1999, also used the term *esclareci-miento* in its name. It was called the Comisión para el Esclarecimiento Histórico (Commission for Historical Clarification).

2. Nearly 70 percent of the Mayan population died in the first one hundred years following the Spanish invasion. Across what would come to be known as Latin America, land was taken from indigenous communities, concentrated in the hands of a small group of Spanish landowning elite, and worked by indentured, forced, or enslaved indigenous workers. In Guatemala, indigenous populations were forced to move to difficult-to-access and agriculturally undesirable areas; namely, the remote Guatemalan Highlands. In the 1870s and 1880s, coffee became the main export, accounting for 92 percent of Guatemala's foreign exchange earnings and an increased demand for more land for the landowning, ruling-class elite (Pratt 1996, 61). This resulted in land grabs from indigenous communities and increased pressure on the indigenous labor force. In 1934, the Labor Department of the Guatemalan government was made an adjunct of the National Police; that same year, the government passed a law requiring all landless peasants to work at least 150 days per year for either the large plantations or the state. This law became the basis for the annual highlands-to-coast migration. (Historically, Guatemalan peasants would migrate to the Pacific coast to work seasonal crops such as coffee and corn. After colonialism, this seasonal migration became a survival strategy for the highland farmers who now faced a shortage of land and crops of their own. This migration is described in Rigoberta Menchú's *testimonio*.) This system of gross inequality and oppression continued until 1952, when newly elected socialist president Jacobo Arbenz issued a land reform expropriating any idle land more than 220 acres and redistributing it to landless peasants, who would pay for it over time. US corporations were deeply invested in Guatemala's planta-tion system; the United Fruit Company alone stood to lose more than 400,000 acres.

Over a period of two years, more than one million acres of land were redistributed to some 100,000 indigenous families. In direct response to these reforms, President Arbenz's government became one of the first victims of US Cold War policy, brought down by a 1954 invasion that was coordinated by the United States, reinforced by CIA cover, and led by a Guatemalan general trained at the US Army's Fort Leavenworth in Kansas. By the mid-1960s, only 10 percent of rural families could live off the land, because the rest were forced off by another round of commercial agriculture land grabs. During this same period, left-wing guerilla movements basing themselves on the model of the Cuban revolution were forming in many parts of Latin America, including Guatemala. These movements were perceived as a serious threat, and although the Guatemalan guerilla movements were initially largely disconnected from the indigenous population, the Guatemalan government responded by implementing a campaign of state terror in the highlands.

Although the guerilla movements did not mobilize the indigenous populations, increased exploitation and repression eventually did. Earnings for Guatemalan agricultural workers declined by 50 percent in the 1970s, and families were pressured to return to the forced labor migrations. However, this resulted in increased contact between groups that had previously been unaware of each other's existence and shared plight, in turn creating the conditions for organizing a range of movements against the system. This was the first time in Guatemala's history that ladino and indigenous peasantries overcame the racism and mutual hatred that had prevented cooperation and united against government oppression. The results were powerful: in 1980, the Comité de Unidad Campesina (Committee of Peasant Unity, CUC) organized a worker strike with some 75,000 participants. From 1980 to 1983, the government staged an outright war against the indigenous population, adopting the "specific goal of eradicating indigenous social and economic structures," eventually murdering more than 100,000 people (63).

3. Considering Guatemala a "laboratory" for the fight against communism, the United States undertook to transform the Guatemalan military into an effective counterinsurgency force (rehearsing tactics later deployed in Vietnam) (Pratt 1996, 63). In addition to death squads, the government's primary approach to indigenous decimation was village massacres and the forced displacement of populations into Vietnam-style "model villages." By the mid-1960s, death squads were a part of everyday life in Guatemala. The infamous secret paramilitary force known as la Mano Blanca (the White Hand) decimated people by the hundreds, leaving mangled corpses in public places in order to cultivate a culture of fear. No one was safe, even prominent

public figures. As Mary Louise Pratt writes, "In 1967 the eminent poet Otto Rene Castillo was tortured for four days before being burned alive . . . [T]he national beauty queen, Miss Guatemala, fell under government suspicion for her leftist sympathies. She was arrested, stabbed, tortured, raped, poisoned, and her naked corpse left out for the vultures" (62).

The extreme quotidian violence continued for several more decades, until General Augusto Rios Montt, previously a department head at the Inter-American Defense College in Washington, D.C., and one of the main architects of the genocidal campaign against the indigenous, seized the presidency in a coup in 1982, only to be overthrown by General Óscar Humberto Mejía Victores just a year later. Under international pressure, Mejía Victores agreed to democratic elections in 1985. Vinicio Cerezo Arévalo became president of Guatemala in 1986.

Eager to demonstrate his democratic sensibilities to the international community, Cerezo Arévalo began courting exiled leaders and personalities to return to the country. Cerezo Arévalo's son personally invited Rigoberta Menchú to return in 1986. She did not take this initial offer due to security concerns, but changing political conditions in Guatemala led international advisers to feel that Menchú could attempt a return to the country several years later. This trip marked another huge turning point in the Menchú tale, because this is when Menchú was transformed from a relatively obscure figure to a national heroine in Guatemala. Ironically, as Arias writes, it may have been the military's mismanagement of her return that played the biggest role in this shift.

In March 1988, the Guatemalan ambassador to Switzerland, José Luis Chea, invited the United Representation of the Guatemalan Opposition (RUOG) delegation at the Geneva meetings to return to Guatemala. The goal of the trip was to see if the political situation in Guatemala had improved and to meet with the National Reconciliation Commission (this was a preliminary commission, not the formal truth commission that was later mandated as a part of the peace accords). An international delegation was formed to escort (and offer some degree of protection to) Menchú and three other prominent exile figures. The Guatemalan government, divided by contradictions between a desire to appease the international community and the hard-line policies still dictated by the military, accused the group of being military subversives and demanded they apply for political amnesty; otherwise, they would be arrested or refused entry into the country. No one complied, and on April 18, 1988, the delegation flew to Guatemala. On the day of their arrival, the Guatemalan military sealed off the airport. Secret service agents accosted members of the press attempting to enter airport grounds and destroyed their equipment. The more than two hundred

Guatemalans who had come to welcome the RUOG members were not allowed inside the airport. This was shortsighted of the military—their security forces so enraged the press and media that it turned the event into a front-page story, with the members of the RUOG portrayed in a uniformly positive light (Arias 2001, 12).

4. Kirsten Weld's book *Paper Cadavers: The Archives of Dictatorship in Guatemala* (Durham, N.C.: Duke University Press, 2014) offers a powerful glimpse into the challenges of negotiating the politics of the postwar period.

5. See Walter Benjamin's ninth thesis on the philosophy of history (Benjamin, Arendt, and Zohn 1968).

6. By the early 1800s, the United States had become increasingly interested in Latin American trade and investment, and by the late nineteenth century, Latin America was a place for the United States to hone what Greg Grandin calls "self-confidence and historical purpose," as both corporations and Christian missionaries preached their faith in "American-style capitalism and all the cultural trappings that go with it . . . individualism, competitiveness, innovation, self-discipline, respect for private property, and, as a reward for such commendable behavior, consumerism" (2006, 18–19). By this point, the United States had already incorporated nearly half of Mexico into its territory and sent warships into Latin American ports nearly six thousand times between 1869 and 1987 to protect US commercial interests. Grandin notes that "[o]ver the course of the next thirty years, US troops invaded Caribbean countries nearly thirty-four times, occupied Honduras, Mexico, Guatemala, and Costa Rica for short periods, and remained in Haiti, Cuba, Nicaragua, Panama, and the Dominican Republic for longer stays. Military campaigns in the Caribbean and Central America during these decades not only gave shape to the command and bureaucratic structure of America's modern army . . . but allowed soldiers to test their prowess, to sharpen their senses and skills for larger battles to come in Europe and Asia" (20). Latin American backlash to US military meddling in the 1920s and 1930s resulted in the Good Neighbor policy, in which the United States vowed to change its ways in Latin America; however, after World War II, this hemispheric alliance enabled the United States, in the name of fighting communism and promoting development, to influence the internal political and economic policies of its allied countries in such a way that increased its power and control in those countries.

7. As has been well documented elsewhere, these countries invariably then transitioned to neoliberal state formation. While neoliberalism purportedly improves well-being by "liberating individual entrepreneurial freedoms and skills within an institutional framework characterized by strong private property rights, free markets, and free trade," David Harvey

and others have successfully argued that what neoliberalism *actually* does is reinforce class divide and bolster the power of the economic elite—an economic legacy that continues to play out in countries in Latin America and beyond (Harvey 2005, 2, 19).

8. Theater artists such as Griselda Gambaro (Argentina), Enrique Buenaventura (Colombia), José Triana (Cuba), and the theater group Yuyachkani (Peru) all wrote plays like prisms, absorbing the violence and fragmented frameworks of meaning, and then sharply refracting them outward in pointed commentary on the politics of the time. A group of Chilean writers and visual artists known as CADA (Colectivo Acciones de Arte / Collective Art Actions) performed numerous prominent creative artistic actions and political protests to challenge the Pinochet dictatorship. Brazilian artist and activist Augusto Boal developed revolutionary theater-based workshops for amateur actors, factory workers, and campesinos; known as "Theater of the Oppressed," Boal's work has gone on to be practiced and implemented across the world. Visual artists such as Chilean filmmaker Patricio Guzmán and Argentine photographer Marcelo Brodsky, and Argentine authors Alicia Partnoy and Jacobo Timerman were persecuted, detained, and tortured before fleeing into exile to make profoundly affective and influential political artworks about their home countries from afar. Guatemalan activist and author Rigoberta Menchú escaped her country only to then work for peace from abroad, ultimately playing a seminal role in Guatemala's peace processes. These artists are but a few examples of the dynamic creativity that flourished during recent periods of tumult in the Americas and has continued into the present.

9. In *A History of the World in Twelve Maps* (1987), Jerry Brotton writes that the English word "map" comes from the Latin *mappa*, meaning tablecloth or napkin, whereas the French word for map, *carte*, interestingly comes from a different Latin term, *carta*, which refers to a formal document.

10. This is similar to what Ludmila da Silva Catela has called "territories of memory"—a notion that explores competing memory claims in the public realm and the ways in which different groups struggle to produce a "wider" narrative of memory inclusive of their own stories (2015, 10–17; 2001, 174).

11. In the late 1980s, a number of prominent visual scholars, including Hal Foster, Martin Jay, and Jonathan Crary, attended a conference hosted by the Dia Foundation on vision and visuality. The proceedings were later published as a slim book entitled *Vision and Visuality* (1988), edited by Hal Foster. This visual turn, as it is now known, led to the development of the Department of Visual and Cultural Studies at the University of Rochester, subsequently followed by similar developments at a number of other universities. On the most basic level, visual culture is understood as the

"shared practices of a group, community or society through which meanings are made out of the visual, aural, and textual world of representations and the ways that looking practices are engaged in symbolic and communicative activities" (Sturken and Cartwright 2001, 3).

12. Other major historical influences include German philosopher Walter Benjamin (1892–1940); French philosophers Jacques Derrida (1930–2004), Louis Althusser (1918–1990), and Roland Barthes (1915–1980); and Welsh academic Raymond Williams (1921–1988).

13. Although Guy Debord is more focused on the role of images in shaping consumer culture, his concept of the spectacle as a social relationship between humans that is mediated by images also deserves mention here. (2014, Thesis 4).

14. Contemporary performance studies has never been invested in disciplinary boundaries. Alternately framed as "an organizing idea for thinking about almost anything" and a "point of departure" (Taylor 2001), a "conceptual point of arrival" (Taylor 2002a), "a mode of analysis that is more interested in doing than in knowing" (Taylor 2002b), and an exploration of how "interactions between bodies produce new meanings" (Taylor 2007), the field is constantly being reshaped by the dynamic, interdisciplinary scholarship that happens under its constitutive umbrella.

15. Schechner also developed a pivotal distinction between analyzing something that *is* performance (something that is easily identified as performance, e.g., a theatrical production or a dance) and something *as* performance (2013, 38).

16. In Chapter 6 of *The Archive and the Repertoire*, Taylor analyzes the various iterations of performance protest involving photography that have taken place in Argentina during and after the Dirty War and what she terms the "DNA" of performance—the representational practice of linking scientific and performative claims, in this case through photo IDs, in order to transmit traumatic memory (2003, 169).

17. In their comprehensive survey of memory studies, Olick, Vinitzky-Seroussi, and Levy argue that we are living in an age of unprecedented scholarly interest in memory (2011, 3–5). While the reasons for this are varied (World War II and attempts to reconcile with the atrocities of the Holocaust dominant among them), they argue that the result is that "'collective memory' has become one of the emblematic terms and concerns of our age" (15–16).

18. While agreeing that memory practices are socially constructed, James E. Young argues against collective memory and for "collected" memory, because "even though groups share socially constructed assumptions and values that organize memory into roughly similar patterns, individuals cannot share another's memory any more than they can share

another's cortex. They share instead the forms of memory, even the meanings in memory generated by these forms, but an individual's memory remains hers alone" (1993, xi). Young is more interested in drawing out the "complex textures of memory—its many inconsistencies, faces, and shapes." He argues that "by maintaining a sense of collected memories, we remain aware of their disparate sources, of every individual's unique relation to a lived life, and of the ways our traditions and cultural forms continuously assign common meaning to disparate memories" (xi). Conversely, Edward S. Casey argues for distinctions between collective memory and what he calls social and public memory. For him, collective memory is created when different people who do not necessarily know each other or belong to the same social networks experience the same event. Social memory describes memories that are held in common by those who are already related to each other through a combination of kinship ties, shared community, or geographic proximity. Public memory, alternatively, "is both attached to a past (typically an originating event of some sort) *and* acts to ensure a future of further remembering of that same event" (2004, 17). The divisions Casey draws between individual, social, collective, and public memory have not gained much theoretical traction, but useful for this study of the relationship between visuality and memory is what he identifies as the constituent feature of public memory: its "formation through the ongoing interchange of ideas and thoughts, opinions and beliefs. It is because public memory is so much in the arena of open discussion and debate that it is also subject to revision, or, for that matter, resumption" (30).

I. AFFECT, HAUNTING, AND MEMORY MAPPING

1. The documentary is in Spanish; all translations are mine.

2. Although *The Tiniest Place* incorporates memory via testimonial narrative, my argument is not that it is "testimonial" art. To the contrary, as Jill Bennett contends, the goal should not be for art to be an exact translation of testimony, nor to retransmit trauma intersubjectively via representation, but rather to "exploit its own unique capacities to contribute actively to these politics" (2005, 3–10). I am interested in exploring how visual texts incorporate memory narratives into and through the visual, aiming to develop a deeper, more expansive perception of memory, one rooted neither solely in testimony nor in the past but that extends temporally, spatially, and affectively to include forms of lived experience in the present (which is, of course, where memory lives).

3. Two of the most significant English language studies of US imperialism and political intervention in El Salvador are William M. LeoGrande's thorough examination of the impact of US policy in El Salvador and

Nicaragua in *Our Own Backyard: The United States in Central America,*
1977–1992 (Chapel Hill: University of North Carolina Press, 1998), and
Greg Grandin's *Empire's Workshop: Latin America, the United States, and the
Rise of the New Imperialism* (New York: Metropolitan Books, 2006), which
investigates how Latin America was used as a testing ground for US strategies
overseas.

4. It is important to note that Cinquera was one of the towns in El
Salvador that was very influenced by liberation theology, which arose
principally as a reaction to poverty and social injustice in Latin America.
While these politics are not foregrounded in the documentary, one man,
Pablo, speaks about when the villagers became aware of their own oppres-
sion. In the lead-up to the war, the far-right and military governments
created a paramilitary organization called ORDEN, to which all men were
required to belong. Cinquera was one of the first towns where the men,
including Pablo, announced their intention to quit to the ORDEN chief. He
denied their request, claiming that participation was mandatory. From that
point forward, the military started tracking Cinquera, and then eventually
invaded the town. This invasion, and the subsequent brutal persecution of
villagers, led many of Cinquera's inhabitants to flee into hiding and, in many
cases, join the guerrillas (http://www.zyzzyva.org/2011/05/05/the-strength
-to-endure-the-worst-a-qa-with-filmmaker-tatiana-huezo/).

5. These accords were initially agreed to in April 1991—just a year after
the first Chilean commission released its report. Hayner notes that the
Chilean report was an originating point of reference for the idea of peace
negotiators in El Salvador (2011, 50).

6. Unlike many other villages in the area, which were Roman Catholic
and therefore often influenced by liberation theology, El Mozote was largely
Evangelical Protestant and thus had a reputation for political neutrality. The
army reportedly told the villagers that they would be passing through, but as
long as they stayed in place, they would not be harmed. However, on
December 11, 1981, the Salvadoran army's Atlacatl Battalion (which was
trained by US military advisers) brutally tortured, raped, and massacred
more than eight hundred civilians, including babies and young children.

7. See, for example, Julianne Burton (1990) and Michael T. Martin
(1997).

8. In "Left, Right, and Center: El Salvador on Film," Pat Aufderheide
analyzes the US media coverage of the El Salvadoran civil war in the 1980s,
noting that US public opinion on involvement in the war was understood to
be critical by both the Left and the Right, and both sides saw the US
mainstream news as "deliberately (rather than structurally) biased—'toward
the other side'" (1990, 154).

9. Visions du Reel, Nyon Suiza, April 2011, Grand Prix La Poste Suisse, Best Feature Film, Jurie's Award (SIGNIS), Best Feature Film; Documenta Madrid, May 2011, Audience Award; Lima International Film Festifal, Perú, August 2011, Best Documentary Award; Monterrey International Film Festival, August 2011, Best Mexican Film; DOCSDF, Mexico September 2011, Best Mexican Documentary, Best Cinematography; José Rovirosa Documentary Award, Mexico, September 2011, Special Mention; Festival Biarritz Amérique Latine, France October 2011, Special Mention; Morelia International Film Festival, Mexico October 2011, Documentary Special Mention, Woman's Association in Film & TV Award; Abu Dhabi Film Festival, United Arab Emirates, October 2011, Jury's Special Award; DOK Liepzig, Germany, October 2011, Best Documentary, Verdi Award; Nominated for IDA Award & IDA / Humanitas Award, October 2011, USA; Viennale International Film Festival, Austria, 2011, Standard Readers' Jury Award; Mar de Plata International Film Festival, Argentina, November 2011, Fipresci Award & Documentary Special Mention; Rencontres internationales du documentaire de Montréal, Canada, November 2011, Women's Inmate Award & International Feature Special Mention; Icarus Film Festival, Guatemala, December 2011, Best Central American Documentary & Best Editing; Cinematropical Awards, USA, December 2011, Best Direction & Best First Feature; Atlantidoc Documentary Film Festival, Uruguay, December 2011, Best Documentary, Best Direction, Best Cinematography, Best Original Music, Best Sound; Palm Springs International Film Festival, USA, January 2012, John Schelesinger Award for Best First Feature Documentary; Spotlight Award, Cinema Eye Honors, USA, January 2012 (http://tiniestplace.weebly.com, accessed April 11, 2016).

10. See Eric Kohn (2011), Robert Koehler (2011), and Sheri Linden (2011).

11. It is also important to note that the postconflict Southern Cone has historically received far greater attention than Central America when it comes to memory and cultural production.

12. Film scholar Bill Nichols developed the influential "modes" theory to classify documentary filmmaking. These include the poetic, expository, observational, participatory, reflexive, and performative modes (2010).

13. For more on trauma theory, see Cathy Caruth (1995), Sigmund Freud (1914), Roger Luckhurst (2013), Diana Taylor (2011), and Bessel Van der Kolk and Onno Van der Hart (1995).

14. For a more extensive theorization of trauma, see Cathy Caruth's *Trauma: Explorations in Memory* (1995).

2. THE MATERIALITY OF MEMORY:
TOUCHING, SEEING, AND FEELING THE PAST

1. While his release in Spain was a significant blow to those fighting to bring him to trial, Pinochet's arrest nonetheless had a major impact in Chile. Human rights issues were back in the headlines, and, bolstered by the international community's identification of Pinochet as a criminal, old domestic cases against him were resuscitated and new ones were brought forth. And even though Pinochet was protected both by Decree Law 2191, an amnesty implemented by the military junta in 1978 to pardon all of their human rights crimes, as well as by the immunity the Chilean congress granted in 2000 to "all former presidents of the republic," the judicial reforms implemented in the late 1990s had shifted the composition of the Chilean courts, removing a number of Pinochet-appointed judges (Jonas 2004) and creating conditions for change in Chile for the first time in decades. This combination of events made it possible for Chilean judge Juan Guzmán to request that the Supreme Court strip Pinochet of his parliamentary immunity shortly after his return to Chile. The courts agreed, and Pinochet was subsequently indicted and placed under house arrest. After additional medical exams and a deposition, Judge Guzmán ruled that Pinochet was indeed fit to stand trial. The Santiago Appeals Court disagreed, again based on medical grounds, and suspended the ruling. The Supreme Court subsequently upheld this suspension in July 2002. All following attempts to bring Pinochet to trial were thwarted, even though many felt that Pinochet's several public appearances and an extensive television interview (in which he claimed he had no reason to ask for forgiveness) proved the medical excuses to be more of an evasive political tactic than a legitimate claim.

2. In *The Battle of Chile*, the film Guzmán subsequently made from this footage, we see a military official turn, point his gun straight at the camera, and fire. The camera jolts and Hendrickson tries to lift it, then slumps slowly to the ground. The camera was later grabbed by protesters and hidden in the gutters so the military would not find it. Guzmán received a phone call that night to go pick it up.

3. While he was filming, Guzmán did not keep the footage at his house, because he felt it was too dangerous. Instead, every week he went to his Uncle Ignacio's house to hide eight to ten reels in a large trunk. The military searched Guzmán's home five times but never found the footage. Guzmán's friends knew that if Guzmán was arrested, they were to take the reels to the Swedish Embassy (Guzmán had a contact in the Swedish Embassy through a Chilean filmmaker, Sergio Castilla, who was married to a Swedish woman, Lilian Indseth, then secretary to the ambassador). As the

Swedish officials drove toward the port city of Valparaiso several hours away, with the intention of putting the reels on a ship to Sweden, they were terrified they would be caught. After being stopped several times by the police, they managed to make it through, only to reach the ship and not be allowed aboard, due to the quantity of trunks they were carrying with them. Fortunately, the captain directed that all the trunks be allowed on board as private diplomatic material, and the ship steamed away from Chile with Guzmán's film reels safely onboard.

4. The Cuban Film Institute (ICAIC) offered to support the editing and postproduction. Guzmán flew to Havana and finished the film a few years later.

5. The three parts are: *The Insurrection of the Bourgeoisie* (1975), *The Coup d'État* (1976), and *The Power of the People* (1979).

6. These numbers derive from the Chilean National Commission on Truth and Reconciliation: *Report of the Chilean National Commission on Truth and Reconciliation* (1991): http://www.usip.org/files/resources/collections/truth _commissions/Chile90-Report/Chile90-Report.pdf (accessed August 2012).

7. For a more extensive overview of Chilean cinema and exile, see Zuzana M. Pick's "Chilean Cinema: Ten Years of Exile (1973–83)" (1987).

8. Toward the end of 1988, Pinochet allowed a plebiscite for democratic elections to take place and unexpectedly lost by 55 to 43 percent. He agreed to step aside, providing certain conditions were met: the new leaders had to work within the bounds of the 1980 Constitution Pinochet had implemented, effectively and vastly limiting possibilities for governmental reform. The incumbent Concertación party (Concertación de Partidas por la Democracia; in English, the Coalition of Center-Left Parties) agreed to these terms, and in 1990 President-Elect Patricio Aylwin took office, ending Pinochet's seventeen years of authoritarian rule (as president).

9. This visual footage has now become the official visual memory of the coup and is shown on repeat in the Museo de la Memoria (Museum of Memory) in Santiago.

10. Winner, Award of Merit in Film, 2012 Latin American Studies Association (LASA); Official Selection, 2012 Western Psychological Association Film Festival; Winner, Best Film, 2011 International Documentary Association (IDA); Winner Best Documentary, Prix ARTE, 2010 European Film Academy Awards; Winner Best Documentary, 2010 Abu Dhabi Film Festival; Official Selection, 2010 Cannes Film Festival; Official Selection, 2010 Toronto International Film Festival; Official Selection, 2011 San Francisco International Film Festival; Official Selection, 2011 Miami International Film Festival; Official Selection, 2010 Melbourne International Film Festival.

11. In addition to the films mentioned earlier, which Guzmán is largely known for, Guzmán has made two personal adventure tales based on books he read and loved as a child, *La isla de Robinson Crusoe/Robinson Crusoe Island* (1999) and *Mon Jules Verne/My Jules Verne* (2005), based on Daniel Defoe's *Robinson Crusoe* (1719) and Jules Verne's *Five Weeks in a Balloon* (1863), respectively.

3. PERFORMING ARCHIVES, PERFORMING RUINS

1. Pantoja was born in a small town on the border with Brazil and moved to Tucumán in 1973. He remembers the years between 1973 and 1976 as an extremely formative time, full of social movements and political possibility. The coup happened when he was sixteen, and all of his high school years and the beginning of university took place during the coup. He had always been politically engaged but remembers 1978 (the year the World Cup was held in Argentina) as a major turning point in his own political engagement. Disillusioned by politics, he was always working and politically active, although not affiliated with any particular party. He found his home in photography, an area he continues to explore thirty years later. He was formally trained as an architect, although he teaches photography and visual theory at the university in Tucumán. During our interview, Pantoja reflected that his teaching has really transformed his art, because it enables him to slow down and be more methodical in his artistic practice. As a result, he is able to merge his practical experience with theoretical grounding and continue to push his work forward. Julio Pantoja, interview with the author, June 24, 2014, Concordia University, Montreal, Canada.

2. The music was by Argentine jazz musician Luis Salinas.

3. The slides were in Spanish; all translations here are mine.

4. This performance took place at the Hemispheric Institute's 2014 Encuentro.

5. Pantoja started with nearly eight thousand images and narrowed them down to around three hundred, of which approximately 80 percent were photographs he had taken. He took the photograph of the forest, but the final photograph of the mass grave was taken by the forensic anthropology team and distributed by the court (no one else was permitted to take photographs).

6. Juan Perón is a complicated and often contradictory political figure. Born October 8, 1895, he was a military officer and politician. He was elected president three times and became the figurehead for Peronism, one of the most important political movements in Argentine history. Known largely as a populist president who favored the working classes, he served as president from 1946 to 1955. The military seized power in 1955 and drove

him into exile, where he remained for the next eighteen years. Even though the new government made support for Perón illegal (including saying his name in public!), he continued to influence Argentine politics from afar.

7. The CONADEP final report gave five primary reasons for this extreme violence, in particular the disappearances and destruction of dead bodies: it served to erase criminal evidence; it created uncertainty and false hope among those searching for the missing; it stalled investigations into the whereabouts of the disappeared; it paralyzed public protest; and it prevented feelings of solidarity between those searching and the broader public (Robben 2005, 278).

8. For more on Las Madres, see Antonius Robben, *Political Violence and Trauma in Argentina*, Ch. 15; Fernando Bosco, "Human Rights Politics and Scaled Performances of Memory: Conflicts Among the Madres de la Plaza de Mayo in Argentina," 381–402; Diana Taylor, *Disappearing Acts: Spectacles of Gender and Nationalism in Argentina's "Dirty War,"* Ch. 7; and *Las Madres: The Mothers of the Plaza de Mayo* (dir. Lourdes Portillo).

9. A 1976 fact-finding mission by Amnesty International and reports by the US State Department and the Inter-American Commission on Human Rights of the Organization of American States all accused the Argentine military of human rights violations. The country was also in economic crisis. Foreign debt had skyrocketed, gross domestic product had declined, wages were falling, inflation was high, and the national currency had depreciated 600 percent by 1981. The combination of human rights protests, increased international condemnation, and the failing economy had the dictatorship on shaky ground. In response, President Galtieri (General Viola succeeded President Videla in March 1981, only to be ousted by Galtieri in December 1981) ordered the invasion of the Falkland Islands, known in Argentina as Las Islas Malvinas. Long-contested ground, the islands were under British control. Galtieri hoped that this move would turn attention away from the economic and human rights problems and toward a narrative of heroic military honor and pride. Things did not go as planned, and Argentina surrendered to Great Britain on June 14, 1982. As Robben writes, "The capitulation was immediately followed by violent protests. The Argentine people were astounded. The national press, the junta, and the Minister of Foreign Affairs had been boasting for months about the military and diplomatic successes, when suddenly the curtain fell. Protestors flocked to the Plaza de Mayo. Cars were overturned, buses set afire, and barricades erected" (2005, 314). Although Galtieri had intended to explain away the loss from the balcony of the Casa Rosada that evening, when the time came there were unruly crowds of more than five thousand people shouting slogans against the military. He resigned the next day. In sum, although the

military's defeat in the fight for the Malvinas was the immediate cause of the fall from power, the growing protests, instability, and unrest that had led Galtieri to pursue the Malvinas in the first place are ultimately the major reasons that contributed to the fall of the dictatorship.

10. The CONADEP commission interviewed more than 1,500 people who had been detained but survived. These survivors gave detailed descriptions of the former detention centers, torture methods, and locations of clandestine sites, often visiting the sites with commissioners. The commission took more than seven thousand statements, interviewed exiles, and took statements in Argentine embassies and consulates around the world. They worked with forensic anthropologists to open and examine mass graves, and they searched the records of morgues and cemeteries. They also worked very hard to locate persons who were missing but might still be alive. Somewhat astonishingly, they found none. Their work was made more difficult by the complete lack of cooperation from the armed forces, which baldly denied the disappearances, often attempted to block visits, and worked to hide any remaining evidence. Given how little material evidence the commission was able to uncover, the depositions of survivors and family members were of utmost importance.

11. The documentary started with images of disappeared men, women, and children, and then shifted to an explanation of CONADEP's work and findings, including that more than 8,800 people had disappeared and 172 babies and children had been abducted with their parents or born while their parents were incarcerated. Often these children were given away and the parents killed.

12. José Eloy Mijalchyk is a Catholic priest and pastor of a church in the El Colmenar neighborhood of San Miguel de Tucumán, the capital of Tucumán province. During the dictatorship, he served as chaplain in the Clandestine Detention Center Arsenal "Miguel de Azcuénaga," where he called for the hostages to "tell the truth." After being named by multiple witnesses as an alleged "secondary participant," he was accused (and later acquitted) of crimes against humanity.

13. The audience sat quietly for a couple minutes after the performance ended. Many were in tears. For the next half hour, people discussed with the artist how the piece had made them feel. Given the nature of the event (the Encuentro is an academic, activist, and artist gathering organized around performance and politics of the Americas), it is likely that many in the audience were at least generally familiar with what had happened in Argentina, but it was the first time Pantoja's piece had ever been shown, and thus the performance was new to all. It was striking how, even though the performance was specific to a particular moment in time and place, the

affective impact seemed to have a more universal reach. One Mexican woman said it reminded her very much of her own country, and others spoke of how it had made them connect emotionally with Pantoja's story but also with the political events that were most personal to them. When the dialogue period ended, people came up to tearfully hug and thank Pantoja.

14. Other texts that review this history in more detail include Kerry Whigham (2014), Bell and DiPaolantonio (2009), Brodsky (2005), and Druliolle and Lessa (2011).

15. The H.I.J.O.S. (Hijos e Hijas por la Identidad y la Justicia contra el Olvido y el Silencio) is a group that was formed in 1995. Among other things, they are known for their *escraches*, which are vibrant street performance–protests intended to publicly identify and call out perpetrators of state terror. For more on H.I.J.O.S., see http://www.hijos-capital.org.ar. http://claudiafontes.com/project/reconstruction-of-the-portrait-of-pablo -miguez/ (accessed August 10, 2015).

16. The large building was split into multiple sections that included the rooms where the worst torture occurred, rooms where pregnant women were held until they gave birth, cells for important prisoners, and even smaller cells for everyone else. There were also massive storage rooms where the army kept everything they stole from people's houses when they carried out abductions—televisions, fans, refrigerators, clothing, books—they took anything they could get their hands on.

17. Although our guide told us that there were plans to incorporate more of the building into the tour in the future, when I took it, the tour passed through a series of rooms on the first floor then proceeded up to the third floor and back down to the basement before exiting out the back.

18. Introduced in Chapter 1, Whigham's concept of resonant violence is again useful here. Whigham contends that the social and affective aspects of violence continue to resonate long after the physical violence or state terror comes to an end; this *felt* violence is much more persistent than physical violence; yet, because "resonant violence is an affective force that is felt within and amongst the individual and social body, it can be transformed or, to continue the sonic metaphor, re-composed through acts *of* the body that can make it resonate less or differently" (2014, 89).

19. There was a competition to select artworks for the park, and seven-teen large sculptures were chosen, six from renowned artists. These artists include William Tucker (UK), Dennis Oppenheim (USA), Marie Orensanz (b. Argentina; moved to Europe in the early 1970s), Nicolás Guagnini (b. Argentina, lives in New York), Claudia Fontes (b. Argentina, lives in the UK), Roberto Aizenberg (Argentina), and Grupo de Arte Callejero (a prominent activist artist collective in Argentina).

4. THE POLITICS OF SEEING:
AFFECT, FORENSICS, AND VISUALITY
IN THE US-MEXICO BORDERLANDS

1. According to the Migration Policy Institute, between 2010 and 2014 roughly 1.7 million Central American unauthorized immigrants lived in the United States, representing 15 percent of the 11 million total unauthorized immigrant population. The relatively small countries of Guatemala (723,000), El Salvador (465,000), and Honduras (337,000) were among the top five origin countries of unauthorized immigrants, along with Mexico (about 6.2 million) and China (268,000) (Lesser and Batalova 2017).

2. On June 16, 2015, in his presidential announcement speech, candidate Donald Trump stated: "When Mexico sends its people, they're not sending their best. They're not sending you. They're sending people that have lots of problems, and they're bringing those problems with us. They're bringing drugs. They're bringing crime. They're rapists." https://www .washingtonpost.com/news/fact-checker/wp/2015/07/08/donald-trumps-false -comments-connecting-mexican-immigrants-and-crime/ (accessed April 1, 2016).

3. Texas has 1,241 border miles, followed by Arizona, with 372.5 border miles, and New Mexico and California, with 179.5 and 140.4 miles, respectively.

4. Smuggling (in both directions) had long been a defining feature of the US-Mexico border, but it saw an increase in the 1980s as a result of the US war on Colombian drug trafficking. Mexican drug smugglers benefited from US efforts to cut off Caribbean cocaine-shipping routes, because Colombian drug traffickers shifted instead to develop ties with Mexican drug smugglers, who had the benefit of being right next door to the United States, with a land border thousands of miles long at their disposal. As Peter Andreas notes, "hundreds of thousands of migrants entered the United States illegally every year during the 1990s, with the southwest border the most important entry point. According to the Pew Hispanic Center, the total number of unauthorized foreigners in the country more than doubled in the 1990s, from 3.5 million in 1990 to 8.4 million in 2000, with the majority from Mexico" (2013, 304). While increased surveillance on the border did result in the apprehension of some smugglers, those arrested were typically the "lowest-level and most expendable members of smuggling operations: the border guides and drivers who were the 'foot soldiers' of the business. Smugglers were first and foremost travel service providers" (305).

5. It must also be noted that the terrorist attacks on the World Trade Center on September 11, 2001, left an indelible mark on the US-Mexico border. Political rhetoric was dominated by calls to "secure our borders" and

"catch terrorists," resulting in renewed attention on the southwest border. As Walter Ewing notes, the first reshaping of the 1994 border strategy came "in the wake of 9/11 with the dissolution of the INS and the creation of the Department of Homeland Security (DHS) in 2004" (2014, 203). This new plan focused on "Smart Border" technology, including camera systems, sensor platforms, and gamma x-rays, although the primary goal continued to be the deterrence of illegal entry. This plan was revised again with the 2005–2010 Strategic Plan of Customs and Border Protection. Entitled "Protect America," this plan "encapsulated the continued rhetorical focus on fighting terrorism" (203). Also in 2005, the DHS implemented the Secure Border Initiative (SBI), which increased enforcement both along borders and in the interior of the country, expanded immigration detention capacity, expedited removal processes, and vastly increased what was coined "tactical infrastructure." This included fences and vehicle barriers alongside the development of SBInet, a system of thermal imaging, ground radar, and drones all intended to detect unauthorized border crossing (203). Plagued by technological defects, cost overruns, and missed deadlines, SBInet was considered a failure and was replaced in 2011 with the Arizona Border Surveillance Technology Plan, which combined cameras, radars, and sensors to "secure" the border.

Other policies to both restrict and criminalize unauthorized border crossing were also being implemented during this period. In 2005, the US House of Representatives passed the "Border Protection, Antiterrorism, and Illegal Immigration Control Act," which made being undocumented in the United States a felony crime instead of a civil violation and imposed mandatory minimum sentences for illegal entry and reentry. In 2006, Congress enacted the Secure Fence Act, which authorized the secretary of Homeland Security to take any necessary actions in order to secure and maintain operational control over the entire border. In 2005, the DHS and the Department of Justice created an initiative called Operation Streamline with the intention of establishing a "zero-tolerance" approach to migrants apprehended without papers. Under Operation Streamline, judges try, convict, and deport migrants en masse, trying up to eighty shackled migrants simultaneously. Defendants are appointed public defenders, who are often given only a minute or two with their client before the trial. The result is that migrants are rushed past a judge and deported—often within forty-eight hours of capture. Judges have been known to "try" thousands of cases in a day. Operation Streamline is complemented by the Alien Transfer Exit Programme (ATEP). Created in 2008, ATEP was designed to return migrants to border regions of Mexico that are distant from where they were apprehended (known as lateral relocation), with the purported goal of

discouraging reentry attempts by placing migrants in an unfamiliar border region where they do not know how to cross and are geographically separated from their *coyotes*. However, ethnographic research conducted by anthropologist Jason De León found that ATEP systematically places migrants in harm's way. He argues that ATEP is not an effective or humane strategy and that many of those individuals deported under ATEP face new dangers after deportation, because they are dropped off without money or belongings in foreign areas where they often do not have contacts, resources, or knowledge of that border crossing. As a result, they are *more* likely to be preyed on by bandits, sexually assaulted, and reliant on *coyotes* than before. There are others (Operation Secure Communities, Operation Vanguard, and Operation Tarmac are all explicitly anti-migrant, as is Operation Wagon Train, under which federal agents raid workplaces looking for undocumented workers), but the last anti-immigrant policy measure I would be remiss if I did not mention, especially given my focus in this chapter on the Arizona-Mexico border, is Arizona's contentious Senate Bill 1070 (SB 1070), which was passed in 2010. SB 1070 gives state law enforcement the right to check a person's immigration status if there is "reasonable suspicion" they are not in the United States legally—in other words, if they *look* illegal. Widely considered thinly veiled racial profiling, SB 1070 was extremely controversial in Arizona; nonetheless, legal challenges against the bill were unsuccessful. In 2012, the US Supreme Court struck down several other provisions of the bill but upheld the provision requiring immigration status checks (*Arizona v. United States*).

6. These archives include the University of Arizona Special Collections, the Arizona Historical Society, and the Center for Creative Photography in Arizona, as well as the University of Texas at Austin's Benson Latin American Collection and the Harry Ransom Center in Texas. Other archives included the University of California's comprehensive Calisphere archive, the National Museum of American History archive, the Bracero History Archive, and Magnum Photo's online image archive.

7. *Jane the Virgin* debuted in 2014 on the CW network; at the time of writing, it is completing its fourth season. *Bordertown* debuted in 2016 on the Fox network and was canceled after one season.

8. This performance took place at the Teatro Heckscher, El Museo del Barrio, New York, April 23, 2008.

9. Ana Teresa Fernández, *Borrando la Frontera / Erasing the Border.* US-Mexico Border; San Diego, California; and Tijuana, Baja California.

10. Raven Chacon, Cristóbal Martinez Yáñez, and Kade L. Twist, *Repellent Fence.* US-Mexico Border; Douglas, Arizona; and Agua Prieta, Sonora.

11. The Arizona OpenGIS Initiative for Deceased Migrants is the product of a partnership between PCOME and Humane Borders.

12. These films include *Amores Perros* (2000), *Y Tu Mamá También* (2001), and *Babel* (2006), as well as a range of other prominent films, including *The Motorcycle Diaries* (2004), *The Science of Sleep* (2006), *No* (2012), and Jon Stewart's acclaimed directorial biopic, *Rosewater* (2014). He has also worked with many of the most famous contemporary film directors, sat on the jury of some of the most prestigious films festivals (Berlin International Film Festival, Cannes Film Festival), and, with fellow Mexican film star Diego Luna, co-runs his own festival, Ambulante, the only touring documentary film festival in Mexico (Ambulante travels around the country holding screenings in places documentaries are rarely available; in recent years, Ambulante has expanded internationally to California, El Salvador, and Colombia). García Bernal has won numerous awards, including a 2016 Golden Globe for his work in the Amazon series *Mozart in the Jungle*, a 2002 MTV Movie Award for *El Crimen del Padre Amaro / The Crime of Padre Amaro* (2002), and the Washington Office on Latin America (WOLA)'s Human Rights Award (2011) for the short documentary series *Los Invisibles*, which he created in collaboration with Amnesty International.

13. Emphasis added.

Amnesty International. 1982. *The Amnesty International Report 1982*. London: Amnesty International Publications.

Andermann, Jens. 2012. "Expanded Fields: Postdictatorship and the Landscape." *Journal of Latin American Cultural Studies* 21 (2): 165–187.

———. 2015. "Placing Latin American Memory: Sites and the Politics of Mourning." *Journal of Memory Studies* 8 (1): 3–8.

Andreas, Peter. 2013. *Smuggler Nation: How Illicit Trade Made America*. London: Oxford University Press.

Antze, Paul, and Michael Lambek. 1996. *Tense Past: Cultural Essays in Trauma and Memory*. New York: Routledge.

Anzaldúa, Gloria. 2012. *Borderlands/La Frontera: The New Mestiza*. San Francisco: Aunt Lute Books.

Arias, Arturo. 2001. "Rigoberta Menchu's History within the Guatemalan Context." In *The Rigoberta Menchú Controversy*, edited by Arturo Arias, 3–28. Minneapolis: University of Minnesota Press.

Assman, Aleida. 2006. "Fury of Disappearance: Christian Boltanski's Archives of Forgetting." In *Boltanski: Time*, edited by Ralf Beil, 89–97. Berlin: Hatje Cantz.

Auchter, Jessica. 2015. "Border Memorial: Frontera de los Muertos." *Hyperrhiz* 12 (Summer): n.p. http://hyperrhiz.io/hyperrhiz12/augmented-maps /1-freeman-auchter-border-memorial.html.

Aufderheide, Pat. 1990. "Left, Right, and Center: El Salvador on Film." In *The Social Documentary in Latin America*, edited by Julianne Burton, 151–172. Pittsburgh, Pa.: University of Pittsburgh Press.

Austin, John Langshaw. 1975. *How to Do Things with Words*. Oxford: Oxford University Press.

Avellar, José Carlos. 1997. "Interview with Patricio Guzmán." Special 4-Disc Edition of *Battle of Chile* trilogy and *Chile, Obstinate Memory*. Directed by Patricio Guzmán. Brooklyn, N.Y.: Icarus Films.

Azoulay, Ariella. 2015. *Civil Imagination: A Political Ontology of Photography*. London: Verso.

Bal, Mieke. 2007. "The Pain of Images." In *Beautiful Suffering: Photography and the Traffic in Pain*, edited by Mark Reinhardt, Holly Edwards, and Erina Duganne, 93–115. Chicago: University of Chicago Press.

Barthes, Roland. 1980. *Camera Lucida: Reflections on Photography.* New York: Hill and Wang.

Bell, Vikki, and Mario Di Paolantonio. 2009. "The Haunted Nomos: Activist-Artists and the (Im)Possible Politics of Memory in Transitional Argentina." *Cultural Politics* 5 (2): 149–178.

Bengoa, José. 2009. *La comunidad reclamada: Identidades, utopías y memorias en la sociedad chilena.* 2nd ed. Santiago: Catalonia.

Benjamin, Walter. 2002. *The Arcades Project.* Cambridge, Mass.: Harvard University Press.

———. 2016. *One-Way Street.* Cambridge, Mass.: Harvard University Press.

Benjamin, Walter, Hannah Arendt, and Harry Zohn. 1968. *Illuminations.* New York: Harcourt, Brace and World.

Bennett, Jill. 2005. *Empathic Vision: Affect, Trauma, and Contemporary Art.* Palo Alto, Calif.: Stanford University Press.

Beristain, Carlos Martín. 1998. "Guatemala nunca más." *Revista Migraciones Forzadas* 3:23–26.

Beverley, John. 2004. *Testimonio: On the Politics of Truth.* Minneapolis: University of Minnesota Press.

Bordertown. 2016. Created by Hank Azaria. Voiced by Hank Azaria and Nicholas Gonzalez. Fox.

Bosco, Fernando. 2004. "Human Rights Politics and Scaled Performances of Memory: Conflicts among the Madres de Plaza de Mayo in Argentina." *Social and Cultural Geography* 5 (3): 381–402.

Bradshaw, Peter. 2012. "Review of *Nostalgia for the Light.*" *The Guardian*, July 12. http://www.theguardian.com/film/2012/jul/12/nostalgia-for-the -light-review.

Brady, Mary Pat. 2002. *Extinct Lands, Temporal Geographies: Chicana Literature and the Urgency of Space.* Durham, N.C.: Duke University Press.

Brand, Roy. 2011. "Witnessing Trauma on Film." In *Media Witnessing*, edited by Paul Frosh and Amit Pinchevski, 198–215. New York: Palgrave Macmillan.

Brodsky, Marcelo. 2005. *Memoria en construcción: El debate sobre la ESMA.* Buenos Aires: La Marca Editora.

Brotton, Jerry. 2013. *A History of the World in 12 Maps.* New York: Penguin.

Brown, Elspeth H., and Thy Phu, eds. 2014. *Feeling Photography.* Durham, N.C.: Duke University Press.

Bruno, Giuliana. 2002. *Atlas of Emotion: Journeys in Art, Architecture, and Film.* London: Verso.

Burton, Julianne. 1990. "Toward a History of Social Documentary in Latin America." In *The Social Documentary in Latin America*, edited by Julianne Burton, 3–30. Pittsburgh, Pa.: University of Pittsburgh Press.

Butler, Judith. 2004. *Precarious Life: The Powers of Mourning and Violence.* New York: Verso.

Cadava, Eduardo, and Gabriela Nouzeilles. 2014. *The Itinerant Languages of Photography.* Princeton, N.J.: Princeton University Press.

Camacho, Alicia Schmidt. 2008. *Migrant Imaginaries: Latino Cultural Politics in the US-Mexico Borderlands.* New York: New York University Press.

Cammisa, Rebecca, dir. 2009. *Which Way Home.* New York: New Video Group.

Campo, Javier. 2013. "Documentary Film from the Southern Cone during Exile (1970–1980)." *Latin American Perspectives* 40 (1): 145–160.

Cardenas, Mauro Javier. 2011. "The Strength to Endure the Worst: A Q&A with Filmmaker Tatiana Huezo." *Zyzzyva*, May 5. http://www.zyzzyva.org/2011/05/05/the-strength-to-endure-the-worst-a-qa-with-filmmaker-tatiana-huezo/.

Carroll, Rory. 2015. "Altar, Mexico: How the 'Migrant Oasis' for Would-Be Border Crossers Became a Trap." *The Guardian*, October 15. http://www.theguardian.com/world/2015/oct/14/altar-mexico-how-the-migrant-oasis-for-would-be-border-crossers-became-a-trap.

Caruth, Cathy. 1995. *Trauma: Explorations in Memory.* Baltimore: Johns Hopkins University Press.

Casey, Edward S. 2004. "Public Memory in Place and Time." In *Framing Public Memory*, edited by Kendall Phillips, 17–44. Tuscaloosa: University of Alabama Press.

Collins, Cath. 2010. *Post-transitional Justice: Human Rights Trials in Chile and El Salvador.* University Park: Pennsylvania State University Press.

Connerton, Paul. 1989. *How Societies Remember.* Cambridge: Cambridge University Press.

Cornelius, W. A. 2001. "Death at the Border: Efficacy and Unintended Consequences of US Immigration Control Policy." *Population and Development Review* 27 (4): 661–685.

Cuarón, Jonás, dir. 2015. *Desierto.* Los Angeles: STX Entertainment.

Da Silva Catela, Ludmila. 2001. *No habrá flores en la tumba del pasado.* La Plata, Argentina: Ediciones Al Margen.

———. 2015. "Staged Memories: Conflicts and Tensions in Argentine Public Memory Sites." *Journal of Memory Studies* 8 (1): 9–21.

Debord, Guy, and Ken Knabb. 2014. *The Society of the Spectacle.* Berkeley, Calif.: Bureau of Public Secrets.

Defoe, Daniel, and N. C. Wyeth. 1983. *Robinson Crusoe.* New York: Scribner.

De León, Jason. 2013. "Undocumented Migration, Use-Wear, and the Materiality of Habitual Suffering in the Sonoran Desert." *Journal of Material Culture* 18 (4): 321–345.

———. 2015. *The Land of Open Graves: Living and Dying on the Migrant Trail.* Berkeley: University of California Press.

Derrida, Jacques. 1994. *Specters of Marx: The State of the Debt, the Work of Mourning and the New International.* New York: Routledge.

DeVivo, Dan, and Joseph Matthew, dirs. 2006. *Crossing Arizona.* New York: Rainlake Productions.

Dominguez, Ricardo. 2011. "Error 404 a Hemifesta 2011." *E-misférica* 7 (2). Accessed February 27, 2018. http://hemisphericinstitute.org/hemi/en/e -misferica-81/dominguez.

Donnan, Hastings, and Thomas Wilson. 1999. *Borders: Frontiers of Identity, Nation, and State.* Oxford: Berg.

Draper, Susana. 2012. *Afterlives of Confinement: Spatial Transitions in Postdictatorship Latin America.* Pittsburgh, Pa.: University of Pittsburgh Press.

Ensler, Eve. 2011. "Politics, Power, and Passion." *New York Times,* December 2. http://www.nytimes.com/interactive/2011/12/02/opinion/magazine-global -agenda-big-question.html.

Ewing, Walter A. 2014. "'Enemy Territory': Immigration Enforcement in the US-Mexico Borderlands." *Journal on Migration and Human Security* 2 (3): 198–222.

Felman, Shoshana, and Dori Laub. 1992. *Testimony: Crises of Witnessing in Literature, Psychoanalysis, and History.* New York: Routledge.

Flatley, Jonathan. 2008. *Affective Mapping: Melancholia and the Politics of Modernism.* Cambridge, Mass.: Harvard University Press.

Foster, Hal, ed. 1988. *Vision and Visuality.* Seattle: Bay Press.

Foucault, Michel. 1972. *The Archaeology of Knowledge.* New York: Vintage.

Freeman, John Craig. 2012. "Border Memorial: Frontera de los Muertos." *Border Memorial* (blog), April 2. https://bordermemorial.wordpress.com /border-memorial-frontera-de-los-muertos/.

Fregoso, Rosa Linda. 2003. *MeXicana Encounters: The Making of Social Identities on the Borderlands.* Berkeley: University of California Press.

Freud, Sigmund. 1914. "Remembering, Repeating, and Working-Through." In *The Standard Edition of the Complete Psychological Works of Sigmund Freud, Volume XII (1911–1913): The Case of Schreber, Papers on Technique and Other Works,* 145–156. London: Hogarth Press.

Fukunaga, Cary, dir. 2009. *Sin Nombre.* Universal City, Calif.: Focus Features.

Gates-Madsen, Nancy. 2011. "Marketing and Sacred Space: The Parque de la Memoria in Buenos Aires." In *Accounting for Violence: Marketing*

Memory in Latin America, edited by Ksenija Bilbija and Leigh A. Payne, 151–178. Durham, N.C.: Duke University Press.

Gerardi, Juan. 1999. "Speech Made by Monsenor Juan Gerardi on the Occasion of the Presentation of the REMHI Report, 24 April 1998." In *Guatemala: Never Again!*, edited by the Archbishop's Office for Human Rights in Guatemala (ODHAG), xxxiii–xxv. Maryknoll, N.Y.: Orbis Books.

Germano, Roy, dir. 2009. *The Other Side of Immigration*. New York: Team Love.

Giunta, Andrea. 2010. "The Politics of Representation: Art and Human Rights." *E-Misférica* 7 (2): n.p. Accessed February 27, 2018. http:// hemisphericinstitute.org/hemi/en/e-misferica-72/giunta.

Goldberg, Elizabeth Swanson. 2005. "Who Was Afraid of Patrice Lumumba? Terror and the Ethical Imagination." In *Terrorism, Media, Liberation*, edited by J. David Slocum, 248–266. New Brunswick, N.J.: Rutgers University Press.

Gómez-Barris, Macarena. 2008. *Where Memory Dwells: Culture and State Violence in Chile*. Berkeley: University of California Press.

———. 2010a. "Atacama Remains and Post Memory." *Media Fields Journal* 5:1–17.

———. 2010b. "Witness Citizenship: The Place of Villa Grimaldi in Chilean Memory." *Sociological Forum* 25 (1): 27–46.

González Iñárritu, Alejandro, dir. *Babel*. 2006. Los Angeles: Paramount Vantage.

Gordon, Avery. 2008. *Ghostly Matters: Haunting and the Sociological Imagination*. Minneapolis: University of Minnesota Press.

Grandin, Greg. 2005. "The Instruction of Great Catastrophe: Truth Commissions, National History, and State Formation in Argentina, Chile, and Guatemala." *American Historical Review* 110 (1): 46–67.

———. 2006. *Empire's Workshop: Latin America, the United States, and the Rise of the New Imperialism*. New York: Metropolitan Books.

Grandin, Greg, and Gilbert Joseph. 2010. *A Century of Revolution: Insurgent and Counterinsurgent Violence during Latin America's Long Cold War*. Durham, N.C.: Duke University Press.

Gray, David, and Jade Petermon. 2012. "Introduction: Memory, Space, and Media." *Media Fields Journal* 5:1–17.

Gregg, Melissa, and Gregory J. Seigworth. 2010. *The Affect Theory Reader*. Durham, N.C.: Duke University Press.

Grillo, Ioan. 2017. "The Paradox of Mexico's Mass Graves." *New York Times*, July 19. https://www.nytimes.com/2017/07/19/opinion/mexico-mass -grave-drug-cartel.html.

Gugelberger, Georg M. 1996. *The Real Thing: Testimonial Discourse and Latin America*. Durham, N.C.: Duke University Press.

Guzmán, Patricio, dir. 1975. *La batalla de Chile: La insurrección de la burguesía*. Brooklyn, N.Y.: Icarus Films.

———. 1977. *La batalla de Chile: El golpe de estado*. Brooklyn, N.Y.: Icarus Films.

———. 1986. *En nombre de Dios*. Brooklyn, N.Y.: Icarus Films.

———. 1979. *La batalla de Chile: El poder popular*. Brooklyn, N.Y.: Icarus Films.

———. 1997. *Chile, la memoria obstinada*. Brooklyn, N.Y.: Icarus Films.

———. 1999. *La Isla de Robinson Crusoe*. Brooklyn, N.Y.: Icarus Films.

———. 2001. *El caso Pinochet*. Brooklyn, N.Y.: Icarus Films.

———. 2004. *Salvador Allende*. Brooklyn, N.Y.: Icarus Films.

———. 2005. *Mi Jules Verne*. Brooklyn, N.Y.: Icarus Films.

———. 2010. *Nostalgia de la luz*. Brooklyn, N.Y.: Icarus Films.

Halbwachs, Maurice, and Lewis A. Coser. 1992. *On Collective Memory*. Chicago: University of Chicago Press.

Harvey, David. 2005. *A Brief History of Neoliberalism*. New York: Oxford University Press.

Hayner, Priscilla. 2000. *Unspeakable Truths: Confronting State Terror and Atrocity*. New York: Routledge.

———. 2011. *Unspeakable Truths: Transitional Justice and the Challenge of Truth Commissions*. 2nd ed. New York: Routledge.

Heineman, Matthew, dir. *Cartel Land*. 2015. New York: The Orchard.

Hesford, Wendy. 2011. *Spectacular Rhetorics: Human Rights Visions, Recognitions, Feminisms*. Durham, N.C.: Duke University Press.

Hess, John. 1990. "Collective Experience, Synthetic Forms: El Salvador's Radio Vencemos." In *The Social Documentary in Latin America*, edited by Julianne Burton, 173–192. Pittsburgh, Pa.: University of Pittsburgh Press.

Hirsch, Marianne. 2012. *The Generation of Postmemory: Writing and Visual Culture after the Holocaust*. New York: Columbia University Press.

Hirsch, Marianne, and Leo Spitzer. 2006. "Testimonial Objects: Memory, Gender, and Transmission." *Poetics Today* 27 (2): 353–383.

Hite, Katharine. 2015. "Empathic Unsettlement and the Outsider within Argentine Spaces of Memory." *Memory Studies* 8 (1): 38–48.

Hoelscher, Steven. 2007. "Photography, Urban Space, and the Historical Memory of Atrocity: The Angel Series." In *So That All Shall Know / Para que todos lo sepan: Photographs by Daniel Hernández-Salazar*, edited by Oscar Iván Maldonado, 55–64. Austin: University of Texas Press.

———. 2008. "Angels of Memory: Photography and Haunting in Guatemala City." *Geojournal* 73 (3): 195–217.

Hoelscher, Steven, and Derek H. Alderman. 2004. "Memory and Place: Geographies of a Critical Relationship." *Social and Cultural Geography* 5 (3): 347–355.

Huezo Sánchez, Tatiana, dir. 2011. *El Lugar Más Pequeño* [*The Tiniest Place*]. Brooklyn, N.Y.: Icarus Films.

Human Rights Watch. n.d. "World Report 2015: Argentina." Accessed March 19, 2018. https://www.hrw.org/world-report/2015/country -chapters/argentina.

Icarus Films. n.d. "Nostalgia for the Light." Accessed March 19, 2018. http://www.icarusfilms.com/if-nost.

Jameson, Fredric. 1991. *Postmodernism, or, the Cultural Logic of Late Capitalism*. Durham, N.C.: Duke University Press.

Jane the Virgin. 2014. Developed by Jennie Snyder Urman. Starring Gina Rodriguez. Narrated by Anthony Mendez. The CW.

Jonas, Stacie. 2004. "The Ripple Effect of the Pinochet Case." *Human Rights Brief* 11 (3): 36–38.

Katovich, Lisa. 2011. "San Francisco Teacher's Guide for *The Tiniest Place*." San Francisco: San Francisco Film Society.

Keenan, Thomas, and Eyal Weizman. 2012. *Mengele's Skull: The Advent of a Forensic Aesthetics*. Berlin: Sternberg and Portikus.

Klubock, Thomas Miller. 2003. "History and Memory in Neoliberal Chile: Patricio Guzman's 'Obstinate Memory' and 'The Battle of Chile.'" *Radical History Review* 85:272–281.

Koehler, Robert. 2011. "Review: *The Tiniest Place*." *Variety*, March 31. http://variety.com/2011/film/reviews/the-tiniest-place-1117944940/.

Kohn, Eric. 2011. "Review: 'The Tiniest Place' Brilliantly Transports Past Salvadoran Tragedies into the Present." *Indiewire*, August 19. http://www .indiewire.com/2011/08/review-the-tiniest-place-brilliantly-transports -past-salvadoran-tragedies-into-the-present-52739/.

Kornbluh, Peter. 1998. "Prisoner Pinochet: The Dictator and the Quest for Justice." *The Nation*, December 21. https://www.tni.org/es/node /13660.

Kozol, Wendy. 2014. *Distant Wars Visible: The Ambivalence of Witnessing*. Minneapolis: University of Minnesota Press.

Kristeva, Julia. 1980. *Desire in Language: A Semiotic Approach to Literature and Art*. New York: Columbia University Press.

Kritz, Neil. 1995. *Transitional Justice: How Emerging Democracies Reckon with Former Regimes*. Washington, D.C.: United States Institute of Peace Press.

Kun, Josh, and Fiamma Montezemolo. 2012. *Tijuana Dreaming: Life and Art at the Global Border*. Durham, N.C.: Duke University Press.

Labrador, Rocio Cara, and Danielle Renwick. 2018. "Central America's Violent Northern Triangle." *Council on Foreign Relations*, January 18. https://www.cfr.org/backgrounder/central-americas-violent-northern -triangle.

Ladutke, Lawrence Michael. 2004. *Freedom of Expression in El Salvador: The Struggle for Human Rights and Democracy.* Jefferson, N.C.: McFarland.

Landsberg, Alison. 2004. *Prosthetic Memory: The Transformation of American Remembrance in the Age of Mass Culture.* New York: Columbia University Press.

Lauria-Santiago, Aldo, and Leigh Binford. 2004. *Landscapes of Struggle: Politics, Society, and Community in El Salvador.* Pittsburgh, Pa.: University of Pittsburgh Press.

Lee, Michelle. 2015. "Donald Trump's False Comments Connecting Mexican Immigrants and Crime." *The Washington Post*, July 8. https:// www.washingtonpost.com/news/fact-checker/wp/2015/07/08/donald -trumps-false-comments-connecting-mexican-immigrants-and-crime/.

LeoGrande, William. 1998. *Our Own Backyard: The United States in Central America, 1977–1992.* Chapel Hill: University of North Carolina Press.

Lepecki, André. 2010. "The Body as Archive: Will to Re-Enact and the Afterlives of Dances." *Dance Research Journal* 42 (2): 28–48.

Lessa, Francesca, and Vincent Druliolle, eds. 2011. *The Memory of State Terrorism in the Southern Cone: Argentina, Chile, and Uruguay.* New York: Palgrave Macmillan.

Lesser, Gabriel, and Jeanne Batalova. 2017. "Central American Immigrants in the United States." *Migration Policy Institute*, April 5. https://www .migrationpolicy.org/article/central-american-immigrants-united -states.

Levine, Abigail. 2010. "Marina Abramović's Time: *The Artist is Present* at the Museum of Modern Art." *E-misférica* 7 (2). Accessed February 27, 2018. http://hemisphericinstitute.org/hemi/en/e-misferica-72/levine.

Linden, Sheri. 2011. "*The Tiniest Place*: Film Review." *The Hollywood Reporter*, June 20. http://www.hollywoodreporter.com/review/tiniest-place-film -review-203437.

Linfield, Susie. 2010. *The Cruel Radiance: Photography and Political Violence.* Chicago: University of Chicago Press.

Littín, Miguel. 1986. *General Report on Chile.* Chile: Alfil Uno Cinematográfica.

Luckhurst, Roger. 2013. *The Trauma Question.* New York: Routledge.

Lynch, Kevin. 1960. *The Image of the City.* Boston: MIT Press.

Maclear, Kyo. 2003. "The Limits of Vision: *Hiroshima Mon Amour* and the Subversion of Representation." In *Witness and Memory: The Discourse of*

Trauma, edited by Ana Douglas and Thomas A. Vogler, 233–248. New York: Routledge.

Mandelbaum, Jacques. 2010. "Nostalgie de la lumière": Un chef-d'oeuvre à la sérénité cosmique." *Le Monde*, October 26. http://www.lemonde.fr /cinema/article/2010/10/26/nostalgie-de-la-lumiere-un-chef-d-oeuvre-a -la-serenite-cosmique_1431375_3476.html#I3uRb4q6pGhdLIxM.99.

Marston, Joshua, dir. 2004. *Maria Full of Grace*. Los Angeles: Fine Line Features.

Martin, Michael T. 1997. *New Latin American Cinema, Volume 1: Theories, Practices, and Transcontinental Articulations*. Detroit, Mich.: Wayne State University Press.

Martinez, Daniel E., Robin C. Reineke, Raquel Rubio-Goldsmith, Bruce E. Anderson, Gregory L. Hess, and Bruce O. Parks. 2013. "A Continued Humanitarian Crisis at the Border: Undocumented Border Crosser Deaths Recorded by the Pima County Office of the Medical Examiner 1990–2012." Binational Migration Institute and Mexican American Studies Department, University of Arizona.

Martinez, Kiko. 2015. "5 Movies to Help You Understand the U.S. Mexico Drug War." Tribeca, October 2. https://tribecafilm.com/stories/5-must -see-drug-cartel-movies-to-watch-before-sica.

Martínez, Óscar. 2013. *The Beast: Riding the Rails and Dodging Narcos on the Migrant Trail*. Translated by Daniela Maria Ugaz and John Washington. London: Verso.

———. 2016. *A History of Violence*. Translated by Daniela Maria Ugaz and John Washington. London: Verso.

Massey, Doreen B. 2005. *For Space*. Thousand Oaks, Calif.: SAGE.

McLagan, Meg. 2012. "Imagining Impact: Documentary Film and the Production of Political Effects." In *Sensible Politics: The Visual Culture of Nongovernmental Activism*, edited by Meg McLagan and Yates McKee, 304–319. New York: Zone Books.

Menchú, Rigoberta, with Elisabeth Burgos-Debray. 1985. *Me llamo Rigoberta Menchú y así me nació la conciencia*. Mexico City: Siglo XXI.

Merleau-Ponty, Maurice. 2002. *Phenomenology of Perception*. Translated by Colin Smith. London: Routledge.

Metz, Christian. 1982. *Psychoanalysis and Cinema: The Imaginary Signifier*. London: Macmillan.

Mitchell, Bill. 2009. "When Memories Set Value of Things: Filmmaker Explores Feelings for Objects from 9/11." *Times Newsweekly*, May 21. http://objectsandmemory.org/Education/Coll_Rec_review_5_09.pdf.

Mitchell, W. J. T. 2005. *What Do Pictures Want? The Lives and Loves of Images*. Chicago: University of Chicago Press.

Moodie, Ellen. 2010. *El Salvador in the Aftermath of Peace: Crime, Uncertainty, and the Transition to Democracy.* Philadelphia: University of Pennsylvania Press.

Moraña, Mabel, and Ignacio M. Sánchez Prado. 2012. *El lenguaje de las emociones: Afecto y cultura en América Latina.* Madrid: Iberoamericana.

Morris, David. 1991. *The Culture of Pain.* Berkeley: University of California Press.

Moulian, Tomás. 1998. "A Time of Forgetting: The Myths of the Chilean Transition." *NACLA Report on the Americas* 32 (2): 16–22.

Nadir, Leila. 2012. "Poetry, Immigration and the FBI: The Transborder Immigrant Tool." Hyperallergic, July 23. http://hyperallergic.com/54678/poetry-immigration-and-the-fbi-the-transborder-immigrant-tool/.

Nance, Kimberly A. 2006. *Can Literature Promote Justice? Trauma Narrative and Social Action in Latin American Testimonio.* Nashville, Tenn.: Vanderbilt University Press.

Nava, Gregory, dir. 1983. *El Norte.* New York: The Criterion Collection.

Newell, Bryce, dir. 2014. *The Tinaja Trail.* The Humanitarian Film Initiative. https://vimeo.com/91049819.

Ngai, Mae. 2014. *Impossible Subjects: Illegal Aliens and the Making of Modern America.* Princeton, N.J.: Princeton University Press.

Nichols, Bill. 2010. *Representing Reality: Issues and Concepts in Documentary.* Bloomington: Indiana University Press.

Nora, Pierre. 1989. "Between Memory and History: Les lieux de mémoire." *Representations* 26:7–24.

"Nostalgia for the Light." Icarus Films. Accessed February 27, 2018. http://icarusfilms.com/new2011/nost.html.

Olick, Jeffrey K., Vered Vinitzky-Seroussi, and Daniel Levy. 2011. *The Collective Memory Reader.* New York: Oxford University Press.

Olin, Margaret. 2012. *Touching Photographs.* Chicago: University of Chicago Press.

Osnos, Evan. 2016. "When Tyranny Takes Hold." *The New Yorker,* December 19 and 26. http://www.newyorker.com/magazine/2016/12/19/when-tyranny-takes-hold.

Perezcano, Rigoberto, dir. 2010. *Norteado.* Miami: Venevision International.

Phelan, Peggy. 1993. *Unmarked: The Politics of Performance.* London: Routledge.

Pick, Zuzana M. 1987. "Chilean Cinema: Ten Years of Exile (1973–83)." *Jump Cut: A Review of Contemporary Media* 32:66–70.

Pindado, Encarni. 2015. "Meet the Man Who Tracks the Digital Footprints of Missing Central American Migrants." Splinter, April 19. https://

splinternews.com/meet-the-man-who-tracks-the-digital-footprints-of
-missi-1793847232.

Ponce, Armando. 2011. "'El lugar más pequeño', un documental estrujante" *Mujeres por la democracia*, February 7. http://mujeresporlademocracia .blogspot.com/2011/02/el-lugar-mas-pequeno-un-documental.html.

Popkin, Margaret. 2000. *Peace without Justice: Obstacles to Building the Rule of Law in El Salvador.* University Park: Pennsylvania State University Press.

Portillo, Lourdes, dir. 1985. *Las Madres: The Mothers of the Plaza de Mayo.* Los Angeles: Xochitl Productions.

Portillo, Lourdes, dir. 2003. *Señorita Extraviada.* Los Angeles: Xochitl Productions.

Pratt, Mary Louise. 1996. "Me llamo Rigoberta Menchu: Autoethnography and the Recoding of Citizenship." In *Teaching and Testimony: Rigoberta Menchú and the North American Classroom*, edited by Allen Carey-Webb, 57–72. Albany: State University of New York Press.

Presner, Todd, David Shepard, and Yoh Kawano. 2014. *Hypercities: Thick Mapping in the Digital Humanities.* Cambridge, Mass.: Harvard University Press.

Raftree, Linda, Karmen Ross, Marc Silver, and Lina Srivastava. 2015. "*Who Is Dayani Cristal?* Impact Assessment." Accessed February 27, 2018. http://whoisdayanicristal.com/downloads/impact/WhoIsDayaniCristal _ImpactAssesment_EN.pdf.

Rancière, Jacques. 2004. *The Politics of Aesthetics: The Distribution of the Sensible.* Translated by Gabriel Rockhill. London: Continuum.

———. 2010. *The Emancipated Spectator.* New York: Verso.

Renwick, Danielle. 2016. "Central America's Violent Northern Triangle." Council on Foreign Relations. Last updated January 18, 2018. https:// www.cfr.org/backgrounder/central-americas-violent-northern-triangle.

Report of the Chilean National Commission on Truth and Reconciliation. 1993. Notre Dame, Ind.: University of Notre Dame Press. Accessed February 27, 2018. http://www.usip.org/files/resources/collections/truth_commissions /Chile90-Report/Chile90-Report.pdf.

Richard, Nelly. 2004. *Cultural Residues: Chile in Transition.* Translated by Alan West-Durán and Theodore Quester. Minneapolis: University of Minnesota Press.

Rivera, Alex, dir. 2009. *Sleep Dealer.* Los Angeles: Maya Entertainment.

Robben, Antonius. 2005. *Political Violence and Trauma in Argentina.* Philadelphia: University of Pennsylvania Press.

Rose, Gillian. 2001. *Visual Methodologies: An Introduction to the Interpretation of Visual Materials.* London: SAGE.

Ruiz, Bernardo, dir. 2015. *Kingdom of Shadows.* New York: Quiet Pictures.

Said, Edward W. 2000. "Invention, Memory, and Place." *Critical Inquiry* 26 (2): 175–192.

Sandoval, Chela, and Guisela Latorre. 2008. "Chicana/o Artivism: Judy Baca's Digital Work with Youth of Color." In *Learning Race and Ethnicity: Youth and Digital Media*, edited by Anna Everett, 81–108. Cambridge, Mass.: MIT Press.

Scarry, Elaine. 1985. *The Body in Pain: The Making and Unmaking of the World*. New York: Oxford University Press.

Schechner, Richard. 1985. *Between Theater and Anthropology*. Philadelphia: University of Pennsylvania Press.

———. 2013. *Performance Studies: An Introduction*. London: Routledge.

Schneider, Rebecca. 2011. *Performing Remains: Art and War in Times of Theatrical Reenactment*. New York: Routledge.

Schuppli, Susan. 2014. "Forensic Imagination." Forensic Architecture Project. Accessed February 27, 2018. http://www.forensic-architecture .org/lexicon/forensic-imagination/.

Schwarz, Shaul, dir. 2013. *Narco Cultura*. Los Angeles: Cinedigm.

Silver, Marc, dir. 2014. *Who Is Dayani Cristal?* New York: Kino Lorber.

Sliwinski, Sharon. 2011. *Human Rights in Camera*. Chicago: University of Chicago Press.

Soderbergh, Steven, dir. 2000. *Traffic*. Universal City, Calif.: USA Films.

Sontag, Susan. 1977. *On Photography*. New York: Picador.

———. 2003. *Regarding the Pain of Others*. New York: Picador.

Stewart, Kathleen. 2007. *Ordinary Affects*. Durham, N.C.: Duke University Press.

Studemeister, Margarita. 2001. *El Salvador: Implementation of the Peace Accords, Volume 31, Issue 10*. US Institute of Peace.

Sturken, Marita. 1997. *Tangled Memories: The Vietnam War, the AIDS Epidemic, and the Politics of Remembering*. Berkeley: University of California Press.

Sturken, Marita, and Lisa Cartwright. 2001. *Practices of Looking: An Introduction to Visual Culture*. Oxford: Oxford University Press.

Suebsaeng, Asawin, and Chris Mooney. 2016. "Seven Movies That Changed People's Political Views." *Slate*, January 7. http://www.slate.com/articles /health_and_science/climate_desk/2014/01/movies_that_influenced _political_views_all_the_president_s_men_malcolm_x.html.

Taylor, Diana. 1997. *Disappearing Acts: Spectacles of Gender and Nationalism in Argentina's "Dirty War."* Durham, N.C.: Duke University Press.

———. 2001. "Interview with Barbara Kirshenblatt Gimblett." What Is Performance Studies? Interview Series. Hemispheric Institute Digital Video Library, December 19. http://hdl.handle.net/2333.1/qz612k86.

———. 2002a. "Interview with André Lepecki." What Is Performance Studies? Interview Series. Hemispheric Institute Digital Video Library, October 1. http://hdl.handle.net/2333.1/ghx3ffzd.

———. 2002b. "Interview with José Muñoz." What Is Performance Studies? Interview Series. Hemispheric Institute Digital Video Library, October. http://hdl.handle.net/2333.1/m63xsjsw.

———. 2003. *The Archive and the Repertoire: Performing Cultural Memory in the Americas.* Durham, N.C.: Duke University Press.

———. 2007. "Interview with Ann Pellegrini." What Is Performance Studies? Interview Series. Hemispheric Institute Digital Video Library, September 27. http://hdl.handle.net/2333.1/37pvmdcb.

———. 2011. "Trauma as Durational Performance." In *The Rise of Performance Studies*, edited by J. Harding and C. Rosenthal, 237–247. London: Palgrave Macmillan.

———. 2016. *Performance.* Durham, N.C.: Duke University Press.

Till, Karen E. 2005. *The New Berlin: Memory, Politics, Place.* Minneapolis: University of Minnesota Press.

US Department of Homeland Security. 2010. "Table 35, Deportable Aliens Located by Program and Border Patrol Sector and Investigations Special Agent in Charge (SAC) Jurisdiction: Fiscal Years 1999 to 2008." *Yearbook of Immigration Statistics 2009*, August. https://www.dhs.gov/xlibrary/assets/statistics/yearbook/2009/ois_yb_2009.pdf.

Van der Kolk, Bessel, and Onno Van der Hart. 1995. "The Intrusive Past: The Flexibility of Memory and the Engraving of Trauma." In *Trauma: Explorations in Memory*, edited by Cathy Caruth, 158–182. Baltimore: Johns Hopkins University Press.

Verdery, Katherine. 1999. *The Political Lives of Dead Bodies: Reburial and Postsocialist Change.* New York: Columbia University Press.

Verne, Jules. 1958. *Five Weeks in a Balloon.* Westport, Conn.: Associated Booksellers.

Villeneuve, Denis, dir. 2015. *Sicario.* Santa Monica, Calif.: Lionsgate.

Walker, Janet. 2011. "Documentaries of Return: 'Unhomed Geographies' and the Moving Image." In *Just Images: Ethics and the Cinematic*, edited by Boaz Hagin, Sandra Meiri, Raz Yosef, and Anat Zanger, 114–129. Newcastle upon Tyne: Cambridge Scholars Publishing.

Walker, Janet. 2010. "Rights and Return: Perils and Fantasies of Situated Testimony after Katrina." In *Documentary Testimonies: Global Archives of Suffering*, edited by Bhaskar Sarkar and Janet Walker, 83–114. New York: Routledge.

Weinstock, Jeffrey Andrew. 2004. *Spectral America: Phantoms and the National Imagination.* Madison, Wis.: Popular Press.

Weitz, Chris, dir. *A Better Life*. 2011. Universal City, Calif.: Summit Entertainment.

Whigham, Kerry. 2014. "Filling the Absence: The Re-Embodiment of Sites of Mass Atrocity and the Practices They Generate." *Museum and Society* 12 (2): 88–103.

Williams, Linda. 1993. "Mirrors without Memories: Truth, History, and the New Documentary." *Film Quarterly* 46 (3): 9–21.

"*Who Is Dayani Cristal?* Press Pack." 2015. Accessed February 27, 2018. http://whoisdayanicristal.com/admin/resources/downloads /widcproductionnotesss3reduced.pdf.

Young, James Edward. 1993. *The Texture of Memory: Holocaust Memorials and Meaning*. New Haven, Conn.: Yale University Press.

Zong, Jie, Jeanne Batalova, and Jeffrey Hallock. 2018. "Frequently Requested Statistics on Immigrants and Immigration in the United States." *Migration Policy Institute*, February 8. http://www.migrationpolicy.org/article /frequently-requested-statistics-immigrants-and-immigration-united -states.